THE
FUTURE
OF ART
A MANUAL

THE
FUTURE
OF ART
A MANUAL

BY INGO NIERMANN

+ A FILM
BY ERIK NIEDLING
AND INGO NIERMANN

Sternberg Press

Ingo Niermann with Erik Niedling
The Future of Art: A Manual

Published by Sternberg Press

© 2011 Ingo Niermann, Sternberg Press
© DVD 2010/11 Erik Niedling, Ingo Niermann, Sternberg Press

Images: p. 29, 130, 139, 171, 178, 208, 243, 287, 290, 299 by Erik Niedling; p. 93 by Jens Ziehe (courtesy of neugerriemschneider); p. 123 by René Eisfeld (courtesy of Freunde der Großen Pyramide e. V.); p. 189, 238, 255, 275, 298 by Ingo Niermann; all others from the film *The Future of Art* by Erik Niedling and Ingo Niermann.

Translation: Amy Patton
Copyediting: Leah Whitman-Salkin
Graphic design: Judith Banham, Middlecott Design
Printing and binding: Brandenburgische Universitätsdruckerei Potsdam

ISBN 978-1-934105-63-4

Sternberg Press
Caroline Schneider
Karl-Marx-Allee 78
D-10243 Berlin
www.sternberg-press.com

CONTENTS

4: Presentation

5: Epilogue

Appendix

Commentary

DVD

Prologue

A Brief (Art) History of the Twenty-First Century

To search for the future of art is a perplexing thing, even at the beginning of the twenty-first century. The future of money, the family, the car, or even progress itself are common topics in a progressive society. But in art the claim to *be* the future per se—to put not only the more sluggish, wayside-fallen art on the right track, but society as a whole— turned virulent in the twentieth century. Should one continue to produce originals despite the increasing possibilities of technical reproduction, it would have to be in the form of prototypes: made too soon to go into production. However radical Marxism was, its design for a total structuring of society began in the dictatorial practice in cooperation with, and in defense against, the artistic avant-garde. Adolf Hitler was an artist whose profound contempt for the avant-garde prompted him to become a politician.

Despite totalitarian regimes exploiting the artistic avant-garde and rivaling them, their ambition to dissolve themselves into society as a whole did not fade. If the world cannot be made on art's terms, then at least art should be made on the world's. If there is talk of ready-mades and an expanded notion of art, then what is meant is a realism that not only imitates or stands for reality, but tries to be identical with

it. The world no longer needs to be molded in an artistic sense, only labeled as such, preserved, and documented. Everyone and everything is already art; the artists and then the critics, collectors, and curators only have to recognize it.

Art envisions something it is not. From the religions and the monarchies that it illustrated, it has inherited the claim of being elevated above concrete reality and remaining valid for all time. When belief in other worlds wanes, then art ultimately represents only the desire for them. The special quality of art consists precisely in its not being good for anything, and it is thus exempted from the world of consumption and progress that underlies changing fashions. Art too can generally be sold, but not for consumption, only preservation. Yet a utopian model for all of society can be seen in the exacting care typical of the museum. Nothing has to pass away, nothing sacrificed for the other. There is only pure accumulation, otherwise only possible with money and other immaterial goods. Even what we no longer desire is kept, so that what is in fashion now will later not be disposed of. It is along these lines that more and more is archived, even outside the scope of art, and with ever more urgency. That which cannot be moved will be placed under landmark protection.

Libraries archive one copy of each book, which takes so little space and costs so little that large swathes of book production have been admitted to archives without much thought. Internet services like Facebook archive not only every entry multiple times, but also every deletion. On the other hand, art is the only area of society that pursues museum archiving as its primary objective. Only in this way can art visibly and durably continue to exist as such. The limited amount of space in museums and institutions ensures that art does not cast the whole world into a pall of rigidity, like the hand of Midas. While it is true that one can simply declare anything at all to be art, this ultimately remains meaningless. Galleries and private collections compete in their grandiose presentation of art in order to increase the chances of having it accepted into a museum. Living organisms can be included only if considered replaceable—plants especially. With animals, things start to become problematic. Humanity's museumification can only be realized once we have attained immortality. In light of such limitations, the objects declared to be art must at least enjoy an original selection or modification process if they are to be believable as unique objects. Absorption of the world by art can only proceed by way of example and—though henceforth as only another possibility—in that the art-

works represent more than just their "artness."

If the art of the museum and of art history really can be anything, then it must also include singular events and processes. � Hans Ulrich Obrist, 137. These have the added advantage of only being reproducible in a limited way or not at all—they can only be documented. Documentation can also be supplemented with relics, further aiding the work's musealization. In this way, every artwork can be seen as the relic of an artistic performance, and ultimately, the entire life of the artist can be seen as one single artistic performance—public in part or not at all—and simultaneously as a relic of that performance. ➤Antje Majewski, 91; and Boris Groys, 221. A person is both a process and a material continuum. The only person the artist can continuously and reliably modify is himself. Perhaps the artist could even find someone to follow him unconditionally, as a willing slave, but he would always have to give him new instructions. In the case of oneself, in the best case, this happens automatically. A successful artistic persona cannot be meaningfully separated from the rest of the person; it is also unnecessary to record his life without interruption in order for it to be credible. On the contrary, such documentation would only sow the seeds of doubt, serving as an admonishment to search for gaps and fissures in this staging of oneself. We can only really ever have the power of disposition over others after their death, as corpses. Establishment of such a power of disposition while still alive, however, can influence life in an enduring way. In the most compact and yet socially acceptable form, the purchaser of the artwork is also this future corpse and his life will be dictated henceforth by the requirements associated with the purchase. What would be more natural than to seek this in the design of the collector's own grave?

Art's relativization of its objecthood has only become more cumbersome with time. Video projections require large spaces; installations do the same, even in storage. Only rarely does the artwork require concentration on a discrete patch of floor or wall space; instead it shapes and structures the whole space, as it once did in churches and palaces. The price art is paying for this increased presence is that long-term visibility in a museum is hardly possible anymore, and even storage is being taken over by collectors and the artists' representing galleries. Thus art remains a product on the market. Temporarily loaning a piece to a museum is only another maneuver that increases value, which is why collectors and gallerists are not necessarily interested in having artworks they have owned or handled entirely given over to

a public museum. This is especially true as museums, too, no longer feel obligated to maintain their collection complete when they can use sales to put on spectacular exhibitions *now*. This is how speculation becomes entrenched as a practice. More and more, art is being stored and conserved at immense cost, for the theoretical purpose of one day being included in a public collection. Even if museums continue to be built at a steady pace, only a fraction of today's most expensive art could be included in them, which is why it is actually time to let go of this expectation.� This is precisely what could cause the next great and impending crash in the art market.➥Harald Falckenberg, 79. Afterwards, the sale and collecting of art would not be fundamentally different from the situation we see with luxury objects, like furniture or clothes by famous designers, which are also often collected.➥Boris Groys, 222. Artists who sell little and at low prices, or who travel from biennial to biennial, have as few prospects for fame and wealth as a small time musician. Just as he offers his music for free download on the Internet only to draw attention to himself, the artist gives his works to galleries on consignment, while the galleries then lend them out—on a trial basis—to collectors who seem important.

In order to provide sufficient space for this, the Guggenheim Museum—under the direction of Thomas Krens—would have to had opened not dozens, but thousands of locations, developing into a franchi of McDonald's-like proportions. This was the basis of my rece discussion with author Shumon Basar and Agnieszka Kurant about whether in an effort to polish its image, Shell shou expand its existing, generously proportioned gas statio to include open lots with small sculpture parks and nocturnal video installations. "Art is the new fu could be Shell's slogan, in anticipation of a post-fossil fuel future.

Art is already increasingly defined by a non-conservable event-like quality, and it is only a question of time before we can reproduce its relics using 3-D copiers, everywhere and whenever we want. This would eliminate the enormous cost of storage, transport, and insurance.➥Gregor Jansen, 117; and Friedrich Petzel, 201. Even today, artworks composed of perishable materials have to be replaced on a regular basis. One can continue to limit the right to reproduce the artworks, but they therefore have no need to be stored in a museum. All art still created with the claim to material uniqueness can be included in the anthropological collection. This could also serve to strengthen another new tendency in art, which—contrary to the monotheistic, essentially object-despising sacredness emphasized until now—stresses the magical potential of the object and presents it in such a way that it becomes tangible and fetishizable.➥Antje Majewski, 98; and Thomas Olbricht, 149. Contemporary art museums, however, like all public venues, still serve the

primary purpose of social exchange. Although it is sufficient when the uniqueness lies only in the public's own presence, as demonstrated by the success of live, open-air broadcasts, art events are characterized by a high degree of singularity, having inherited a principle of uniqueness.

This has been exacerbated even more by the shift from objects to events. Unlike theater performances or concerts, there are few repetitions of the art event, if any. Though it can lead to great success among the public, artistic distribution always begins with an intentionally imposed scarcity. It is only this scarcity that distinguishes it from other areas of activity in society, whether the other arts, or politics, social work, sports, research, or religion. Art is the hubris of being able to do anything, but never in the "real" or with significant force. ➙ Olafur Eliasson, 43; and Boris Groys, 230. In art, explicit dilettantes run wild, while explicit professionals limit themselves to a mere sketch. In this, we can see the idyll of a space with no sovereign (at the price of its impotence), or a boisterous interdisciplinarity—except it generally remains a mere side-by-side. Which is why we need curators who devise relationships among "artistic positions" and act as meta-artists. ➙ Hans Ulrich Obrist, 140. Rather than simply illustrate interdisciplinarity, art can allow itself to be co-opted by other sectors, provided that they do not expect direct application or use. ➙ Antje Majewski, 102. It can, however, easily lose its autonomy in such deliberative integration. What is coursing through art, by way of compensation, is a historical interest in the art of the modern age. One that supports its claim of pointing society the way forward, even with regards to content. ➙ Hans Ulrich Obrist, 134; and Boris Groys, 229. In this tendency, art is like philosophy. When, in the wake of academic specification, philosophy could no longer fulfill its traditional claim to provide a comprehensive explanation of the world, it began to deal primarily with its own history. At the beginning of the twentieth century, the artistic avant-garde, which was unbeholden to any academic standards, took its place only to be likewise dissected and, in part, reanimated over and over again. This is part of the tendency to subject art, which is no longer defined by the mastering of handicrafts, to scholarly criteria in the manner of an academic discipline. ➙ Boris Groys, 227. It could lead as a consequence to a widespread merging of the discipline of art with that of art history, analogous to the development of traditional studies of literature and the more recent discipline of creative writing. An artist's teaching qualifications are no longer measured by the importance of the museum collections and exhibitions his works are featured in, but the extent to which he strives to influence

art history through publications. He can do this in art historical essays, but also by acting as a researcher who investigates his own and other exhibitions' effect on viewers.➡Olafur Eliasson, 36.

The criteria for relevant art developed at the art academy are replacing the museum as a filter.➡Boris Groys, 228. In a leisure society that yearns for artistic articulation at all levels, art is often exclusively perceived within a pedagogical context: with regard to one's own path to becoming an artist.➡Boris Groys, 228. An artist only enjoys lasting influence as an "artist's artist." Just as humanities scholars generally only address other or future humanities scholars.

The ones who stay marginalized in this scenario are the collectors. In an effort to avoid being discredited as greedy or speculative, they have learned to conceive of their collecting as an art historical,➡Harald Falckenberg, 79. or artistic,➡Thomas Olbricht, 151. practice; however, being dilettantes, this practice is one in which they are bound to remain second-class curators and artists. With the devaluation of museum collecting as a practice in art, enormous areas of collecting will be laid waste, just as we saw with the digitization of music and literary media. What remains is to support artistic processes and events in advance as a patron, as one would for theater or opera. But a passive and altruistic patronage model has lost some of its appeal in recent years.➡Philomene Magers, 69.

Art that embraces collectors is generally regarded as art-historically inferior on account of its representative function.➡Philomene Magers, 70. Yet every collection appears representative, if not in the individual works, then all the more as a whole, degrading each discrete artwork to a token fragment➡Philomene Magers, 70; Thomas Olbricht, 151; and Boris Groys, 234. that can be disposed of as soon as it no longer fits. Since most purchasable art has no chance of ever escaping the arbitrariness of collectors and enjoying eternal sanctification in a museum, and inevitably represents its collectors, why shouldn't it seek ongoing public presence precisely by involving collectors? It would only have to assume such a size and robustness—becoming even larger and more stable than the Egyptian pyramids—that it no longer requires the support and care of a museum, and a compelling and dynamic artistic persona that will have to be cultivated over years and decades. It doesn't even have to be visible to be remembered as important in 100 years by humanity's intellectually superior descendants. In the following conversations with artists, curators, gallerists, collectors, and theorists, I develop an artwork that does precisely that: it provides the collector with an impressive, repre-

sentative effect, but also creates a space for his disappearance. → Gregor
Jansen, 122; Hans Ulrich Obrist, 137; Thomas Olbricht, 151; Boris Groys, 235; Tobias Rehberger,
254; and appendix, 303.

Because the other arts have nothing on the visual
arts in terms of radicality and expansiveness, → See my essay "Zukunft der Literatur,"
I trust the visual arts to take the next step toward a new, *Bella Triste* 13 (2005).
profane universality, maybe even beyond the confines of
art. Visual art is not fettered to language and can also be
understood purely intuitively or at least misunderstood. → Antje
Majewski, 100; and Olaf Breuning, 162.

Over the past twenty years, many of my closest friends have been art-
ists, and I have been following the dramatic rise of a new generation
of artists and gallerists in Berlin since it first emerged in the 1990s.
I have never limited my literary work to writing and publish-
ing. In 2000, even before my first novel was published, I was
a founding member of the collective Redesigndeutsch-
land, where I developed a simplified grammar for the
German language. This later led me to the book *Umbauland – Zehn deutsche*
Umbauland, the first book in the Solution series. → *Visionen* (Frankfurt am Main:
The Great Pyramid project → Appendix, 303. devel- Suhrkamp, 2006); *Solution 1-10:*
oped in the book grew out of the idea I presented *Umbauland* (Berlin: Sternberg Press, 2009).
in the exhibition "Atomkrieg" (Atomic War), → A group exhibition at Kunsthaus Dresden,
namely the idea of a cube made of the ashes curated by Antje Majewski and myself
of all humanity. Thanks to rather coincidental in 2004.
participation in exhibitions, for years my Artfacts.net
ranking as an "artist" has been a four-digit one. I'm sure
that I would score much worse in a global ranking of au-
thors. I write in my native language, German, a language in its
death throes whether the end comes soon or is put off for a while;
one that is hardly ever translated into languages better suited to sur-
vival, such as English, French, or Spanish.

And yet my acceptance in the art world is tricky, as it owes to
an expanded curatorial activity that is precisely about integrating work
that is not explicitly meant to be art into exhibitions. If I want to be
successful as an artist, this non-artistic activity could prove a liability. I
am suspected of being merely a prankster who abandoned philosophy
for literature and now, on a whim, is infiltrating art. Today, artists, par-
ticulary those who invest little time in the development and production
of their art, are only successful when persistent in concerning them-

selves with the art world. Not at all because so much knowledge and so many contacts are necessary, but because the art world wants to be taken seriously by its members.

This piques my ambition to gain fame and fortune with this single idea, and to make this intention obvious from the start. The timing seems favorable, since the noughties boom is over and finally there appears to be an opportunity to be on the lookout for fundamentally new approaches. Where in previous years, good money could be earned with variations on existing recipes for success, the fact that lasting recognition would at best only be granted by the pioneers of the nineties was to be expected. In this book, I converse with exactly these kinds of pioneers and some of their forerunners. These artists are generally already professors at a university or, like Genesis and Lady Jaye Breyer P-Orridge and Terence Koh, they have a unique potential to be gurus. I'm concerned with lasting effect and therefore have no reason to keep my eyes peeled for the next hottest shit. Rather, I'm interested in how artists react to no longer being hot. Gabriel von Loebell has preceded me in my entry from left field, yet has recoiled from pursuing that path to the end, which emboldens me in my idea to make it with one work or not at all.

The twenty conversations held between late April and mid-June 2010 in Berlin, Hamburg, New York, Frankfurt, Taunus, and Thuringia, Germany are structured as a teaching program in which I have the art business explained to me from ground up and discuss the various stages of my own idea for a futuristic artwork. In editing the interviews, I have limited myself to omissions and slight adjustments of syntax. As with the Great Pyramid project, a dramatic narration is improvised in real life during a number of set appointments. The interviews are organized as an epic divided into the four chapters: Investigation, Creation, Incubation, and Presentation. As the protagonist, I share the stage and co-direct the film version with the artist Erik Niedling. Since he, like me, did not study art, he regards the meetings with important art figures as an opportunity to radically take his work to the next level. At the beginning of the journey I speak with Niedling in New York, I provide an interim summary, and in the epilogue, we weave together my idea with his for a new series of work.

Being a man of letters enables me, in my search for truth, to use methods that do not satisfy today's academic criteria. One such method—already explored in antiquity—is dialogue. Instead of concise modules of

exercises, the following manual captures speech. It does not personalize the pedagogical content, but rather teaching itself. Niedling and I are exemplars of learning, like the kind you may know from *Sesame Street*—only the lessons we received over fifty condensed days of traveling and tuition are not a dramatization. When a topic comes up several times, I have included references to corresponding passages in other interviews. Moreover, the appendix offers a section outlining the evolution of ideas, from the Great Pyramid to the artwork I developed over the course of the journey, ending with Niedling's future series.

The concepts by Niedling and myself could be interpreted as clumsy attempts to compensate, through sheer size and vehemence, for our marginalization as self-taught practitioners in an increasingly academic art world. And yet, the success of exactly this kind of strategy could also strike out on a fundamentally new path: the future of art.

1:

Investigation

Erik Niedling

ENTROPY
A FLAWLESS WORK OF ART
ROLE PLAY

*Hamish Morrison Galerie, Berlin. I know the artist Erik Niedling (*1973) primarily as a photographer of the woods, rooms, and private photo archives. For his current exhibition "Redox," he created the subject himself by collecting the national and international press of a single day, sorting it by section, and then burning it. While not even the tiniest shred of paper remained in the off-white newsprint color, you could still read the type in the ashes. A black lacquered hole of unfathomable depth yawns in the front room of the gallery.*

You and I are shooting a documentary about our search for the future of art. I'm setting off on this quest and you're coming along with me. And now we're going to start with your exhibition "Redox."

We're looking for the art of the future, your future, and also my future.

The thing that always put me off about art is its materiality—that you have to worry about these things, their preservation. And in your pictures it's mostly about the destruction of material. Not in itself—the material isn't gone—but someone prepared it in such a way that it became a newspaper and can retain information. And now the information is in the process of disappearing.

It isn't disappearing; it's only moving towards another aggregate state, so to speak. It's more fragmented and has been conserved again for the time being. But the moment I began this conservation—in other words, made the photograph—the deterioration process had already started again. Actually the only time I have a problem with losing data is in the transfer from one medium to another. The information as such is still there, it's just in a new

25

order that is determined by destruction on the one hand and coincidence on the other.

Would you say it's about the fight against entropy, how we're always bound to lose in the end?

Yeah, everything is disappearing anyway. At some point it's gone. You can prolong the period of time before it happens, you can decelerate it. But any attempt to save some kind of information forever is doomed from the start. And the time until then has always interested me because it is so undefined.

Now we have these people buying works of art, and they'll nevertheless be asking themselves and the gallery, okay, so how long does a photo like that keep?

How long does a carton of milk keep? It depends on the criteria you set. Of course the photograph will turn to dust one day. And when exactly that happens depends on a number of criteria over which I can have no influence.

So what if a collector buys a piece and something happens to it? That

doesn't have to be a slow process of deterioration; it could also be something like …

… a kid's birthday party.

So what then? Do they get a replacement from you or was that it?

Under certain circumstances I give them a replacement. The work is an edition; there are three of each piece. If it were destroyed by some act of nature then the collector would get a new one for the price of production, the sole cost of materials. I haven't thought about it beyond that.

Why did you burn newspapers and not art?

Because for me, newspapers are more of a temporary information carrier. The most important headlines today are yesterday's news by the next morning. Also the newspaper has a symbolic character for me because it is in the process of vanishing. It's slowly dismantling itself as a medium and has almost given up on the daily news, because almost no newspaper can publish anything that you wouldn't have already read online.

The photographs are digital.

I don't draw so much of a distinction there. They're photographs. In this case they were taken with a high-resolution digital camera for technical reasons. In the end it doesn't make a difference in terms of reception.

Could you imagine the work presented any other way besides framed, on paper, hanging on the wall? Could they also be …

… projected? No. Theoretically it would be possible, but the plan for this "Redox" construct had always been to have the newspapers turn from one form of paper into another.

What really interests me is this problem of materiality and duration. I have the feeling that if I find an artwork of the future it would have to attempt a solution.

A solution to decay?

Both are problematic as far as I'm concerned. I think it's bad when things deteriorate but also when they stay. I have a fundamental problem with property. It really becomes a problem when I myself create something. The only reason I can live with this when it comes to books is because many are printed at once, so a single copy isn't really that

important. It's scattered into the world and a copy will survive somewhere at some point down the line. Also, a book can be completely tattered and trashed but the information is still there.

> I've done books too. My problem was similar. Because a book—say some mistake finds its way in, it gets reproduced over the entire edition and there's no way to undo it. But if I'm printing in the darkroom and a print gets shot to hell, I'll throw it away and make a new one.

The problem today lies in the moment you type just a Y in the computer and hit SEND. The nice thing about books is that compared to that, you proceed in a very controlled way and do everything very conscientiously: now, at this is moment, I am letting go and from now on the book is how it is. You have to write it in such a way that you can let go.

> Yes, but if that's such a good feeling for you and making art makes you so uneasy, then why have you come to the point where *that's* what you've decided to do?

The problem holds an allure for me. With the books there's also always … of course I know all about mistakes in books. Real mistakes. You open the book and look until you find at least one mistake. But maybe I could create an artwork that …

> … is free of errors? Flawless?

Yeah, is completely flawless. I'd like that. That seems more possible for me because of the fact that art can be so easy. Even if you do a book with only fifty, forty, thirty pages, it still consists of …

> … thousands of letters.

But the art I would make would be very simple. The great thing especially about conceptual art is that the real artwork can be very simple, but the way it's implemented in the world … all you can do is give instructions. Very simple guidelines. The complexity develops from that alone.

> The complexity doesn't necessarily have to be found in the artwork itself. That's another thing I've been asking myself a lot these days. And after this exhibition, when we go on this trip together and meet these different people, for me it's also an attempt to answer this question for myself: How does this continue? Where does it go from here? What comes after "Redox"? For me, "Redox" is on the one hand an endpoint for a ten-year work on the subject of history, the transfer of information, tran-

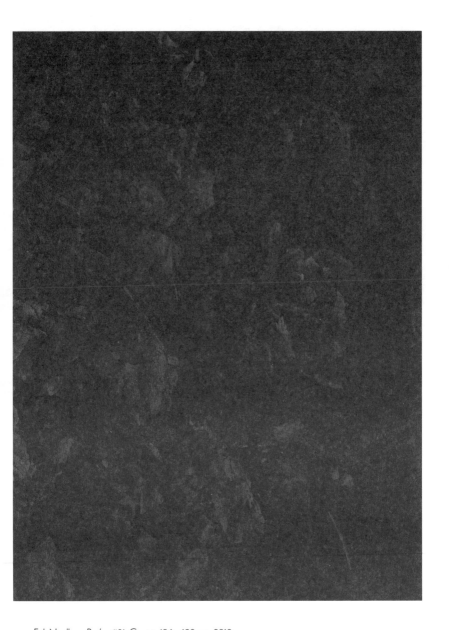

Erik Niedling, *Redox #01*, C-print, 156 x 122 cm, 2010.

sience. And on the other hand, it could be the starting point for a completely different artistic practice. But I also wouldn't rule out the possibility of it being the end of my work as an artist.

Aren't you afraid of that?

Fear is probably the wrong word in that context. I can be afraid of something happening to my kid. But I can't be afraid of the plans I set up for my own life, afraid of failure. Because that immediately puts me on the defense. I am sure that even if the decision falls against the making of art, I personally would be able to deal with it. Because the decision would be mine.

For once I'm the one that is going out on a limb here. I'm a writer and suddenly I'm saying, yes, I'm making art now! Not something like, oh, I'm just fooling around here.

You'll do a real proper job of it. It's always the full nine yards with you!

Yes.

I like it too. Why not just cut to the chase?

Then again, once it's all said and done, I could always say, whatever, it was nothing …

… didn't work. Nice try though!

I think it's good, the art world thinks it's shit. Who cares. I'm just going to keep writing books. Meanwhile you'll hold back. You'll just watch at first, keep an eye on me to see how it works out.

I'll tag along on your art individuation; it'll be interesting for me too.

I'm Don Quixote and you are …

… Sancho Panza? Right? Bonnie and Clyde? I don't know. There are probably lots of different pairings like that in literature, in film, in history. It's just role assignments for who's who—whether you're Faust and I'm Mephisto or the other way around—that will probably become clear later on. The fact is, we are both on different missions but are interested in how the other's mission turns out.

Of course, I wouldn't want to get to the end saying, yeah okay, that's it, was nice … and you're sitting there in shambles.

I'm an adult. I am responsible for myself and do not blame third

parties for things that have supposedly gone wrong.

I'm only saying that because I have already once started a big project.

Did it fail at a similar point?

It's still going on: the Great Pyramid, a gradually growing, eventually gigantic grave for potentially everyone in the world. But it eventually fell into total shambles for my partner Jens Thiel, and he strongly reproached me for that. ➡ I published an account of Jens

I've known Jens Thiel for a very long time. Thiel's life as an entrepreneur in my book *Minusvisionen – Unternehmer* And I don't see the risk of it failing in *that* *ohne Geld* in 2003. In late 2006 we particular way with us. For example, founded the Friends of the Great Pyramid say you're making the greatest art- Society along with Heiko Holzberger, the prima- ry purpose of which was to elaborate and apply work of all time, it's really the great- my idea of a tomb for humanity. ➡ Appendix, est thing, it's just … paaaah! And I just 303. Thiel left our society in 2008 and keep muddling through the middle rungs, since 2009 he has presented his own Great Pyramid project occupying peering up every once in a while like I've been the Society's original website and doing for the past ten years. Just step by step—a presenting Society-generated little resonance here, somehow getting a bit further content. The Society's web- site has moved to www. there … that wouldn't throw me into the dust. Jens thegreatpyramid.de. Thiel had a problem with that. He felt like you profited from the pyramid thing more than he did. That wouldn't happen to me, because I believe that what we have in mind is for my gain more than anything. In that way it doesn't have anything to do with a reflection to the outside world, none of this is about what's going to happen in a concrete sense.

Yes. I try to approach every project in a way that makes each step great in itself.

Right, not only the result.

The Great Pyramid was also planned like that, first with the chapter in *Umbauland* (2006/9) where I wrote about it for the first time, then we did the project with the German Federal Cultural Foundation, founded an association, the architectural competition led by Rem Koolhaas, the Pyramid Festival, the Pyramid Gala, the worldwide press, the book that began the Solution series. ➡ Ingo Niermann and Jens Thiel, eds., … Everything was just great! And the *Solution 9: The Great Pyramid* (Berlin: Sternberg Press, 2008). falling-out with Jens started when his personal existence suddenly depended on whether or not the pyramid was actually built. Also that it should be completed as soon as possible.

Mistake.

The vision became a disaster the moment the next step *had* to happen.

> Jens Thiel—we used to be neighbors. Did a lot of thinking together, worked in different lines of attack. And my relationship with him fell apart with something like that, too. He and I were just tossing ideas around and at some point someone mentioned the word "pyramid." For me the pyramid was just an allegory for a huge collective effort. And that's where there was a break between me and Jens. This idea of the pyramid had lived on in his head and he just neglected to tell you this one little detail about its origin when you then allegedly took his idea and made it into the idea for the Great Pyramid. Because no one can claim to have invented a pyramid. It's been there practically forever. And you took up this form, maybe the location too, and were the one to make it an international sensation as an interdenominational place of burial. In other words, I can see a lot of different risks ahead, in terms of us and our relationship and plans, but I'm not afraid of them.

I'm very curious to see what happens.

> I'm curious too. And in the end, when our journey is over, we should just get together and talk. Maybe not in an art setting, maybe we'll go up a mountain or deep into the forest and we'll see if we've developed whatever anxieties, whether or not our fears have been confirmed. Or if this big leap I am hoping for will happen. Let's give it a shot!

Olafur Eliasson

EXHIBITION AS EXPERIMENT
TRUE DEMOCRACY
BUILDING A CITY

*Martin Gropius Bau, Berlin. One enters Olafur Eliasson's (*1967) exhibition "Innen Stadt Aussen" via a path made of old paving stones, which leads to a wavy, distorted mirror. Subsequent rooms with various colored lights lend themselves to shadow play. A sputtering water hose appears in a strobe light, spraying and thrashing around incomprehensibly. The center room contains scaffolding that reaches from the skylight to the ground; it tapers towards the bottom and is fitted with a funnel covered in reflective foil. Months before the exhibition opened, Eliasson had mirrors driven through the city, reflecting the images of buildings and passersby. We met Olafur Eliasson in his multistory studio and teaching building in Berlin.*

You very often work with mirrors and shadows. One could say that those are the first images that ever existed. Reflections were around before humans—on the surface of water, for example—and there were shadows, too.

I don't think so much about that, though. I work a lot with whatever is actually going on in a particular space when people are in it as it corresponds to mirrors and shadows. The fact that mirrors and shadows have been around for so long probably says more about why people can deal with them so easily, because they don't seem like such unknowns. Shadow is there as a natural participant in the space. And of course shadow forces us to ask ourselves, where does the light come from? Then suddenly there's a direction in the space. So in this way the space or the lighting conditions can be measured by using shadows in the room, because light is hard to perceive otherwise.

Much of your work consists of surprising tricks, but one can always understand how they work.

> Yeah, in that sense my work is relatively unspectacular. It's pretty transparent. Just now we were talking about shadows and you are right: shadow is, of course, an extremely simple medium. We first see shadow as a consequence of the body. If my body wasn't there, the shadow wouldn't be either. That means shadow is, in principle, proof that I am actually there. On the other hand, the way we see shadow on the floor or on the wall is often in a way that makes us think, oh, I wouldn't have expected my arm's shadow to look like *that*. That's actually pretty interesting. So I move my other arm to see what happens. And suddenly there's a kind of reversal of perspective, suddenly the shadow creates the body. You could say the idea that first you make a shadow, then the shadow makes you, is a kind of trick. But I still think it's very beautiful. The word "trick" has a slightly negative ring to it. In my opinion the idea that you could virtually be able to see yourself from the outside could be quite healthy, because you can better see the other relationships you are a part of. The social, cultural, or political contexts we move in are, for the most part, objectified because they exist outside of us. And I think it's a great experiment to be able to see ourselves inside of them.

There's a center space in the Gropius Bau exhibition, a floor-to-ceiling kaleidoscope. You call it *Microscope* (2010). Why?

> A title is like an extra arm on the body; you can have a lot of influence over the work with a title. With *Microscope*, I wanted to name it something that would add detail, something that would refine it. I could have called it *Great Big, Giant Monster Kaleidoscope*, too, then that might have been the more normative, generalizing facet of the work. With *Microscope* I'm saying, those up there are usually skylight windows where daylight comes in. And basically what I have done is attach something like a kind of lens to this window, hanging all the way down. If you look closely, it doesn't reach all the way to the bottom. It hangs five centimeters above the floor—which is practical because otherwise people would run into it with their feet. Right now it's something like an airship, slightly hovering. The eye of a microscope also looks at bacteria or whatever from above, and that doesn't go all the way to the bottom either. Then the

bacteria run around down there so of course we can observe each other very well at the microscopic level. All of this is a bit metaphorical. But this idea that an art exhibition makes visible something that is usually hard for us to see, something outside of our field of vision, is important to me—that an art museum is a place you can clarify things.

You're engaging in something with the viewer. You were saying something about experiments. But you don't evaluate the experiments, do you?

What do you mean, "evaluate them"?

You could perform a series of experiments. People could take part in the exhibition, maybe with a certain set of instructions or also without.

Yes, but I've already done that several times. I'm interested in the part of the exhibition that isn't necessarily tied to my work. The exhibition should also be seen as a social space or as a model for a social space. There is much more going on in an exhibition than just contemplating the work. ➞ Friedrich Petzel, 206; and Tobias Rehberger, 250. An exhibition space is of course extremely in-

fluenced by its own intentionality because people behave much differently with respect to it than they do on the street. But nevertheless you see a kind of publicness—for example, in the way that a lot of what one sees is as part of a group. Seeing things collectively is less common in art history. But the fact is, when I am standing in front of an artwork by myself, the experience is completely different than when someone is standing right next to me. You just can't compare experience of being in the Louvre alone and standing in front of the *Mona Lisa* with twenty other people. If I were to design a kind of experimentation procedure like that, it would leave out part of the work's potential. But I have done several exhibitions where I tried to gather empirical data and asked the people, do you see the color as such and such now? And I'm still working on a project where there are twenty artworks and I'm really asking the people to say something about their experiences: the perception of time, of gravity, vestibular activity, cognitive questioning, etcetera. Because an art exhibition is, of course, an unbelievable platform for gathering data like that. On the other hand, there's always the question as to whether or not doing so temporarily undermines the potential of the art experience.

But the art experience could be exactly that.

The challenge with the art experience is also that there is a return of criticality. And of course it is often the case with a very clear, empirical study that the generalization is almost a slight commodification, there is something slightly commercial about it. And as of now I have yet to see how I could make a readymade out of that. But it is interesting nevertheless.

You could also collect data without the people noticing. Take your *The Weather Project* (2003) at the Tate Modern in London, for example—over two million people saw it. You could make more smoke, less smoke, make the artificial sun brighter or dimmer, and see if more people lie down on the ground or less.

The challenge for me would be to collect a bunch of data that would support the individualization of the viewer. The fact is, of course, that everyone sees something different. Everyone sees himself or herself, you could say. Not only because we think differently, we also see differently on a fundamental level because you and I do not perceive the color yellow, for example, in

the same way. And you could make a kind of map of the differences, where a group of cognitive researchers and I show how each viewer is fundamentally different from the next. And in the whole idea of art communication, art pedagogy, public relations—the whole notion of a museum—I would have to get used to the fact that the only common denominator there between people is that they are extremely different. I think it is possible to develop a plural language that speaks to everyone in a truly extraordinary, phenomenological way. Good artworks also do that on their own, but often the problem is that the institutions' communication efforts are so limiting or alarming that everyone feels slightly moralized or patronized—controlled—by this extreme generalization. You could say supporting differing perceptions is a project of individualization. And of course there is also immediately a substance there from which one might create a kind of collectivity, because if we see differently, then all of a sudden we are different together. Just now you mentioned *The Weather Project*, and I think one of the great things about that project was that everyone had a different experience, but it was shared in that everyone had it. There was an extremely interesting—and for me also surprising—collective construct in the room, where everyone did something together. But it was an extremely strong, subjective experience on the individual level, too. You could say European politics tends to lean in the direction of either we are all the same and extremely reliant on collectivity and normativity, or we are all incredibly egocentric and want no collectivity at all. And the challenge right now is to build a democracy in a parliamentary way, one where we are different together, so that we create an inclusive democracy that is much more supportive of diversity. But that still looks like a horrifying model. And for me, *The Weather Project* is an instance where you could say singular and plural can come together in a single space, and one can very well be singular and plural at the same time.

In this case it worked because the people had a lot of space to behave in. They could go closer to the sun, move further away ...

Yes, but a big room doesn't always mean a lot of space. It's often divided in a classical way, so that there's only one great spot. So a big space can also be extremely small. Even small rooms can

be very generous in that sense. I think the quality of a space lies in its integration with time. Time and magnitude are inseparable. And so the quality of the exhibition in London might have been that it took time to get from A to B. The space in London had a large ramp, so you could bumble downwards on it for a while.

Have you ever considered making work that needs no space at all? Something you could download on the Internet, something involving a pair of glasses?

Hmm. I did make a digital piece, a screensaver, and that was incredibly fun. The funny thing, of course, is that a screensaver only appears when no one is looking at it. But that doesn't necessarily mean that suddenly there is no space. That's why I can't really think of an artwork where there is no space. I once sang "Me and Bobby McGee" with my Icelandic friend Ragnar Kjartansson—he sings and plays much better than I do—I was pretty much in the background. We did it for an exhibition at the ICA in London. But the song can only be perceived when it comes over the loudspeakers and into the space.

Or directly in your ears.

Yeah, or in your ears. But space is relative anyway. I don't necessarily see my works as being so dependent on space. They might be more space making or dematerializing. But give me an example of an artwork that wouldn't need any space whatsoever.

One artwork that wouldn't even need to go through the ear canal—or any outside space for that matter—is a consciousness-altering drug.

Hmm.

Yeah, you could also come up with something that someone would eat, or drink, and then something changes.

Yes, that's true. Behind me here is the studio kitchen. Two great people—Asako and Lauren—are at work here every day. And, as you might be able to smell a little bit, behind the kitchen is a compost pile with a lot of worms in it. And up on the roof is a roof garden. Yesterday we ate the first tiny little leaves of spinach up there. And so the house here also has a project in which we eat our own personal harvest every day. That isn't always enough, but the kitchen is important and if you put it like that, sure it is a kind of project—it's just that it's by Asako and

Lauren. Then every day, we sit here in this room with all the people that work here in the workshop and eat together.

In the Gropius Bau exhibition, there is a table with models developed out of simple geometric forms. Your exhibition has a lot to do with the city and how we perceive it, but you've basically built a city on that table. Could you imagine doing that in real life?

Yes, I would very much like to build a city. And recently I tried to talk someone into letting me build a museum, which in principle is something like a city. Where in a museum you generally walk from one room into another, this one would have you going into one building, then out again, then into the next building that might be a very different thing, very old or very new—like seeing a small part of the city as an art museum. Basically the advantage of a city is that it doesn't pretend to be real, because it very often shows its own construction or how it came to be what it is. A generous urban space enables a renegotiation of itself. And that was my idea: to build a city. It would be a city that is also always showing itself as a model. A reality machine, but one where reality is different from one day to the next. That's a hard sell, politically speaking. Which is why everything tries to pretend that reality is objective and not subject to change.

The buildings in this city would be in constant flux?

No, but the relationships to it would be, and with that the buildings, too. One would support the non-static, dynamic qualities inherent in the space. You could imagine a space where the power structure allows no change in perception at all. A space that is extremely commercial and very narrowly dictates what one should see—a store, for example, with jeans or something—where perception is very strongly influenced by normative demands and the people tend to experience the same thing. You could also say that these days it's hard to imagine how someone in a museum with a van Gogh painting hanging in it would say, yeah, the painting is this way today and tomorrow it will be different. The museum would have a hard time insuring that, and it would also be hard to justify how van Gogh is suddenly *relatively* good—depending on the day and the visitor. Everyone says there's no question about it, van Gogh is of course fantastic as anyone can see and those who don't see that just don't understand it. But it would be nice to support a different way of deal-

ing with it, where someone could say, it depends. That might be interesting for you, it isn't for me but we can nevertheless be here together at the same time.

How could you do this with the van Gogh, how with a jeans shop?

There is a kind of intentionality or staging in every room. You can pretend the staging is not there, as if the space were real, and just call it authentic. The jeans store acts as though it came straight out of the Wild West. Almost down to the horses, though of course I'm generalizing a bit. I don't think it's possible to change something in a revolutionary way all at once. But I do believe that several questions of responsibility—what is our body in space? How does the body create space or is it the space that creates the body?—simply go unasked because they make it harder to sell jeans. You say, yes, you do actually want to be like *him* here. Buy the pants and then you're like him. And unfortunately there is often a similar normativity going on in art history. When I speak of the relativity of space, then it's not because I'm trying to make a hard space soft or to say, oh, now the space is beyond our comprehension. The point is that from a relative idea of space, you can claim a different idea of collectivity or social interests.

How big could a city like that be? The one you are developing, I mean.

Quantifiability has never been important to the way I've developed ideas until now. I think it's hard to say that a certain size of city is good or bad. The question is how generous the city is in terms allowing the idea of the public to continue to develop and reinvent itself on a constant basis. We also want a public space to radiate the values of our society. A great city, you could say, would be one where you can walk down the street and say, whoa, I can clearly tell that we live in a democracy. And that is not the case. A city will often pretend to be very generous when it actually isn't at all. The concept of social services has also become extremely static in the meantime. So, personally, I think we could hope for an urban space, for a public space, for a friction from which one could develop a kind of criticality. And what kind of space would we need to establish a process like that? And there I think you could investigate street spaces—the sidewalks, walking on sidewalks, the flooring. What comes out of façades and into the streets? What comes from the street

and into the building? A shop—how does it affect the street in front of it? How does the street affect the shop? What power structures are being expressed there? Is it explicit that power structures exist? Berlin, in a certain sense, is a good example of a space caught in the middle. There tends to be a regulation of human movements. But, on the other hand, there is very little regulation compared to other big cities like London or New York. So here we see something that is hard to see in other places in the world.

Thinking of you being commissioned to build an entire city, the first thing that comes to mind is that it would most likely be in Southeast Asia—Korea, China …

[*Laughs*] Yes, building an entire city sounds very undemocratic at first. It would be hard to imagine in Europe, I guess. But I'm not talking about something along the lines of Brasília. I still don't know how a city like that would look, and I won't know until the day we've finished building it. And even then, it will keep developing. The potential of architecture or urban space development very much suffers as a result of architects having to thoroughly visualize a building and promise their clients that, yes, that's really how it's going to look afterwards. My city would be hard to see in that sense.

Okay, if it doesn't work with capitalist financing then you'll have to find other sources. And that would be either public funds or you would have to find a patron. Bill Gates could say, I'll give you money to build a new city.

I've been talking to my friend Hans Ulrich Obrist ➡ Hans Ulrich Obrist, 127. for a long time about how we need to design a city together. When I say city I don't necessarily mean I want to draw every single building or something. The city is basically a framework for living. And what's interesting about it is something really different from whether a building has round or triangular windows. I believe we can use that idea to make a statement about other cities or the way cities are currently developing. What we are aspiring to is an urban planning experiment. You could say that public funds would provide an added value in that people have given money together—just like I'm pleased that I could make my school with the university in Berlin using public money. On the other hand, I'm not one to be so afraid of private funds that

I can't work with them at all. I've tried a few times to get people to commit to the idea of a museum that would use the city as a metaphor. There is already a very ambitious museum that goes in this direction—though not nearly as radical—in Kanazawa, Japan, where I recently had an exhibition. A great museum built by SANAA. But it is still very formal. Every room is different in size, though somehow the same. You could also imagine thirty buildings being connected by a walking tour, a little trip through the city. The time component—in other words, the duration or the temporality of life in the city—is critical in that context. The derelict building is not necessarily any worse than what is being built right now. So I think the diversification of time could be supported more. That we can make room for something very slow, something a little faster, and something super fast. The model in Martin Gropius Bau is like a microscopic version of the museum I would like to build. And right now I don't necessarily see the difference—other than scale—between what is on the table and where we're sitting now. It's also interesting to see reality as a model. Because when we see reality as a model then it allows for more change than if we were to say, that's just how it is, that's reality. So for me the Martin Gropius Bau model is real, too. The city may be small but it's also real. It's really there.

What is your relationship to architects? I remember Rem Koolhaas saying once—and he had you in mind—they really have a clever way of doing it, the artists. They have much more freedom than those of us who are architects by profession. They get better budgets.➡ "They are doing things very efficiently that we don't do very efficiently. But they being artists get more money for it. If you are an artist and do a pavilion you get more than if you are an architect and do a pavilion. That's the kind of big trick and the hidden struggle between the different disciplines." (Rem Koolhaas in an interview, February 2008, Beijing, unpublished.)

Yeah, sure we have it better than the architects. Architects are constantly having to listen to clients. And artists often find themselves in a situation where the clients are saying, of course, we wouldn't want to influence your work. If you were to change the color for my space then I never would buy it, because it wouldn't be art. So I agree with Rem Koolhaas in his opinion that artists have it much better than architects. But of course architects have the advantage of being able to actually build a building in the city. The disadvantage of art is that it is often stigmatized by its

representation: it's the avant-garde, it's society's clown. As an artist it's harder to actually move into society. Art also suffers from its being somehow elite, difficult to approach, for the arrogance of its museums. The art world has an unbelievably broad potential, though it often comes with a slowing-down. And right now it's difficult for this kind of deceleration to fit into society. So I'm envious of the fact that architects can actually build a city. And I have to say some architects are very, very good. They see things artists don't see at all. They look at a bench and think, sitting, huh? Even though no one is sitting on it. And an artist would look at that same bench and think, wood and iron and paint. Which is to say the architect and the artist see form and function differently.

But you want someone to look at a bench without automatically thinking of sitting. Or at least think of sitting in a new way.

Yeah. Basically I would want there to be a kind of friction in every kind of activity, one that also allows an investigation of or criticality toward becoming one's own activity. A great bench permits these fundamental questions: Should you sit in it? How should you sit in it? How does it feel? This kind of generosity has a long history in art. This is also again and again the case in good architecture. And for both, of course, in a different way.

Gabriel von Loebell

WEIRDO IN THE PROGRAM
SOCIAL COMMITMENT
THE ART WORLD AND ALCOHOL

*Haus der Kulturen der Welt, Berlin. Gabriel von Loebell (*1976) prefers not to meet us in his studio, saying there is nothing there to see. Looking around for a quiet place to talk, we end up in the foyer of the Haus der Kulturen der Welt, where there is currently a group exhibition on the subject of rage. We take a seat on two blue sofas in the corner. Von Loebell could be the poster child for career changers. Like me, he studied philosophy and psychology.*

My name is Gabriel von Loebell and I was born in Bogotá, Colombia. My parents met there and had two of their three children there. I was the first. I have an Austrian mother; I spent a lot of time in Salzburg, a little time in Vienna. I have been living in Berlin for the past twelve years.

You didn't study art?

No, philosophy and psychology. And in the end I became really interested in psychiatry and did that too.

How did art come into play?

Insanely late and never particularly ambitiously. I met this Viennese group eight or nine years ago, Gelatin, and we hit it off and immediately started working on something together. And that turned into eight, nine, ten, eleven, twelve exhibitions ... I can't say for sure how many.

What was the first thing you did together?

It was called *Die Schlotze* (2003). It was a haunted house for

the Berliner Festspiele in this building in Schöneberg that goes over the street. We built wooden carts and led the people tied to them through a course of corridors and passageways that we'd built in the apartment, and we set up various spooky situations. The code word you'd call to stop it was "Deutschland," by the way, because it did somehow became a little bit brutal and disgusting and a lot of people didn't want to do it anymore.

Gelatin, now Gelitin—they'd already been around for a while.

They've been around since the late '80s. They got together as students at the art academy in Vienna and a few other people came in too; they were always getting bigger and smaller.

I read somewhere that that you had been dubbed their therapist.

Hmm. Yeah, you just take on certain chores when you're not one artist but a group, and when there are other people coming in too. We had a show in at Leo Koenig's in 2005 where we built a human copy machine in his gallery in New York (*Tantamounter 24/7*).

What did you do?

> We had this DIY house that only cryptically looked like a copy machine and locked ourselves in there for a week. Then we had objects that you could feed us through a chute twenty-four hours a day, seven days a week. We took these objects and made copies of them with craft supplies we had in there—paints, sheets of paper, Plasticine, hot glue guns—and returned the original and the copy through a chute that was twice as big. People would wait in an area that was like the waiting room at a doctor's office.

It was never about you becoming part of the actual group?

> No. I wasn't into it enough. Or that kind of closeness and continuity and intensity in collaboration isn't really possible for me, I guess.

So besides that you also do your own individual work.

> Yes, yes, yes. I did a ton of different kinds of performances and readings with various academic topics, for example. Just now I'm talking about pedophilia in Mexico, for instance, or what psychopaths are or what psychopathology is. So there is a whole series of other things I try to do.

You do performances. Can you describe what it is you do?

> All of them are really different. A lot of times they involve a lot of nerve-racking tension, very often with an audience, with a certain form of provocation. I can name an example: getting on the roof of the CDU [Christian Democratic Union] headquarters in Berlin—which looks a bit like the bow of a ship—with a megaphone, flag held in front of me, singing the *Titanic* song to the people down below. Or in Salzburg, dropping guinea pigs on the guests at the festival premiere using custom-fitted parachutes made just for that purpose, so that they kind of drifted down. You know about the stuff with Gelitin—the copy machine would be an example. Or *Rabbit* (2005)—a giant rabbit almost sixty meters long and four, five meters tall that fell out of the sky and landed on its back somewhere in the mountains of Ticino in northern Italy, split side and flayed bowels and all. It is knitted and stuffed and is starting to rot, and it's allowed to lie and be there up to a certain year.

Who paid for it in that case?

I think the gallery Massimo di Carlo paid for it.

And what happens to the remains when it's all over, will they be sold?

I don't think so. At some point they have be cleaned up. I can't remember the year it's supposed to happen, but no.

So it was a publicity campaign for the gallery?

Maybe. Maybe they see it all as a big PR gag. We were just allowed to do it and thought it was insanely beautiful.

You once made it into the tabloid *Bild*. In that case you played an ape (*Monkeycage*, 2008).

Yeah. That was in a very beautiful gallery on a street corner a few years ago, for the Berlin Biennale. I had a costume made and lined the floor with wood shavings, just like the kind you would have in a real gorilla cage, and installed a structure in there. It was lit up all day and night, and I didn't speak. I also studied gorillas a little bit in order to infuse a loneliness, monotony, and an oscillation between man and animal in the relationship to the people that came and looked into the cage. And then, yes, *Bild* came. But I don't think of that as anything special. That's just a kind of broadcast politics that is pretty random. Wherever there's room, you just plug something in.

The artist makes an ape of himself ...

Yes, yes, yes. That's what it said. It's also okay. I'm happy to make a something of myself. It makes me feel like I'm more colorful and diversified. And that's why I understand what the sentence was saying, also what it means in terms of various associations it has in German but ... oh, for chrissakes.

So you peed in public, right?

No, I didn't. I had a semi-private situation there with a bucket full of very good cat litter—very effective when it came to absorbing smells and fluids—and that's where I did my business. I didn't pee in public, that's not what it was about.

What are you working on now?

I'd like to make documentaries. I just made one in Miami with two of friends of mine—Knut Claasen und Nicolas Amato; it's supposed to be in the Miami Art Basel program, God willing. It's about pedophilic men. In Miami there was an attorney whose

daughter was molested by their nanny; as a result, pedophiles have to live under a bridge and wear GPS locating devices. I think they live under that particular bridge because it's in a very central location but nevertheless fulfills the criteria of their staying at least 800 meters away from public spaces. It's a sex-offenders law that applies in several US states. They're actually supposed to be given housing but the state of Florida isn't doing anything about it, instead they take advantage of the generally hysterical attitude toward sex criminals. So this particular case has a lot of very interesting aspects to it: that it's between Miami and Miami Beach, which is where all the art freaks head whenever there's a fair. A kind of social hysteria that a case like that allows; the various, probably horribly handled cases of the individuals that live there; the poor jurisdiction exercised there, the miserable police investigations, the way delinquents or the mentally ill or pedophiles are handled there, etcetera.

Do you have a gallery representing you as a solo artist?

No, luckily I don't. I am talking to several at the moment but I am delighted not to have one right now. No.

Why?

Because it really sets the work stylistically and doesn't give me the freedom to switch subjects whenever I feel like it, just not having to live up to a certain cliché of the artist because there's a pressure to produce certain things at certain set dates in this really simple and stifling way. And I don't think of myself as so much of an artist at all.

Do you see that problem with Gelitin? They're represented by several galleries.

The majority of what we do doesn't have anything to do with galleries. I remember the opera we did in Turin—that only had to do with the fair, or the cooperation with Creative Time in New York, two, three years ago. The fact that you often can't live from that, or that the question of money being tougher in that situation as opposed to doing classical, gallery-represented artwork is obvious. But maybe it's not that important.

How is it with you? Do you live from your art or from something totally different?

Yeah, yeah—I make a living with a lot of different things. I taught

for a while, I live from art stuff, somehow I manage to muddle along. I just have to do thirteen things at once.

And the people at the core of Gelitin? Their galleries include Gagosian, Greene Naftali, Leo Koenig, Perrotin. Those are very respectable galleries.

I always had the impression that galleries like to tack more affordable, interesting, living oddballs at the end of their program. If you look at the programs, it's always individual artists, the majority of which are twenty or more years older than I am and a hundred thousand times more established. They're also a hundred times more expensive.

What about working in an academic context—is that out of the question for you?

I always had a big problem with the whole academic lot. I was an extreme loner in school and I developed a style of living and working that was too free for academic life, even for writing. That led to poor grades and/or especially good grades with a few professors. Working in academia is something I can't really imagine as far as interpersonal relations and designing everyday life is concerned. Neither in terms of a clinic nor an institute. I'm done with academia.

One could say your career as an artist has been made possible by developments from the 1990s, where art became much more open. People are giving lectures and that's art; they make documentary films, that's art.

Well I know there's room for discussion there, but I don't see the documentaries that I'll hopefully be making in the future as art and I don't see the lectures as art. I'm thankful that the context it places in labels it as art but I didn't initiate it that way and I didn't force it either, because I don't understand it enough, because I spend way too little time dealing with it. But the social system is very present for me, the gathering of people and the tasks that should go along with art and come its way, but …

What kind of tasks?

They're social tasks, like replacing religious or metaphysical needs. It's the need to be intellectually challenged by the perception of and thinking about art. It's an occasion to see a lot of people, create social situations in the context of an opening.

Do you sometimes feel used?

No.

Because, as you described with Gelitin, you go out of your way to give art this rather non-commercial extra?

Well sure, of course sometimes I'd rather be a highly paid, introverted, romantically overdone painter under contract with some blue-chip gallery. But I noticed early enough that I can't do that, that I don't have the talent for that, and there would be too many things that interest me intellectually—that's part of my non-ability—standing in my way. So it just doesn't play out like that.

You say you have no talent. You wouldn't have to have any in the first place. You could …

I've seen that too. But I don't really trust myself to do that. Even to judge whether someone who's well paid has talent or not. So basically because—quite the understatement—I have no idea about art history. But also because—like an imposter—I understand very well how this work is sorted one way or another, how the work is evaluated by gallerists and the media, and the manufacturing of objectivity that makes work good work. I understand all of that, and it's also okay. I'd rather the people doodle some shit than see them become attorneys or end up in the CDU. That might be general, but it's basically a sacrosanct, sympathetic, slightly boring position on the matter.

You've been around since about 2000, so you experienced this huge boom in the art world.

I witnessed it. I went to fairs and noticed that it's pretty crass. I hope it will keep on like that, that as many people as possible profit from it. I would of course be happy if people were to start seeing the social aspect. That can happen in a lot of different ways without having to do exhibitions in nursing homes or have mentally handicapped people playing the accordion at openings.➡ Boris Groys, 230; and Antje Majewksi, 102. I also have a lot of ideas that don't necessarily have to be artistic. Just now, for example, I tried to raise funds for a project for homeless kids in Colombia. That means going from embassies to rich people to local industries and just asking for money to help kids living on the streets. To try something totally new out, and also

because I have very socially conscious parents. That's somehow a part of me too. That there has to be a way to do something for others who are in situations that are constantly getting worse and worse, as kitschy or romantic as that sounds. To find places where too much is happening to just accept from my narcissist-hedonist, Berlin-Mitte situation.

How did you do it, how did you get the money for this project?

It's still not clear if the money is there but it looks really good. I have two ladies pursuing these contacts I built up in Colombia. What kind of concrete discussions did we have? BASF, Siemens, the Japanese and French embassies, two or three NGOs, things like that.

Can you imagine doing a charity project that could also be seen as art?

No, I can't imagine that. You're always going back to this art thing …

You started it. You talked about the art world and how you wished it were different.

Oh yeah, that they get this commitment to social concerns in there or that it becomes more responsible, that it doesn't stay this pile of antisocial nonsense.

But how do you imagine that working out?

Charity events.

That there would also be a raffle for street kids at the opening?

You asshole. Yeah, that sounds funny. No, most certainly not, because I don't have that kind of organizational talent. I also don't think it would do anything for me and because it wouldn't be something I could get so excited about. There's just no thrill in that.

Rirkrit Tiravanija would be an example of that in the 1990s.

Never heard of him.

He cooked at openings. ➡ Friedrich Petzel, 205. It had a social function. You didn't have this anonymous caterer anymore; instead it was the artist cooking. An artist that embodies just that. So you could be the raffle artist.

Doing the raffle as a sideline … no way. Both of those are awful ideas. I don't have that many new ideas yet.

You just said you have a whole row of ideas.

The ideas I was talking about are not ideas of how someone who's an artist or in an artistic context can be more socially aware, they're all documentary ideas. What is the UN anyway and what could it be? That would be a subject for which I would take three months to visit five examples of the UN in Zaire, Colombia, Bangladesh, do very careful research on them, bust into the upper-tier UN officials' offices and force them to do interviews where I would confront them with all the shit they're dishing out. And I'd confront them with the social reality of their own lives, which means trying to look like they're actually doing something.

That would be possible in an art world context, too.

Yeah, but not with the investigative or psychologically interesting part of the work. Of course you could shoot something like that as an artistic film and then find a collector for it. But I don't think the intermediation would be nearly as complex as I would want it to be.

This feeling that art needs to be infused with more morals is virulent. Take the next Manifesta for example, where it mostly has to do with coming to terms with neo-conservatism, with globalization critique.

I haven't noticed. I think the work being done along those lines is often just very weak, because they're artistic and have to stay artistic. And so they only have a limited active influence and are difficult to apply to the perspective I'm picturing for new techniques for cooperation and social work. I think an artistic perspective on it is simple and pathetically boring or just ineffectual. So that's why I'm not interested in socially involved art, or being socially involved artistically. Just to name an example of something you can laugh about, something you can get unbelievably turned on by and in my opinion is extremely effective: the Yes Men. They're two friends of mine from New York that go to huge industry conventions or corporate conventions or lobbyist conventions and pass themselves off as someone else—as the official representatives of BASF in the Czech Republic—and give lectures on the further development of whatever company they're talking about in that land. They let the lecture or discussion escalate to a very specific situation or handling of a problem or point to the corporation's economic viability. They made an incredibly good docu-

mentary about themselves called *The Yes Men Fix the World*.

And you like that.

> I think it's badass. But it is also infinitely inartistic, insanely well put together, unbelievably courageous, and indescribably funny.

The thing you are calling inartistic today can be the very thing that's artistic tomorrow.

> Yes, of course. Then the concept just has an infinite extension and everything I make is somehow art. No doubt about it.

What do you imagine the art world of the future to be like?

> I've never thought about it. I'm happy when I keep reading good writing about art, when I keep seeing good exhibitions. It's rare, but I like it when people recommend things to me. Then I go there and think it's nice when it happens that I was able to consume at a relatively high level.

Right now we're sitting in an exhibition about rage. Are you enraged?

> Yes, yes, of course. I am a choleric guy. I've gained a lot of motivation from being enraged. With my rather choleric-extroverted way of going about things, you could say rage is something that I have or know. So an interview or a conversation would actually always have to be something between two people that have a therapeutic relationship, or that are in love. Because there the interest in trifles or little things is so high. It happens pretty quickly that I feel—and I keep doing this over and over—somehow too important. I'm really not sure why I keep spouting off all this poorly digested, ill-considered cheese. Why are we talking about these things at all? I understand how someone could be interested in such a quirky, slightly addle-brained, slightly weirdly composed lifestyle that I have to live. But I don't think it's so important nor do I think it's all that successful. I'm very disoriented, infinitely confused and unsure of what I'm supposed to do. So the social issues work well because it's a good solution to finding something like gaining a certain form of distance and establishing a way to work together. That can be something like a Gelitin thing; that can be a conversation like the one we are having now, or it can also go much further as a way of expanding the areas of curiosity or commitment.

You just named two things: therapy and love.

Yes!

Two kinds of art kits.

> Back to art again. Are you enraged? At art maybe? More like you're bored.

Nah. Not important enough.

> Yeah, of course it's not important. But you're making it very important here.

When I talk to people that teach art, they all say the students think of them as therapists. They tell them about their romantic troubles, why that's the reason their work...

> God! Someone like that is so inappropriate to be doing something like that. That's real malpractice once it gets to a certain level.

Well, and the other thing is the collectors that keep pumping all the money in. For them, I think it's about love.

> In relation to art?

You could say, roughly speaking ...

> I used to collect stamps, and I collect those little Lufthansa cosmetic bags they give out in first class. I collect something, too.

But it doesn't have a social component. This whole thing with, "We're inviting you out, you get a dinner, we're giving you something to drink, you'll meet great people."

> Yeah, I don't know. Yeah. I'm glad.

This feeling that you have, maybe it's ...

> ... due to the fact that I so rarely have conversations?

No, not at all. You told me you were at an art party yesterday and talked to all kinds of people.

> No, I didn't really talk. That was more of an awkward, standing-at-the-bar with super celebrity artists and tossing a few beers down my gulch. There are just a few artists that I'm pals with and that's why I go. It isn't especially good for me; God knows they're not particularly chatty. God knows they're not intelligent or especially interesting for the things I'm interested in. But I just like some of them and so I'm somehow a part of it. I would absolutely love to have something to do with other people, I don't know, I'm totally fascinated by dance or volleyball.

I really would like to talk to many more people. Which is really hard to do in interviews because the interviewer does such an extreme job of keeping to himself and just lets me blather on. I have had good experiences with only a few of the conversations I've been involved in until now, and that was either in situations where I was in love or with therapists. Even though they also say very little a lot of times, it depends on the kind of therapy.

They say even less.

They say a lot less and you don't see them very often. So we could have just had this discussion lying down. Yesterday I happened by chance to see this HBO series called *In Treatment*. And because I know how a setting like that looks, I was of course very surprised by the whole thing. But I actually thought it was all really lovely. And also very intense. This normality of a conversation touches me more—which is really about something.

But in *In Treatment* it's all about the patients being disappointed by the therapist. I don't know if you saw the first episodes.

No.

They're actually always disappointed right from the start, but then they come back.

Yeah, that's part of the whole thing. That you have to be disappointed at first because a lot of people have a completely incorrect image of what a therapist is and are coming from a very naive perspective, because they think he's going to be able to set them straight in two or three hours with some kind of shrink trick. So they very often become agitated, aggressive, withdrawn. But then therapists very often—thank God it's often—are successful in gently, but very clearly offering a relationship unlike any they have experienced before.

Did you ever consider becoming a therapist?

Sure, lots of times.

And why didn't you do it?

I think it's because I don't have the capacity for empathy, and the focus on individual people would be too intense.

De:Bug, the magazine, once touted you as an expert on intoxication.

Someone just called me up and said, you have something to do with psychology and you've also done drugs, right? And I said,

yeah sure. So they said, then let's talk about drugs and what it does to people and why it makes you so fucked up.

Without drugs, the art world would be unthinkable.

Oh yeah?

Without alcohol anyway. Don't you think?

I don't know. I don't know of any studies on the influence of alcohol or other drugs over the course of art history and in their great minds. ➡ Terence Koh, 169.

I don't mean the artists; I'm just talking about the art industry, the way it works. There just aren't any openings without alcohol.

True, but there would be a lot less intimacy or ability to relate if it weren't for drugs. Or if there weren't this technique for disinhibition. That's a very interesting subject, especially because the stuff is legal and because the majority of relationships are based on it, on the fact that you got to know each other while drinking. It's also a topic I'd like to get into more. A kind of cultural history of alcohol, because it's just an awesome thing.

I went to the Sharjah Biennial last year. Sharjah is an orthodox Muslim Emirate where no alcohol is served. So they bussed people over to Dubai for the party.

I would go crazy because there's probably so incredibly many good-looking women there and none of them are available. What do I know? Naive ideas about what happens at an art party in an Arab Emirate.

Maybe that's the thing that makes the art world what it is. That anyone can go there and drink for free.

Yeah, but most of the time it isn't all that great. It used to be bad white wine and some baguette. It never dawned on them how bourgeois and dorky that actually was. And now, as we saw yesterday at Olafur Eliasson's, it's all about monster drinking parties where alcohol is free from ten to midnight. Yeah, yeah, it's true. I didn't really understand what you were getting at just now, but they do drink there.

You just said you were interested in the social aspect of art, that it's a reason to go to openings. It doesn't have anything to do with wanting to save money. Just the fact that there's free alcohol immediately creates a very unique atmosphere. And I can't think of any place where

there are so many opportunities to get alcohol for free than in the art world.

> Yeah, maybe. I never thought about it, could be. Well, yes, in clubs. If you're the DJ or the boyfriend of the girl working the bar.

But you have to know somebody. In the art world, you can just go. Maybe not to the Eliasson party, but to a regular opening.

> And I'm sure there are people that do that. Maybe they just make a round through all the openings, right?

You're somehow young, and after a while you'll just end up being an artist or a collector.

> Ah, now you're accusing me of that a little. That's splendid. Fine, if you say so.

I'm not accusing you of anything. I really don't know …

> That thing hanging on the wall over there, I could make that too. I'll just make it now.

You just said that you met the Gelitin people—in those days they were still Gelatin—did you meet them at an opening?

> Actually it was at Art Forum, I think. They were yakking in Austrian and I did too because I can do stuff like that, and so we got to know each other.

So you were going to openings back then.

> Yeah. For the same reason that you just … so there are three hundred people standing around some thing and you go stand with them, and there are a few people you know there. I mean, you also can't avoid seeing these people. Not that I want to. Well yeah, in the meantime I do actually and it works, too. But back then it was like, well, what else are you going to do after a long day at university? You go to an opening from seven to nine. And it's warm there and you stand around outside and there are good-looking girls there. Yeah, and cool guys—and not so cool guys. Uhh. People also arrange to meet each other in these places without it having anything to do with art. ➡ Gregor Jansen, 116. Those are social-psychological topics. Standing around in a group and quickly being able to swap partners is different than being squeezed in the corner of some bar, sitting with one person. The people talk a lot but they also don't talk about much.

And if you don't talk about much then it's also nice to switch partners really fast because it never gets to a topic or becomes an encounter either one of you would want to sit in a bar for.

Philomene Magers

IDEAL ARTIST BIOGRAPHY
QUANTITY AND QUALITY
THE ULTIMATE LUXURY GOOD

Sprüth Magers, Berlin. Yawning behind a typical prewar building façade on Oranienburger Straße is a gallery of museum-like dimensions; in it is an exhibition of Andreas Gursky's Ocean Series. ➡Gregor Jansen, 118. *Upstairs are the gallery's spacious offices, which Philomene Magers (*1965) and Monika Sprüth have been running for nearly twenty years. Magers' office alone spans a good 500 square feet; work by John Baldessari and George Condo hangs on the walls. Would gallery representation be out of the question for me? Am I already too old for that? Do I lack the prospect for continuous art production?*

How did you get into art?

My grandparents were collectors; my grandfather was very close friends with that whole group of informal painters in the Rhineland. Cologne was bombed during the war, so when it was over my grandparents and this whole group of artists moved into a kind of shared living situation in the countryside, just outside of Bonn. Later, they formed a club called the Thursday Society because they never met on Thursdays. That restarted cultural life in Cologne. And my mother grew up in that climate as a little girl, and she went on to open a little avant-garde gallery in Bonn and showed a lot of video there, lots of early feminist work—Judy Chicago's *The Dinner Party*—was friends with Beuys, got in touch with several of his students, then met Walter Dahn and Rosemarie Trockel and all the Mülheimer Freiheit artists. ➡Friedrich Petzel, 193. My mother died very young, twenty years ago, and as a result I closed her gallery, spent a year gathering my thoughts as to how I would do it if I were to

open one myself, and ended up opening my own gallery. I was twenty-five.

Who were the first artists you showed?

My first artist was Sylvie Fleury. Both of us had friends that were very well-known artists, and then we decided to start together. We had the same fears about what it means when you already know how it is in art, but then you start over again by yourself. So for Sylvie, in her dispute with her longtime partner John Armleder, it was about how a young female artist positions herself in relation to a big, masculine history of art, but in a different way than someone like Jenny Holzer. Sylvie took up clichés from Minimal and Conceptual art too, the way Jenny Holzer did with Donald Judd, for example. But there was a playful aspect to it; she did it with a wink. I really identified with that back then because I had the feeling it would probably be the way of our generation. It came from having grown up in the Cologne art scene of the 1980s, very much influenced by my impression of the overheating market. As teenagers we're all of course very moralistic, so it really put me off the way all these "isms" were being developed again and again every six months and some position or another was always being dismissed. I always really admired Konrad Fischer and especially Heiner Friedrich. And everything Heiner Friedrich showed in Cologne—in other words, Flavin, Judd, and stuff like that—no one was interested in these things when I started doing the gallery. And I had the feeling that after all this total excess in the 1980s, there was suddenly this complete emptiness in Cologne. It was like a giant party had just played itself out. At the same time I started working with young artists I thought were really great. Andrea Zittel was one of them, who oriented herself to a large degree on certain early modernist ideas, or Karen Kilimnik in a strangely conceptual, completely radical way. That was a group of women where these extreme references were going on, and I just felt like we needed to take another look at the whole thing again. I was lucky that no one in Cologne was interested in artists like Baldessari, Judd, Flavin, or Robert Morris, and none of these old, established galleries were doing it anymore. That's why I was able to work with these artists in Cologne, though it was completely unsuccessful economically speaking. No one wanted

that at that particular point in time, I mean really no one. We did a show with Flavin, the last exhibition before his death, with the Tatlin towers (monuments for V. Tatlin, 1964-90) and the unbelievable pieces that everyone just has to have these days. Really no one was interested.

In any case, the market at that time was …

It was totally extreme, but that's just how it was. The good thing was that I didn't know anything else. That's the time I started in, and my mother's gallery was also extremely unsuccessful. And when you just start with absolutely zero, it's hard to be rattled by much. So it was okay. I was also really young. [*Laughs*]

How is it these days? You represent over forty artists, am I right?

Is it over forty? I never counted. [*Laughs*]

And now how many people are working for you here and in London?

Between thirty and forty.

You don't actually represent an artist; you represent his or her work.

Yes.

So it's about providing support in the long term.

Yes. That structure is definitely a distinguishing feature of this gallery. The catchall term "galleries" actually encompasses two groups of professionals. First you have the pure dealers and then there are the gallerists. I just learned that it's more clearly defined in English. You have curatorial galleries and selling galleries. Which is lame, of course, because it implies that curatorial galleries are somehow galleries that don't sell. But there are galleries—and this has become even more extreme over the past ten years—whose main focus is simply selling art. They are first and foremost dealers and have a large team of salespeople. And our gallery is essentially one of the other species. It starts with the fact that the artists we primarily work with all have an assistant that works both in the gallery and in the studio, so the friction stays as low as possible. The main focus of attention is to offer everything the artist might need in terms of support. How much the artist decides to make use of it varies from person to person. But in principle it's almost more like an artist agency. Very few of the artists in the gallery work in a really large studio production setting. Sometimes artists will hire a few people to help out with the final phase of a project but basically it's all small studios with sometimes only one artists' assistant who also works in the gallery. The majority of our artist's like to work in a relatively private atmosphere, and it seems to me that they really like it when we take over this whole organizational thing.

The goods, in other words, the artworks, are commissioned by you, right?

Basically there are two areas. There are the goods that you take on commission ➡ One common, though by no means but the thing that has compulsory model is the fifty-fifty division become more and more im- of sales revenue, excluding the cost portant in recent years is the of production.
secondary market. A secondary market emerges the moment artists become successful. In other words, people start dealing the work. If a certain greediness enters the picture, you have to maintain a presence in order to guarantee the artist a certain level of protection. You have to try to keep the prices at a certain point so that all the people who've always collected

the artist—also the museums—can continue to buy work by that artist. And the moment you stop paying attention and sell to people who develop that kind of secondary market there's a giant gap; there are unbelievable auction results that are ten times what the work would cost in the gallery. ➡ Friedrich Petzel, 198. Which of course always makes you wonder why people do that. Are they so insanely misinformed, does it really only have to do with this heated auction situation? Is it very personal power structures, say three guys sitting there in the room where one wants to prove to the other that he can pay even more money for it than the other guy did the last time. It must have to do with some kind of exhibitionistic passion or this feeling of virility, something you don't get when you're discretely buying something in a gallery, because then the global public has no idea that someone just bought the artist XY's most expensive piece. ➡ Hans Georg Wagner, 274.

So if I were to just walk in—say you've never seen me before—and say, all right, is there still a Gursky for sale? What does it cost, I'd like to buy it. You probably wouldn't just sell it to me, or would you?

No. But I would talk to you and try to find out if you really have the kind of personal passion that would make me feel like it's okay to sell it to you. So in the end it has to do with distinguishing between the people who really have a passion for art and want to be involved with it and those that would just rather buy an expensive painting than invest in the stock market, where you know they're only buying it so they can sell it somewhere else. We represent quite a few artists, but we have to be conscious of the fact that every one of these artists really has one, single ... he has himself, his life, his work, and this whole complex of problems an artist is pushed into anyway—that of realizing himself, questioning himself, etcetera. I think there is no limit to the amount of esteem and responsibility one ought to feel for these individuals; it is inestimable. So a typical situation would be that the artist is young, is at the academy—maybe there are already people interested in his work—then he'll often get hugely successful even before he's thirty and that's where the problem begins. I would always say that even if the whole world wants to buy your art, you still have to try to maintain the price structures in such a way that truly passionate people

can continue to be a part of it for a long time. It's a complete delusion to think that passion for art clusters around wherever there's the most capital. It can't be like that, and that's also not how it is. And the moment you become relatively successful, you can be sure there's going to be a downward slope as well. And in the end it has to do with keeping the downslope as low as possible. Because a dip like that always causes a personal shock. I'm not an artist myself, but I have a strong, protective feeling. And finally seeing to it that it goes in such a way that if someone really is a great artist, then with sixty they'll make it to the safety of absolute recognition.

You warn against overproduction.

No, I don't warn against overproduction. That's not what that means at all. There are very different artists. With the one you have to give him an occasion and with the other it just flows on its own. And no, I am not of the opinion that this is something to be manipulated in some way.

What I was trying to get at was ...

... a flood in the market.

No, the other way around. So that you can get any kind of visibility at all in this global art industry with more and more museums and all the biennials ...

No, Duchamp produced very little.

Yeah, but on the market Duchamp is also ...

No, no, no. The problem with Duchamp is more that art that has such a radical conceptual approach always has it tougher than something that is easier to experience with the senses. ➮ Antje Majewski, 96; and Boris Groys, 215. Which doesn't mean that one is better or worse. Look at Judd or Flavin's market developments: both incredibly rocky, still not where they should be—two of the most important sculptors of the twentieth century. Flavin is clearly lagging at the moment because he worked with neon lights and everyone is thinking, yeah, and next thing you know Philips will quit producing those things. It's just that for most people the haptic, senses-based ... though standing in a great Flavin space is of course an extremely sensual experience. They don't understand that. In the end this whole discussion about anti-form at the end of the 1960s, beginning of the '70s, the idea

of taking non-art worthy materials and making work with them never really hit home. Right now you can buy 1980s' Flavins for virtually no money at all. There are a few holy pieces—those are expensive now—but not as expensive as they really should be.

What's virtually no money?

For one of the most important sculptors of the twentieth century, I think 40,000 dollars is pretty negligible.

You can get a piece for that?

You can definitely get a Flavin for that. These days it's rare, but you see it again and again. And the question is, what happens there now? Is it true that when this material becomes old and the only way you can get these neons is by special order from Philips' studio ... or some freak will start producing these neon tubes only for Flavin. Then it could be that this material suddenly gets an aura that people don't see as quite so artless. But I think there's a long way to go until then. And even Judd is nowhere near as expensive as Warhol, for example. And I really think the only difference is that with Warhol, even though there was this huge production and also an incredible amount of crap, it's still a panel. Which means you can hang it on your wall. And there's paint on it. ➡ Friedrich Petzel, 200. That has a different value in people's perception than something that has been manufactured.

Getting back to the quantity of production. You said that both are okay, a lot and a little. To put it more radically, imagine I were working on an artwork and know from the beginning that I will only make one piece in my lifetime. It will take quite a while, and there will only be this one. Could you still imagine representing me or is that ...

That is of course a very interesting approach. So if that were the case, sure. There are artists like that. There's one artist—I don't want to say his name—but he studied at UCLA. John Baldessari took me to his studio ten years ago and I bought his thesis project. And I was always incredibly interested in him and always visited his studio. I think he went six or seven years without producing any new work. All he showed were little modular elements, ideas, models, and sketches, but sure, the moment you are convinced by a person and an idea, you naturally support it.

How are new artists brought to your attention in the first place? Do you go to open studios?

Yes, I do, but a huge amount of it comes out of talking to our artists. That someone's talking and says, hey, I saw this there. Or, hey, take a look at that. And really thinking about it a long time. Going back and double-checking it again and again.

You just said something about an ideal biography. It started at the academy, where already …

Well, yeah. Actually that's the problem these days. Of course it has to do with this incredible acceleration in the world, an overheated market situation and the unbelievable significance visual art has to society right now. It was first and foremost music in the 1960s and '70s, and this rock star status that people in the visual arts have now is rather unusual. The fact that there are all these collectors constantly opening up their own museums is a relatively new development. There are so incredibly many people constantly out to discover the latest, greatest, youngest artists. ➡ Harald Falckenberg, 80; and Olaf Breuning, 162. I want to watch myself so that all of this doesn't sound like a granny telling stories about the war, but I just saw a film that some friend of the Kraftwerk people made in Düsseldorf about Beuys' last day working at the art academy. It's a completely awkward little Super 8 film and there you really get the feeling—and I remember this as a kid—that the studying situation used to be more innocent. That it wasn't about successfully positioning yourself in the market as soon as possible. There are incredibly successful art schools, like the Rijksakademie in Amsterdam or all the American art schools, where I always had the feeling that the people are so extremely trained in being able to present themselves. ➡ Friedrich Petzel, 203. And the people there are all still very young. Especially in America—studying art is insanely expensive, and after such-and-such many years you're just spit out and you really have to be positioned the right way. It used to be incredibly annoying the way these completely clueless German art students weren't even able to talk about their own work, then it was incredibly impressive to go into an American art school and everyone could lecture endlessly on their work. But I ask myself, how possible is it to really develop something in peace when it's always about looking directly at its evaluation?

You say art is becoming more and more important to society. How do you explain that?

I just believe that there is always some area or another where people like to make a name for themselves. And all of these clichés really do work. If everyone has all their villas and their yachts and their private jets, then it's about having the ultimate luxury good to which you can't really attach a definitive price tag. That is, of course, the ultimate thrill for those people—that there is such a thing that can be worth a million, worth ten million, and at the same time you get a certain social recognition. Just now in the past ten years there were a lot of people, especially in America, that became unbelievably rich in a short period of time, and they weren't millionaires, they always immediately became billionaires. They were all between thirty and forty and suddenly had a crazy amount of money. And historically in America, everyone that has money has to devote themselves to some cause. The reason that cause happens to be visual art has, in my opinion, to do with the fact that you really get something for your money. It comes out of a totally extreme capitalism like the one we're living in now, more than people that—and a lot of people do this too—give the Met a few million or the Salzburger Festspiele or Bayreuth, and then you have your name on a golden plaque and get to go to all the chic parties in a tuxedo with your wife in an evening gown. For people to whom that is important, it also leads to an enormous pleasure gain. But you don't have something you can bring home and hang on your wall, where anyone that comes in knows that it's worth three million. The positive explanation, so to speak, would be that visual art is where the most relevant statements are made. But I don't know if that's really true. Where are the most radical positions produced? I think in the early 1990s it was very much fashion. All the boundaries dissolved between art and fashion, and there were people like Miuccia Prada and Helmut Lang who really produced an aesthetic that determined a large part of the world as we see it today. And that was really based on a kind of total design, almost a kind of *Gesamtkunstwerk* idea. In other words, it's not the fashion designer laboring with individual objects like a sculptor, but really designing the world. And there's always some art form that's currently designing the world the most. My problem is just that I'm so entrenched in the visual arts that I'd find it extremely presumptuous to say that it's really the art form with the most aesthetic influence. I just think it's

the most presentable. With this extreme materialism that has determined the world, particularly in the past ten years—it's the easiest art form to use for that. ➡ Boris Groys, 218.

Think about the way it used to be, back in the day there was a court painter—could you imagine a renaissance of the collector-portrait?

Nah, I wouldn't know why there would be. There are two genealogies with the historical collector-portraits. First there was the portrait of the patron: by then they had already discovered the ego and I'm going to associate myself with the Church and indicate myself as a patron. Aside from the religious dimension, we definitely see this narcissistic dimension of today. But then there are these collector-portraits where you see a transitory situation, in other words the transition from ruler-portraits to the sheer possibility that a portrait of normal, wealthy fellow human beings could exist. All of that is based on whatever social developments. Why should it be interesting today? The last collector-portraits I can think of are those by Warhol, and I find all of that downright strange—some weird collector ladies that I still know personally, somewhat unflatteringly captured by Warhol. ➡ Tobias Rehberger, 249. But the interesting thing is, and I had a good conversation with Harald Falckenberg about this a few years ago, when Flick opened his collection here... ➡ Harald Falckenberg, 83. Falckenberg really is a great collector; his collection is a collector-portrait in itself. It's an absolute psychogram and portrait of the collector that comes together out of all of these different works. And that's really the opposite of these collections that I call always-did-everything-just-right collections. They always come in and say, I only collect masterpieces. Those are trophy collections. The most expensive this, the most expensive that, and it's always pretty clear which artists are represented in collections like that. I don't want to talk in percentages, but there really are a huge number of people pulling together dull-as-dishwater collections, like buying all the same furniture or all the same clothes. They're always great pieces on their own, but the overall tone sends me crashing down into total exasperation. Because I have the feeling that not one of them contains even the most rudimentary self-revealing decision on the part of the people that collected it. And that's what's really interesting and what Falckenberg said back then with ref-

erence to Flick's collection. He was so vehemently attacked for the fact that he, as a person whose family money was earned with Nazi forced laborers, goes and buys art. And if you take a close look at the collection, in almost every work there is this ideal of healing. The notion of healing through art is a theme that runs through the entire collection, and at the same time something really touching is the sheer size of these artworks. It really is a pretty exact psychogram of this German son of a business kingpin, beholden to this think-big attitude, and at the same time there's this hope of freeing himself from it. And yes, if a collection does contain so much of the collector's personality then I do think it is interesting if this collection stays together in the long run, and you really can read the mental attitudes of a particular point in time. As a portrait of the collector, figuratively speaking. [*Laughs*]

Harald Falckenberg

ART AS A MIRROR OF THE TIMES
LAST WILL
THE COMING CRISIS IN THE ART MARKET

*The Falckenberg Collection, Hamburg. Harald Falckenberg's (*1943) collection is housed in a 67,000 square foot space that was once a rubber plant. In addition to his own collected pieces, he also exhibits artists that, in his opinion, are undervalued, and work from other private collections. Currently on view is an Andreas Schulze retrospective.*

You were born in 1943 and studied law, but then you went into business.

Not right away. I was also a coach for twelve years. In other words, a private tutor in the legal education context. I went into a family business pretty late, 1979, and from then on I was executive director—I still am today.

What kind of company is that?

We manufacture mostly gas pump nozzles, those used to fill cars with gasoline.

You only started collecting later?

I started collecting at fifty—beginning of 1994. I had already been fairly involved with art by then, as the edified bourgeois tend to be. As a student I had built up a little collection of local Hamburg greats, but I gave it up later. I had to teach myself practically everything. That took at least five years.

And how did it start when you were fifty?

It was a mix of rational considerations and emotional decisions. I wanted my life to take another turn; I didn't want to end in the routines that had developed. And the second thing was that I

thought that when I go into retirement in fifteen years or so, I'd like to have something that I can devote myself to, intensively. And I knew that it's harder to start with sixty-five. I wanted to start before then.

Okay, you decided, I'm fifty, I'm going to be a collector. And then what did you do?

I'm going to be a collector—that's nonsense of course. People collect all kinds of things for all kinds of reasons, with completely varying intensity and totally different intentions. *The* collector as such does not exist. Particularly when it comes to the press, *the* collector has a very specific, often negative image. The collector wants to use his collection to show off, the collector wants to draw on public funds, the collector wants to blackmail local authorities, and the collector wants to use the museums to gild his artworks and make them valuable. All of those are clichés that might apply to some collectors. But when I look around Hamburg and see the twenty, thirty collectors of contemporary art here, actually none of them operate in that way and have those kinds of intentions—in other words abusing the museum to his own selfish ends. They energetically support institutions with a lot of personal dedication.

But going back again, how did you start collecting? You really resolved to do it, you didn't somehow slide into it?

No, a decision was made. Then I allocated an annual budget and at the same time tried to get an overview of what it was I wanted to collect. At first I was very dependent on consultants. And I wanted to move away from consulting, because my intention when it comes to collecting boils down to having experiences. And I'm the one that has to have the experience and not my consultant. I mean, I like getting suggestions and I'm always open to criticism, that's how it has to be. But in the end, I have to decide what happens there. And I have to say, at the beginning it was really difficult. I had to gain a lot of experience. And it helped a lot that I became treasurer for the Kunstverein Hamburg shortly thereafter and had the pleasure of knowing the director Stephan Schmidt-Wulffen, who specialized in art theory, Kontextkunst [Context art] ➡ Friedrich Petzel, 206. and things like that. I had actually never heard of that before, and that was a multi-year lesson dear Stephan gave me.

But you also got started right away. The lesson was also in collecting.

Right. I put my faith in the fact that certain gallerists were around, like Hans Mayer from Düsseldorf. In the beginning they sold me some Andy Warhols and work by Wesselmann. Those were of course also already names that *I* knew. And I thought, well, can't go wrong with that! But even a few months later, I had to figure out that in a certain sense I had only gotten the leftover pieces from these artists, the ones good collectors didn't want. And then this practical experience taught me that a collector should actually collect in his own time and that it makes little sense to collect artists that have already been famous for twenty or thirty years. There's no point. It also leads to a lot of redundancy and overlap with other collections. I quickly stopped collecting famous names like that. But I have to say, it was very useful to me later, when the 1990s ended and the prices became very high. In my entire life as a collector, I have not sold many works. I'm guessing I have sold around ten pieces or so in these fifteen years. But I only sold them so I could es-

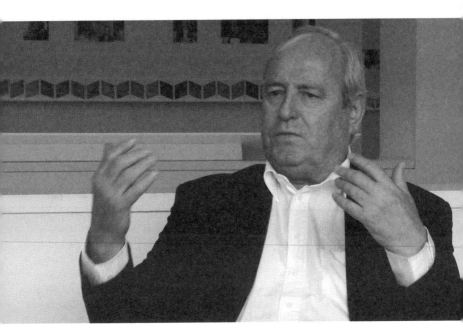

tablish this space. Somehow I felt entitled to do that. And you really can take care of construction costs here with a Gerhard Richter [*laughs*] and a Richard Prince and Gilbert and Georges' old work. And I thought that was really nice. Even the Andy Warhols—which weren't real humdingers in my view—went for a lot of money at the end of the '90s. And well, then you just have to let go of something. But like I said, I have sold very little. I have also always kept at least one piece by artists I admire—like Gerhard Richter, for example—as a nominal item, so to speak. Meanwhile I typically have thirty, forty, fifty works, bodies of work, from the contemporary artists that I collect.

How many artworks do you have altogether?

Around 2,000.

If you calculate that over the fifteen years ...

How many I bought per day, right?

Right.

There are of course occasions where you buy a lot of different work all at once. Once I also bought a collection. Or do the math, go ahead!

It's always a question of how you count it, isn't it?

Nah, the counting is relatively simple because there's a digital record of all the work. So the counting just happens on its own. Every piece of work that comes in here is photographed and entered into the system in such a way that it can be reproduced in catalogues and books. And just to clarify, if there's a twenty-part piece of art I don't count the twenty parts—it's counted as one. With fifteen years of intensive collecting, not all of these items have the same level of quality. A collection also lives through poor work. The quality of an artwork is not my first priority, but rather the artist. ↬Boris Groys, 221. I try to see the artwork as the expression of an attitude and also a situation specific to a human being, how he sees time, how he perceives social conditions. ↬Boris Groys, 220. I am interested in the influence of the French Revolution; I'm interested in the influence of the World Wars. And basically what I collect is grotesque, subversive art. Dadaist groups were emerging just after the great World Wars. Dadaism after the First World War and Situationism and Fluxus after the Second, both directions that

had to deal with nihilism and the great void left in the wake of these wars. The Viennese Actionists were part of that too. Where you then try to build new societies through art. True, it usually didn't work! Like Beuys said, every person is an artist. This idea vanished later on. In the punk era, Kippenberger turned it into, every artist is a person. ➤ Boris Groys, 220; and Genesis and Lady Jaye Breyer P-Orridge, 176. That was the reversal of the relationship, and with that the noble attempts to change mankind with art were shelved. But that shouldn't stop us from thinking about it, also about the failure of such models, which will then remain utopias for some. ➤ Boris Groys, 230. I'm not inclined to deal with utopias so much. I'm interested in the kind of failure laid out in these great models and attempts. How does man come to terms with failure? I think that it's a very universal problem. How do we process the fact that these great systems ended before they ever really hit the ground? Every attempt to give the world some kind of order has failed, because these attempts do not comply with the course of life.

The art you're interested in subverts this order? So it is able to do that? Or does it have to fail as well?

Well, okay. My art, which deals with something subversive and goes back to the grotesque in the Renaissance, to the world turned upside down—that is, the line from the grotesque of the Renaissance to caricature to Dadaism, Surrealism—starts with punk and No Future. It's the attempt to take the meaning out of art. It's not about understanding art as a reflection of something great, but about the everyday and society trying to find its bearings. Postmodernism has been heavily criticized, but I don't think the criticism is entirely justified. Because we have found the classic avant-garde's ideas about fundamentally changing society—which began with the Futurists—in the great movements of the twentieth century. And that is why the postmodern condition is an important revision. It deals with the fact that we can no longer say anything for sure, and that art distinguishes itself more through social practice than it is ennobled by the artwork. This postmodernity is a documentation of failure, if you will. A lot of people don't like that because they want to see art as something important, something that you don't have otherwise, where you can find yourself again, finally, after this whole

stupid life and the common conditions of our society. Where—
like heaven on earth—you can straighten things out into some-
thing better. I don't want anything to do with this straightening
out. [*Laughs*]

You say the artist is more important to you than the individual artwork.
How important is it, then, for you to know the artist?

For me it isn't about the artist personally, but about the psy-
chogram of the artist, the typical attitude. I see the artist as a
person in contemporary history and an individual with a special
perspective on contemporary history or the history of ideas.
But I would never presume to analyze him on a very person-
al level. I'd like to refrain from that. Which is why I also have
very few artists as friends. The only two artist friends I have,
well maybe three, are Franz Ackermann, Jonathan Meese, and
Werner Büttner, but that's where it ends. And I don't talk to
them about art when we're together. I want to preserve my free-
dom there—just as the artist does. I don't like these collectors
that storm into studios and keep the artists from their work. But
if you see an artist like Otto Muehl or the Viennese Actionists, or
if you think of Paul McCarthy, then you do have to think about
certain things. For example this tremendous infantilism, dealing
with dirt, filth, anything you can think of. And then you have to
reflect on infantilism, for example. Most people are shocked to
hear the word infantilism, but you could also see infantilism as
an attitude with which the artist opposes civilization and with
it, order. This type of bohemian doesn't exist anymore. But I'm
interested in the artist in this typology as a Pop artist, for ex-
ample. Pop art debased the high art of the erudite bourgeoisie.
And artists dealing with Pop art classified themselves accord-
ingly—as a lot still do today—integrating themselves into soci-
ety and like singers, actors, and athletes, by their mid-twenties
they already have the better part of their career behind them.
They are no longer the people that spend a lifetime working on
their oeuvre. When it comes to the oeuvre, they say, hey come
on, I could care less. They live in our society, in this society of
the spectacle. And that is our whole art world today. Anyone
that doesn't participate in this spectacle, whoever says, I'm not
going, I'm not going to allow myself to be represented at Art
Basel, I won't allow that—he doesn't exist as an artist. ➡ Friedrich

Petzel, 200. Just imagine, the Hamburger Kunsthalle did thirty-seven solo exhibitions last year. That's not a museum anymore! Its director, Mr. Gaßner, says that 90 percent of all visitors come into the exhibitions and only 10 percent come into the collection. That's the art industry today. And these exhibitions are, of course, with young contemporary artists. Exhibitions with old masters require an endless amount of time, an endless amount of money, insurance. You might manage one really important exhibition every five years. But with younger artists, they have the support of the gallerists, the artists, the collectors—all of these people that are also somehow involved. Everyone benefits from everyone else, and anyone not participating in that will remain obscure. You can, however, take very different positions in this network. You can do something like the Leipzig School, who threw themselves very deliberately at the market with concentrated actions led by gallerist Judy Lübke, appealing to buyers with a yen for kitsch. And by that I don't mean the individual artists [*laughs*], there I would look at it in a more nuanced light. But the market-specific moment in the Leipzig School, that was an open statement: go to the people that want something kitschy—bang! And it was a dazzling success. But you could also say, I want to see the whole thing more critically. Then you maybe support the Merve and FUNDUS book series like I do, get into art theory. But I am nevertheless part of the system.

Do you have art at home? To what extent would you allow artists to design your life?

From what I've said, it's clear that I would like to maintain a certain distance from art. I don't want to be nailed down any more than the artists do. I want to be able to think freely. And when you have something in your midst, it becomes harder to think. This program—that some collectors have a penthouse on top of the collection, so to speak—is very foreign to me.

You started in 1994. The art market had hit quite a low then.

I wouldn't say that. I'd say it had completely bottomed out. The art market collapsed pretty abruptly in 1990—back then it was the Japanese bubble. But it only hit real bottom in 1994, 1995, after the boom years in the 1980s. The model will go that way again this time, by and large. There's a lot of loose money out

there because a lot of people earned a lot of money, but the majority of this will concentrate on the great classics, the famous names. Art by unknown artists is almost impossible to sell today. I've heard the young galleries have seen an 80 percent decrease in business. There is every indication that the crisis will move in a ten-year rhythm here too, and I assume that in another two, three years we'll be seeing the bottom out in the art market, like the one we saw in 1994, 1995.

So there's a delay between the economic decline and then the decline of the art market.

Yes, there are definitely things that can be observed quite clearly. If you take the Leipzig School, for example, the buyers were for the most part speculators that hoped—in the development of the previous years—the prices would continue to balloon more and more. And the conditions were so good, especially in the past ten years, because almost exactly ten years ago the auction houses began auctioning off younger art as well. ➡ Friedrich Petzel, 198; and Boris Groys, 221. Now the collectors could take the work they bought to auction two, three years later and cash in on their speculation gains. The young, unknown artists were especially interesting there because the investment margin is so great. ➡ Philomene Magers, 68; and Olaf Breuning, 162. And this whole market doesn't work if the sales figures aren't there. The gallerist Pat Hearn once did a symposium in New York, and she talked about the 1980s as the hedonistic "decade of desire." And if you were to characterize the last ten years, then it wouldn't be about hedonistic, heated desire, but more about cool calculation. I would say it's a "decade of greed," and we will suffer the consequences. You could always say that Neo Rauch, to name an example, costs five, six hundred thousand euros. But if no one's buying him anymore, then these five, six hundred thousand euro prices are left hanging there. But all that has to do with the art market. That has nothing to do with the quality of the art. You have to keep that separate. A lot of people also say that art is finally becoming good again. The gallerists should say that a little louder! So the whole time they've been selling bad art for hundreds of thousands. Well! As a collector, I don't have a great deal of anxiety when it comes to facing this decade. But the people participating in the markets, they're going to have to take a good look at where they're going to end up.

How was it for you when the prices rose like that? That meant you could buy less and less with your budget.

Well [*laughs*], let me say that prices of 15, 20, 25 percent of the work I have have also risen to ten times what they were before. I was lucky there anyway. But you can't forget that 80 percent of the work in my collection has definitely stayed at the price it was before. And that's not such a bad thing either, because I don't buy from the price perspective. It never irked me all that much. If I have twenty, thirty pieces by Kippenberger or by Prince, and these prices spike, then I don't buy any more. There are always new, interesting artists that come up, also new artists that are discovered again. I was part of rediscovering Paul Thek. ➡ Antje Majewski, 90. Then I bought work by Richard Artschwager, which in my view is completely undervalued. Because I'm not dependent on whatever specific artwork, it doesn't bother me that I can't complete my stamp collection now and again. Which leads me, by the way, to another thought: I—unlike many collectors— also have no interest in preserving my collection. I have no interest in what happens to the collection after my death. The only responsibility I have is to the artists. Were I to quit collecting, I would try to place these artists' work sensibly and well in other collections.

How do you picture doing that? At a certain point in a few years you'll say, as of now I've stopped collecting, now I'm only going to concern myself with how I position the individual parts of the collection?

If I'm in charge of running a business, of course I'm going try to find someone to take over those responsibilities. In other words transfer the business to someone else to keep it from suffering. Those are the attempts I've been making for several years now, making various offers as to how this collection can eventually be given over to the city of Hamburg. One of the reasons I set up this Harburg space was because I know my collection wouldn't fit in the Kunsthalle. It would be ludicrous for me to say that 20, 30 percent of it has to be hung in the Kunsthalle, and then other pieces in the Kunsthalle collection would have to make way for them. That idea is pretty abhorrent to me and that's not a demand I'm interested in making. Anyway, in the end it's up to the director to do as he sees fit. A collector shouldn't interfere with that all too much. That's why I created this space, so that I can

show it from time to time. And here I wanted—and I'm doing it too—not only to show my collection but also to put up exhibitions that have some connection to my collection, to give the whole thing some life. That's how I imagine it to be: that this is a building where exhibitions are being put on as a kind of satellite to the Kunsthalle or the Deichtorhallen—something like PS1 in New York—and that the collection would be available as a fundus for museums, exhibitions, and maybe permanent loans. And if it's given over to a foundation that belongs to the city, the city would definitely be in a position to sell the art if a director feels that parts of the collection do not fit his concept and he wants to do something else, but only on the condition that the money be invested back into the collection. It doesn't have to be called Falckenberg, nor do the holdings have to remain as they stand. That was the idea. Like that. And that might have been a little complicated. [*Laughs*] In any case it's definitely been in discussion for several years now. And just when we were almost at the end—the contract had been finalized, it only needed to be signed—the financial crisis got in the way. And yes, yesterday an announcement was made that the Galerie der Gegenwart is closing its doors for six, seven months—at least the upstairs areas. Supposedly to repair the fire shudders but probably to save money. It goes to show what a difficult time local authorities are having keeping culture upright in this situation.

But those are pretty major concessions—that you would give the collection to the city and even tell them they can sell things out of it.

Yes, but someone has to be there to manage it. Because the deciding factor isn't usually the money, it's the work you put into it. Mr. Gaßner, head of the Kunsthalle, had an incredible amount to contend with in terms of all of the financial problems, and at some point I realized that he has neither the time nor the leisure to deal with it—though I know he has a great deal of appreciation for the collection. That is why it lent itself to the solution with the Deichtorhallen, where with Dirk Luckow, the director, I also have someone that I know very well and where I know it would also be a good cooperation. The city parliament will vote on it at the end of the year. We're talking about 570,000 euros. Then we'll see.

The 570,000 euros, what would they be used for?

That's 70,000 for a curator at the Deichtorhallen and 500,000 for the maintenance of the operation, also exhibitions. It is very frugally calculated, and I have committed to personally taking over any surpluses should the 500,000 be insufficient, so the city can very clearly figure it out. We're looking to see that something comes of it. You know, if you say, I'm just going to give it to you, that doesn't necessarily work out so well. Let me name an example: Kaspar König took over the Museum Ludwig and come hell or high water, he wanted collectors to donate individual pieces or sell them under very favorable conditions. In my case, he had set his heart on Kippenberger's gondola (*Sozialkistentransporter*, 1989), certainly one of his key works. I said, Kaspar, that is one of the most important pieces in my collection—that makes no sense for me! And who knows what will happen when you leave in five years. Maybe your replacement doesn't like Kippenberger at all and then the gondola disappears into storage. Okay. So, I say we meet each other halfway: I'll loan it to you for twenty years. And twenty years from now neither of us will be alive anymore, so our heirs will have to deal with it. So for your lifetime, you have it as long as you want. All right. And that's what we did. Then I came into the Ludwig Museum eight months later and the gondola was no longer in the exhibition. I said, Kasper, it's not there anymore—it's already in storage! And then another eight months later I get a letter from the management saying that it's too costly to maintain the gondola in storage, would I like to take it back. That was the twenty-year donation! I think that's a wonderful example. Because you can't say and stipulate exactly how the public sector will handle something. ➡ Friedrich Petzel, 202. And that's why it isn't just about giving something away. There has to be the groundwork for a collaboration. I thought the thing with Flick at Hamburger Bahnhof was a good example. ➡ Philomene Magers, 70. I had heard very early on that Mr. Flick also wanted to donate a few pieces. Then he didn't do it, at first because the general sentiment was so much against him, then it would be misinterpreted again as him trying to buy himself into favor. He did it very quietly and secretly, after four or five years, and did end up giving the city of Berlin 170 very valuable artworks after all. This would indicate that apparently the cooperation between the city and the Flick Collection has a sound basis and is now also being con-

tinued—no matter what your take is on the Flick Collection. I
don't know how it would have been if Flick had just donated it
all right away. Now, years later, he can see that directors and
curators handle it in an intelligent way, just the way he wants.
The directors and curators notice that he doesn't interfere and
isn't making demands, they notice he donated 170 artworks. It
won't be that way forever, but right now both sides are giving
something. And if you only donate, then you've given something
to start with but who knows if the donee really wants it. It could
be a Trojan horse.➔ The contract Falckenberg closed with the city

Like you said, the boom of the of Hamburg at the end of 2010 did not in
 fact arrange a donation, but rather what
aughts was very much the result is currently a twelve-year permanent
of the fact that auction houses are loan. The city is to raise the annual
 570,000 euros in return.
now offering contemporary art as well.
Do you think there needs to be another
tool on the market, so that the art market
can reach new heights?

I can't say. Experience shows that these crises run in ten-year
cycles. Now we're down to the Bible, the seven fat and lean
years. Those are certain rhythms that repeat themselves like
the curves on the stock market. And what we know now is that
valuable art is still highly tradable. What is also foreseeable is
that our society is absolutely incapable of dispensing of spec-
tacle, of events, and it doesn't want to. That means the classic
exhibition-art made for biennials, triennials, for documenta …
it's going to remain very important—also for the Kunsthalles.
After everything we've experienced until now, this exhibition-
art will be very much in the forefront in the coming years.

Do you have a feeling for where art itself is heading?

I believe art is always a mirror of the times. And because of
that, it will always go wherever the times do. And if society
continues to dumb itself down, then art will continue to dumb
itself down as well. That's a logical development. If you look at
what's become of television; if you look at what's become of the
press; if you look at how there's hardly any serious criticism
any more, only in a very few places, and also because critics
aren't paid anything anymore—those are changes that cannot
be reversed. The fact that a Kunsthalle with a large collection
did over thirty-five temporary exhibitions last year—yeah, why

do you think it did that? Because the federal state government demands 300,000 visitors or they'll cut support. And do you actually think—especially if you see all the political reactions to the financial crisis—that the world is getting better and more reasonable? Well I can't imagine that to be the case. And that way of dealing with things, this putting off of problems, will also precipitate its way down to art. I do not believe that art moves mankind. I believe that art portrays and that art shows something drastic happening. Sometimes artists have a clearer picture of developments to come, in their freedom, but spearheads of society they are not. Instead they're observers, sometimes penetratingly exact observers. But what should they move?

Antje Majewski

A FICTIONAL ARTWORK OF THE FUTURE
MAN OF SORROWS
BULLET HOLES

*Antje Majewski's (*1968) studio—like those of many Berlin artists —lies in Wedding, an area in the northern part of the city. Gentrification moves at a slow crawl here, unlike in Kreuzberg or Neukölln. Leaning against the wall is the oil painting* Meteoarises *(2009), where we see the singer Arises* → Arises, given name Katrin Vellrath, also composed music for the film The Future of Art. *holding the yoga table pose while burdened with an enormous meteorite. The painting is part of* The World of Gimel, *a series currently in progress. Majewski and I co-founded the collective* Redesigndeutschland *in 2001.* → See Niermann, Solution 1-10: Umbauland, 23. *In 2004, we co-curated the exhibition "Atomkrieg" in Dresden* → Kunsthaus Dresden, May 19 to July 11, 2004. See Antje Majewski and Ingo Niermann, eds., Atomkrieg (Berlin and New York: Lukas & Sternberg, 2004). *and in 2005, we staged the dance theater piece* Skarbek *in Bytom, Poland, and Berlin.* → See Antje Majewski and Ingo Niermann, eds., Skarbek (Berlin and New York: Lukas & Sternberg, 2005). *In 2009, Majewski and I collaborated in "Dubai Düsseldorf," a project that envisioned the prospective fusion of the cities Dubai and Düsseldorf* → Kunstverein Düsseldorf, August 29 to November 8, 2009. See Ingo Niermann, Solution 186-195: Dubai Democracy (Berlin: Sternberg Press, 2010), 72. *For the latter she developed an artwork of the future, but not one she would necessarily like to realize.*

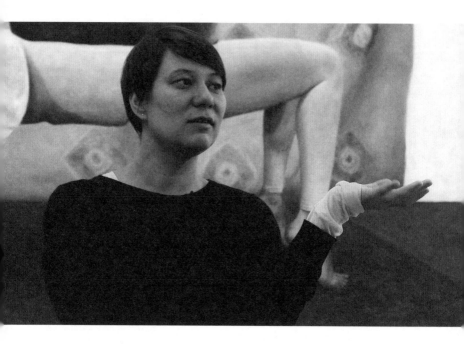

Last year, you exhibited an artwork of the future: the *Entity*.

> Yes. The *Entity* is a fictional artwork of the future. The idea
> is that in the future, I will work with a biotechnology firm to
> develop an organism that has no sensory organs, that cannot
> reproduce or move its own body and whose only activity con-
> sists in digesting itself. It comes into the world already com-
> plete, so to speak, then digests itself from the inside out and at
> some point is mummified. This artwork is to be exhibited in a
> pavilion, possibly also in a Kunsthalle, and replace all remaining
> Kunsthalles. That's as far as the story I developed goes. There's
> a painting upon which we see the artwork being presented to
> a future museum director. It's a large, realistic painting show-
> ing several figures. The rich female collector that will hopefully
> finance it in the future is giving it to the museum director, sur-
> rounded by nothing but assistants or co-curators or whatever
> they are in splendid garments. A painting based on Piero della
> Francesca. Another one hundred years further into the future

and the Kunsthalle is plundered. The *Entity* is now collecting dust somewhere in the corner of a fruit and vegetable stand and has long since mummified and turned to a dry, little ball.

The *Entity* is also ascribed a cultic function.

Well, let's put it this way, the artist in this narration, Antje Majewski, is not necessarily identical to me. There is a story in the form of an illustrated text and in it there's talk of this artist Antje Majewski, but that's not necessarily the same person as me. I just want to put that out there in advance. All of that takes place in the future and who knows if I will do something like that in the future.

And if a biologist were to come along now and say, technically that's already possible …

Yes, then I'd like to do it. Right now I would. But who knows if I'll still want to do something like that in two years. So I'm now talking about things I'm developing for a future that will probably never take place, namely in connection with the "Dubai Düsseldorf" exhibition, where there's supposed to be a shared vision for these two cities. The idea was to make a work of art that is not pictorial, doesn't represent anything—which would in other words satisfy the aniconism of Islam—and the same time it would also do something Western art is always wanting again and again, namely a cathartic moment or a kind of identification with the artist as a Man of Sorrows or the one who takes it upon himself to process things society has rejected or doesn't want to process. In the case of the *Entity*, this remains completely abstract. It consumes only itself. You can project any kind of content possible into this digestion process. But it will evoke empathy; at least I think it will. You get the feeling there's a living thing there, and this poor creature has none of the nice things we have: it can't see, it can't feel, it can't taste, it doesn't have sex, it can't even run away. All it does is die. Sympathy would be a very normal human reaction to that. And it is through this sympathy that you'll begin to reflect on yourself. So there's a Kantian sublime effect—in the sense that this creature seems so incredibly strange.

You can't help him either.

You can't help him. I mean, sure, it isn't greater than we are or

something. When I talk about being forced into self-reflection, I'm only saying that in a different way you could perhaps be happy with the fact that you can perceive anything at all. That you can feel, taste, see, run, touch—and think.

The *Entity* shows the limits of cognition.

I think people have a huge tendency to emphatically identify with any living thing at all. It could be anything. There are people who think iguanas are great. Creatures maybe a lot weirder than a ball like that. I imagined the *Entity* as a relatively perfect sphere that looks a bit shriveled from the outside, like a kind of fruit, in yellow-green. And it smells repulsive. The human being is a social animal to such a huge degree that it, I think, would try to adopt a creature like that somehow, and then he or she would figure out that there's this limit. It can't respond. A turtle can still lift its head and supposedly look at you. Or it uses its claws to crawl forward. And this thing is so closed up in itself that communication is no longer possible. All that can happen is a projection that is reflected back at you. Insofar it is a look into the mirror.

A little bit like when someone is lying in a coma.

Exactly.

You speak of a cathartic function. Can you name artists whose work caused you to have these kinds of experiences?

I don't know if I've had these experiences so strongly myself … actually, sure I have. That would be Beuys. Paul Thek. Somehow it doesn't work with me with Bas Jan Ader, even though I like him a lot. Okay, surely van Gogh is a classic.

That was your experience with van Gogh?

What I can definitely understand is the fact that I think that a lot of his paintings are migraine paintings. I know spatial warping like that from my own experience.

But does it have a cathartic effect then? Looking at a picture like that?

No, not for me. But I know it was handled that way in terms of reception.

All of those are …

I could name two more that just came to me: Alina Szapocznikow and Eva Hesse are also classic. I think there you can start to

think of quite a few relatively quickly. Kafka.

You're not naming any painters.

Paul Thek painted. Van Gogh painted.

Yes, but you said that for you, van Gogh isn't that experience. With Paul Thek it isn't the paintings either, is it?

No, it's more the action-based work.

And the *Entity* itself isn't a painted picture either.

It's a reflection procedure. I don't really produce the *Entity*. And if what you're asking is whether or not I would do it if someone were to approach me about it? Of course I would, just because I'd be curious. But whether or not it gets made isn't important. All that's made available is a story, and that means there's a built-in distance to it.

So you're saying this cathartic function of art isn't actually a central concern in your own work?

[*Pause*] Well, I in any case haven't been [*pause*] a figure like that so far.

What do you mean "a figure like that"?

Well, Paul Thek and Beuys are art figures. A person isn't just like that, you have to make one of yourself. You have to decide to create that type of figure. Decide, for example, on a way that you'll be portrayed, or a certain way of expressing yourself, or maybe also a certain way you might feel for now. ➡ Boris Groys, 221.

You mean their art wouldn't work if you didn't know about their person?

Yes. In Beuys' case that is very obvious. He did practice a very extensive self-stylization.

And Paul Thek? What about him?

Yes, and also through photos. His art is for the most part unpreserved. It is only documentation material. There are a few sculptures that work for me. But a lot of what goes on in the broader reception has to do with him as a person.

His emblematic work is surely his *Pyramid* (1971). With a cast of himself as dead man lying inside.

The catharsis does actually work through people. It comes from the theater: a person acts something out that you can put your-

self into, and in the end the audience leave the theater with the feeling they've been washed clean of their suppressed aggressions or whatever. And with my *Entity* it's not necessarily so much about catharsis as it is a kind of activation or sensibilization of the viewer. Nothing's really being processed there. If you take someone like Beuys, then the cathartic moment consists in something like the way he processes this whole war trauma. Just like you could say Artur Žmijewski is actually dealing with catharsis the whole time. Basically a kind of psychoanalytical invocation of something so horrible you are usually not allowed to name it.

For me it seems like a kind of encounter therapy: to walk naked into the gas chamber and start playing catch, or setting different Polish extremists loose on one another.

I talked to him about it once and he confirmed it. In other words that he does think it is a process with at least some parallels to the classical Freudian psychoanalytical process. The fact that you're naming and showing things that cannot otherwise be seen. And that this process is of course painful, that you'd actually rather not live through it but in the end there is an opportunity to come out of it and into something like freedom. But now we're talking about Žmijewski. [*Pause*] And if you're asking about objects by someone like Beuys or Thek, then there might be something else going on there besides catharsis. Catharsis is extremely easy to understand in relation to Thek because he was very pious Catholic. You can really stick him with a concept like the Man of Sorrows. He also did performances that operate with religious symbols. But if you take individual objects like that by Beuys or Thek, then they might already have a whole other function altogether. They have something like a kind of energy carrier function.

With Beuys it has a lot to do with these energetic models—warm-cold.

Yes, in principle to create esoteric magnets that way, or batteries or fields.

Behind you is your painting that features a rock, *Meteoarises*. Is there a relationship between this rock, the *Entity*, and maybe also the objects by Beuys and Thek?

That's not a rock, it's a meteorite. I don't know if you'd call that

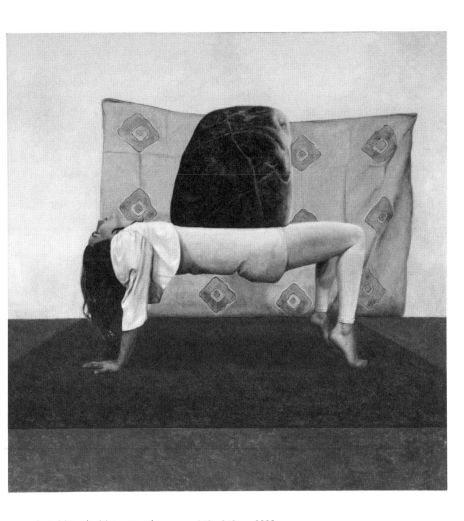

Antje Majewski, *Meteoarisis*, oil on canvas, 240 x 240 cm, 2009.

a rock. Actually it's a hunk of metal that falls from the sky and is originally this [*makes a tennis ball-sized hollow with her hands*] big. It's part of a series I'm working on now that is actually about these kinds of charged objects. [*Pause*] Well, it's just different in that I don't start out assuming these objects are charged to begin with. In other words I charge them here. I charge them with different meanings, but every time I also throw this charging into question. There is a series of paintings in which these objects appear: that's a stone, that's a seashell, those are different objects of natural origin or that imitate nature. All of those are objects that carry a kind of magical possibility in them. In other words, magic in the "age of resemblance." As Foucault called it, analogic magic—things that look like something else or are called something similar to something else, or because they fell out of the sky, for example. And I took the objects to Africa a few weeks ago, because I was interested in this idea of bringing them into a whole other culture, one that structures things differently than I do when thinking about them and can describe them differently or interpret them in another context. In other words, it would take these objects and return them with a different charge.

This meteorite, for example, did you relate it to something you came up with yourself, or did you only see the potential of relating it to something?

The potential. That's why I'm saying, I myself am not that kind of figure, not right now anyway. For me, art works as an opportunity to communicate content that cannot be conveyed otherwise. It is a vehicle—or it's supposed to be. And I think what interests me about objects is emptying that vehicle function and going ahead and naming it at the same time. In other words, to say, this painting is a vehicle, a receptacle, just like this stone can be a receptacle. And a meteorite is especially well suited to that because in many cultures it's a carrier of secrets or it can take on a magical function. Just because for a lot of people it's a pretty crazy thing when something just falls out of the sky like that. Plus, it's iron! You can make something out of that. In every culture, the people who worked with iron were at the cusp of being magicians. The blacksmith is always also the wizard or the one who's a little bit outside of the normal village, and is subject to very specific rules. So in that respect, I thought if I bring a

meteorite to Africa or whatever country, I'm sure to find some-
one that can ascribe it a very specific meaning.

Then the transfer has to convince you?

Not necessarily. In the stone's case there were two interpreta-
tions in Africa, both of which I thought were really great. The
first is, I was in Senegal—which is an Islamic country—and I
was told they use lava rock (which also symbolizes a cosmic,
elemental force) to clean their hands before prayer if there isn't
any water. And to people from the Islamic cultural circle, the
stone very obviously looks like the stone in the Kaaba. So in any
case it would be a very special stone, just because it's black and
square-shaped. But then there was also a second interpretation
by an artist who said that for him the stone brings up the ques-
tion as to whether or not God has inscribed something into this
particular stone. In other words, if the stone contains a sign.
And he associated it with a gravestone he placed in front of his
studio for a friend. He and this friend had discussed that very
question: does God inscribe something in stones? And when he
died, he wandered around in this village and looked until he'd found
this very special stone. To him, it's the friend of his that died, so
to speak. Then he went in and drew a connection between that
stone and my stone and also gave me another object as a gift, one
that's made out of iron and that the Chinese had buried there as
the stadium in Dakar was being built. It's a kind of cosmic metal
brick that is very heavy and that he had painted gold.

Does that change the way you see your own painting?

Hmm. No, because I hadn't ascribed it any kind of significance.
It hadn't any meaning from the start. Now of course you could
say the energy emitted from something like a Beuysian heat
source doesn't have any meaning either. All he's saying is that
it's a positive or creative energy.

And has the meteorite itself become more powerful for you?

No, because for me it was already powerful before. It's just
that I was also given this other object, and I have the feeling I
could walk around with that now and set it up anywhere in the
world—now we're getting really esoteric!—and maybe it could
radiate something. Who knows, maybe it's radioactive.

What kind of effect does this radiating have?

Zilch. [*Laughs*] Like I said, I'm no follower of stones. No, of course that's not true that it doesn't have any effect. [*Pause*] Actually it's really strange. I'm from Düsseldorf and back when I was in school I was really interested in Beuys. He was still alive then and was a professor in Düsseldorf. And somehow I imagined I would study under him. I'm noticing only now that it really did have a big influence on me. There are two very strange, different poles that probably no one would associate with my paintings, namely Duchamp ➡ Boris Groys, 215; and epilogue, 286. on the one hand, and Beuys on the other. Duchamp also made these weird little objects that are also like reservoir tanks for any kind of meaning you can think of, shifting and nesting in themselves. In which, according to his theory, there are definitely still various perspectives, and these then form a kind of knot. That might be the idea, that you can form some kind of knots, which can then emit something in turn. You can't say they're emitting this or that meaning or significance. That's open. But what you do have to do is collect and bundle.

This emission, what effect does it have then? Is it something like a consciousness-expanding drug? Does it work as an amplifier of other perceptions?

As to whether or not I can manage that with my objects, I'm not so sure. But it could be both. It could be that it makes you yourself broader, that it causes a kind of expansion or enlarges the internal space. Or, as Duchamp would say, that it represents a bullet hole—I'm talking about *The Large Glass* (1915–23) now—in our three- or four-dimensional time-space continuum. His theory was that maybe there is actually an n-dimensional space, from which we are only shadows. And that art, so to speak, produces totally ephemeral little bullet holes in the horizon of experience we normally live in. We, with our sensory organs and our bodies, are incapable of perceiving these further dimensions. The funny thing is, you can think them. You can calculate them mathematically. And from that you can develop an internal idea of how that could be. Of course it can't be accurate because we're not those kinds of beings. But the strange thing is that we humans are capable of developing these thoughts at all.

Why did you become a painter then? Coming from Beuys and Duchamp.

I keep asking myself the same question! [*Laughs*] No, it's just

because ... if you assume there are these bundles, then they can contain anything you could possibly think of, including any kind of image. And I'm interested in this very abstract feeling on the one hand, and on the other hand I'm interested in how it would be to just unfold all of that into lots of different kinds of stories. In other words, all the things that can happen.

The way you say, I'm still not that artist, it sounds as though painting were a big, long ramp that leads you there—or maybe not only you.

It's all about communication. I think it'd be nicer if I could produce things inside the person looking at it. In other words, throw him into a world in which he might then encounter something. In *Roadside Picnic* (1971), the Strugatsky brothers' novel, a man keeps going into a zone that's been polluted by aliens. And in it are lots of strange objects. These objects are completely foreign to people, some of them even obey different laws of nature. And the humans, in their human way, go in there—they're like trash trawlers or waste management officials—and decide, okay, this weird thingamabob, you can use that to do this here in our human context. And until now I have not been able to put myself in the position of being the alien, so to speak. I'd rather the viewer be the one who put the thingamabob there.

That's what I meant: a takeoff ramp not only for you, but also for the viewer.

That's also always part of it with Duchamp. Many of his works are essentially launch pads like that. It's all these perspectival arrangements through which you might possibly get somewhere, or through which you might learn more about how you yourself perceive things. That's what I mean: in front of and behind *The Large Glass* there's the world. You look at it and also you look through it. I'm interested in the world or possible worlds. I'm interested in showing the world or possible worlds on these two sides. Also the fact that you have a viewer. I have always had quite a few people in my pictures that encounter or react to each other. But I'm not exactly sure where that would lead. It could be that on the one hand, it becomes more concentrated, folds inward, and becomes more abstract. And on the other hand, I have more and more of a desire to build the narration up even more, to make the paintings even more complex and connect them to each other and knot them up and build in

nothing but hinges and still more parallel stories with all of them referring back to each other. At the same time it would still revolve around this empty space the viewer has to fill in himself. [*Pause*] Maybe I'll paint these objects from *Roadside Picnic* too. I've been planning on doing that for a few years now already. But it could be that it takes another five years until I can do it. It may be another five years before I can. I would always only be interested in painting them. I don't want to produce objects myself. I have the feeling that a painting offers more freedom insofar as one thing is already clear: it's an illusion. A theatrical, illusionary space. You step in and fill it with your own. An object would be much too literal for me. That's something I also find a little kitschy about these Beuysian objects—you have this thing and it says, I am an energy transmitter. Then it looks like an energy transmitter, and I'm not even allowed to touch it! That's the worst. [*Pause*] If you bring a real object into a three-dimensional world, I think it would be better if you could also touch it, or stand on it. And as long as that's not possible with the way our art world is organized, �Thomas Olbricht, 149. I think it would make much more sense to make things that only occur in the realm of ideas anyway.

Couldn't you just say, these things are there to be touched, changed?

You can say that, but on Monday I was having a discussion with Simon Wachsmuth, for example. He had a picture on the wall with silver balls on it and said the viewer is reflected in them and becomes part of the picture, and that he or she can also move these silver balls around on a kind of magnetic surface. So then of course I asked, oh yeah, can I touch it? [*Laughs*] And he said, well all right, just this once. The thing usually just hangs there of course, and you're *not* allowed to touch it. And then I said, okay, but if the viewer is usually not allowed to touch and change it, how is he supposed to know that it's even variable? And then he said, well, you can tell by looking at it. And I didn't think you could see it at all. So I just took a ball and pushed it and of course it instantly made a total scratch on one of these adhesive surfaces. Luckily the whole panel was already claimed under insurance, so I didn't have to pay several thousand euros. But that's normally the case. You have something by Öyvind Fahlström that was conceived to

be interactive, or all the remnants from happenings or whatever interactive performances: the moment they enter the museum, a process begins by which they become mummified. Edward Krasiński's studio in Warsaw is a good example of this. He died a few years ago and had transformed his apartment into a *Gesamtkunstwerk*. There are a lot of little objects there, lots of installation elements that transform the apartment into a strange kind of labyrinth. Five years ago they still said the studio should remain open, things should happen there, young artists should be allowed in, they should be allowed to make art themselves in the middle of these works by Krasiński or act in response to them. I called them two days ago and the word was no, the family is absolutely against having anything happen there anymore. You can take photographs, you can look at it, but it is a museum. And then later on it was, well, you know Krasiński is more than just an artist now; he's a national treasure, so to speak, he might be showing at the MoMA soon.

And there's so much institution-critical art there, so much critique of the sacralizing of art.

Yes.

Maybe you have to make a place like that yourself, where people can go and touch things and relate these things to other things.

Yeah, that's an idea. To found a center for unsellable art right here in Wedding. [*Laughs*] I think that would be great. On the other hand, I know exactly how much work that means and that I would rather put it into my own work. But I do think about it.→ Antje Majewski did actually open SPLACE I want art to be able to mean a direct for twelve weeks the following summer transmission of experiences or of life. I'm together with Magdalena Magiera, Dirk just not interested in some pile of dead ob- Peuker, and Juliane Solmsdorf. A new jects that I can then go and sort out somewhere for one evening only in a several according to value criteria—that the object basi- the foot of the television cally only specifies how well you know your stuff. In tower in Berlin. other words, that you've arrived at a very specific position within a discourse and have already understood all of the other positions before it. And the moment the viewer understands it, he can attribute himself more value, because he's in a position to participate in this discourse. I wish I could

beam the paintings just as they are into the minds of other people, without all these detours through goods that have to be produced and displaced, that have to be stored; without rooms full of other dead objects.

You are in a privileged position compared to the painters that are already dead in that you still might be able to experience that in your lifetime.

Well it's not all that easy. [*Laughs*] There is more involved than just stimulating the visual cortex and having a few flashes of light. To really be able to transmit the kind of thing I am describing, you would basically have to be able to transmit the entire contents of the brain. [*Laughs*] And that's really a far cry from where we are now.

What do you want to send, the things happening in your brain or the painted pictures?

I would think both are great: the painted pictures in their materiality, but I also think it would be great if I could really concentrate some kind of picture in my mind, like I do before I make a painting. Sometimes years go by where I'm working on a painting in my head—not in the details, but in the feeling of the painting. You only know it isn't quite right yet. Then something shifts again and all of a sudden this feeling is very clear but doesn't necessarily contain whether the woman is wearing a pink shirt or a white one. And of course it would be great if you could beam this feeling over directly, without having to go over materiality. But it is more complex than just a thought. It's a thing that you can look at from all sides, but not a film. I couldn't make up for that by making movies. And it isn't a book, either. They are things that stand still in time and are condensed.

A lot of art today can't be understood without additional information, even if you're living in the same time. Information printed on a piece of paper that gets handed to you, maybe just a rumor circulating through the art world. Without it you wouldn't be able to comprehend the meaning that suddenly makes an artwork interesting for a lot of people. The transferability is extremely vulnerable. You could say that it's actually like all the data carriers we have today. Where you know, okay, the DVD might somehow keep for another ten years, but then ...

Sure, but that's of course a fundamental problem of art history.

That you study Dutch still life paintings, and you painstakingly try to work out exactly which object is tied to which allegories or which literary sources. Back then they also had extremely elaborated systems of meaning that we don't understand so much anymore. And nevertheless I can go into the ethnographical museum, for example, and look at an Indian miniature painting or Mayan sculptures—I certainly don't perceive them as the people created them intended, and nevertheless something gets across. Maybe I'm being really naive here, but I don't think it's so important that the thing conveyed is same exact thing that the person that made it intended. More important, perhaps, is a kind of intensity or horizon of experience. And there again that has a lot to do with the human ability to feel empathy. I don't think it's relevant if I know exactly which element means what on a Mayan sculpture, exactly which God was being appealed to. Even if I knew, I would never really be able to comprehend what was going on there. But that's why I still can't just leave them to the scholars.

Would it be important to you to be able to touch them as well?

You can. If you go to Mexico, for example, and crawl around on one of those temples, then it is something different than standing in a museum in front of a vitrine.

There are two directions. The first is that you wish you had an even more direct transfer of information, one that no longer needs the information carrier. And the other is to the contrary, that you wish for a more direct handling of materials. But you could actually do both. Maybe the future is exactly that.

I think the best would be if someone would—in my lifetime, please—develop a method for migrating my brain to a less fragile medium. [*Laughs*] But I always think if that really were to happen, then it would actually prove that everything here is only a construct anyway. Because it would just be too much of a coincidence that that would be developed in my lifetime.

There's the simulation stochastics. If we—this is the Nick Bostrom argument—are ever in a position to transfer the brain in all its complexity to a digital data carrier, then probably we could do it not only once but billions and trillions of times. In other words, if we are at exactly the point where we could do it, how likely is it then, dammit, that we

are already a simulation.

> Exactly. [*Laughs*] But the chances of that happening in my life-
> time aren't so good. If it did work out, I think it would have to be
> in another two generations or so.

But that doesn't change the likelihood of it happening. As soon as you
see that it is possible ...

> You could also enclose these new thought machines in bodies
> that look completely different from ours. That are much more
> beautiful or much more functional and above all live much
> longer and never get any diseases, etcetera.➡ Genesis and Lady Jaye
> Breyer P-Orridge, 183. But if there continued to be human beings, the
> branch of art that actually concerns itself with material things
> could become important again, with the sense of touch or the
> communication of very individual experiences. It could lead to
> things that are made by hand becoming a lot more important
> again; that at some point you just disengage. I think in the fu-
> ture art can continue to expand in different areas of society,
> which is already happening now. This morning at the academy
> in Weißensee, for example, we had a talk by Ute Meta Bauer,
> who is applying to be president of the school. And she talked
> about how production design, information technologies, and
> artists work together at MIT. And from that comes a lot of so-
> cially relevant and also technology-enthusiastic artworks, like
> plantable caravans or especially prettily shaped electric cars
> that you can stack on top of each other. In other words, where
> the artist basically becomes a worker for the industry, but in
> the best sense of the word. The same way big companies also
> have mini-laboratories now, where they do nothing but develop
> things for which no one has any immediate use. Because they
> know that in ten years this crazy idea might turn out to be the
> product that then becomes a total success. That is certainly a
> whole area unto itself, that art becomes some kind of cutting-
> edge future innovator, because there are these people that
> somehow think outside of the box. I basically see socially criti-
> cal art as part of the same area.➡ Boris Groys, 230. It doesn't lay
> the groundwork for the capitalist machine, but for the political
> machine. This whole vehicle moves clumsily along by way of
> division, correction, division, correction, but somehow it goes
> forwards or sideways. Like an amoeba, the system pulls over

this foreign body that's developed there, assimilates it, encloses it, encases it, forms it into an elegant little granule, and then it moves on. But what I mean with this individual experience is like in the old Japanese culture, for example, the way cherry blossoms were depicted or perceived, and the cherry blossom festival is there not only to mark the beginning of spring, but also so that people really go there to have an aesthetic experience. And that you basically can afford this pure aesthetic experience even more if you're unemployed anyway. That you can really devote more time to making things that make you happy. I can't imagine that with the probably 20,000 years humanity has adorned their weapons, clothes, pillows, furniture, and buildings, investing an unbelievable amount of time in the process, that this impulse to appropriate the things that surround us will just disappear. With it, you also mark your territory—that is my personal dress, I embellished it, *only* I embellished it like that. There are patterns you can copy, but everyone does their own version. I could imagine that coming up again if the people have much, much more free time on their hands.

Damien Hirst

ART OUT OF PEOPLE
THE FIRST ONE BILLION DOLLAR ARTWORK
ONE-HIT WONDER

*Haunch of Venison, Berlin. The gallery, owned by Christie's auction house, is showing an exhibition of Damien Hirst's (*1965) greatest hits: vitrines with pill cases and surgical instruments, rotting meat being circled by buzzing flies, and some halved mammals in formaldehyde. Hirst is wearing several skull rings and blue-tinted glasses from Prada Sport. Standing on the balustrade before the interview, he raises his arm in a Hitler salute. Hirst is the first I tell of my plans to create an epic work of art. As silly as he may seem today, he did author several key works of the 1990s; in the 2000s he turned the selling of art into an art in its own right.* ➡ Gregor Jansen, 120. *The exhibition opening starts just after the interview. When Hirst notices that we are still filming him, he shows London gallerist Jay Jopling his bare ass.*

What do you think of the work of Gunther von Hagens?

Oh yeah, "Body Worlds." The guy who looks like Beuys. I went to see that show.

It's a weird process. The thing is called plastination, isn't it?

He invented it.

It's a brilliant process. There are three or four pieces which are just mind blowing. I mean a lot of people say to me, why don't you use people? And I always think, you don't use people because it's either not shocking or it's too shocking. Even though you know they are real people, it's very hard to believe it. The pieces with tattoos are amazing, because they give it a sort of reality and it sort of shocks you and you go, this used to be somebody. And then those smoker's lungs, you think it's how

they were. That guy on the horse is a great one. And I often
thought about that, because in order to be able to exhibit it to
the public, you have to say, it's science rather than art. This is
educational. That's the way he gets away with it.

I heard this rumor, when you came up with the shark—it was probably
just a joke—that you said, when my grandma dies, I will put her in a
vitrine.

I think years ago maybe I said … I kind of remember.

To work with human corpses is taboo for you?

It's not a taboo. I'm interested in getting people to feel things.
And I love art. Anyway, there is no limit to what you can do. I
have got many ideas that involve humans. An idea I still think
about is a piece called *Creation Explained*, which was a man
and woman fucking cut in half, with the penis inside the vagina,
like you could actually see it and walk around. I thought that'd
be a great object and a brilliant thing to do. But I think what I
want people to look at, they can't look at because you've cut a

man and woman in half. It won't go beyond that. So if people go in there and go, oh my God! And you got all the newspapers, they will go, shock! Horror! People cut in half! Guy using people! And what I want them to look at is something else.

Maybe we just have to get used to it. You know, after a while …

I mean, if people were used to it, I'd probably do it.

Where is the border? Could you do an ape?

There are no borders. I mean, I did that when I put a rotting cow's head in the middle of a gallery. But like 90 percent of the people, after a week, wouldn't come in the gallery. So, it defeats the object.

But there *is* a rotting cow head in the show.

Yeah. But it's not a real one, is it?

It looks pretty real.

Yeah, it looks real.

It's not real?

No.

You faked it—but why?

Why is it not real?

Yeah.

There are no drugs in that [*points to one of his* Medicine Cabinets], either. They are empty. I always think art is more … there is something theatrical about it. If it looks real in an artwork, that's all you need to do. If it looks real, it is real. In real life things smell. That's why paintings are good.

The flies in your show smell as well.

Yeah, it's a balancing act.

It's a really intense smell and I like it.

You like it? Great. I'll send you some. You have a toilet in your house that flushes, don't you? It does flush?

[*Laughs*] Yes. But I know those toilets that don't flush from the countryside …

[*Laughs*]

… and they have a nice smell as well, I think.

Yeah, but what about just having it in the room? I don't know.

If one can afford an artwork of yours, it shouldn't really be a problem to have an extra room for the smell.

> I made an ashtray once, which is like eight foot, and it is filled with real-sized cigarette butts. You walk in the gallery, and it smells like the worst party you've ever been to in your life— but the morning after! And I don't want you to think that. I want you to be seduced by it from a distance. I mean, to look at it and go, wow! That looks interesting! And then, when you get to it, I want you to go, urghhh! So there's a level of smell that you want to achieve.

What is your prediction? When will there be the first one billion dollar art piece?

> [*Laughs*] Fuck knows! It's bound to be an old person. Maybe it's already happened.

In what sense did it already happen?

> Wasn't there talk that maybe Greece was gonna have to sell the ... Pergamon? Not the Pergamon, that's here! It was the prime minister saying that Greece should sell the Parthenon, wasn't it?

I mean of a living artist.

> Well, I don't think that will ever happen. Not with a living art-ist. But then, that raises the question: if we said in twenty-five years, when it will be an artist you never heard of, then your question will be, what about a trillion? But I think you're not going to get that. It's a lot of money.

Maybe it's just a question of size and you just have to make an artwork that is big enough. Then the price will be just adequate.

> I'd imagine it goes just the other way. I'd imagine it'd have to be really small. Like a diamond.

I remember, you had that ...

> What's the most expensive material in the world?

I think the radioactive ...

> Plutonium!

Plutonium or polonium. When they killed the guy in London ...

> Well, let's make something out of that.

You know, the German secret service, they once bought plutonium.

How much of that?

Just a few grams. And it was amazing—to buy enough plutonium to build a bomb, it cost something on the black market like 800 million euros. So you're pretty close to one billion. Just to get enough plutonium.

So, great! If you get just two of those and sign them, there is your work. Don't invite me to the opening, however, without a suit. I need the suit.

Imagine me, I'm forty years old, I'm a writer and I would consider becoming a really famous artist. What would I have to do? Would I have any chance or am I too old?

You want to be famous for art, though? I mean, you could be a famous artist if you kill the Queen. Or do you want to be famous for making art?

Yeah, let's say I shouldn't get imprisoned for it. And not kill myself.

If you make great art, you stand quite a good chance. Go for it!

Is it possible, given how the market works, that I could make it with just one artwork? Or is it necessary that I make an amount of works?

There are all levels of fame out there. I mean, there are a lot of musicians out there who've done one-hit wonders. I've read an interview with the guy who did "Spirit in the Sky." That was a brilliant song.

Doctor and the Medics? It was only a cover version.

Yeah. But he said, I've got one hit and it was brilliant. He said, I've got one hit, "Spirit in the Sky." We play it. He said, I don't care, because some people have *no* hits! And I've got one. I did a gig in Denmark, recently. But we did "Spirit in the Sky," ten times, he said, and they still had three encores.

What do you think about the digitalization of more and more parts of life? Will this affect the art world in the twenty-first century? Could you imagine building an intelligent artwork?

You mean, like if you made a painting, that if you said, "What do *you* represent?" it would say, "What do you represent?" back to you? Let's make one. Or a half-finished artwork that every time you try to touch it, says, "don't even think about it."

Creation

Gregor Jansen

COLLECTOR PRINCES
AN ARTWORK FOR THE
TWENTY-SECOND CENTURY
TETRIS

Tell me about how you got into art.

I'm from the Krefeld area in Germany. My father worked at a textile factory. Actually I was always more on the natural sciences track—I did math and physics for my university entrance exams and planned on getting into computer science until I was about sixteen or seventeen. Then I had an accident and ended up lying in a hospital for a pretty long time, and it was through these kinds of rest periods, phases of reflection, and a rock-climbing friend from Krefeld, that I got a knack for art history.

*Gregor Jansen (*1965) is director of Kunsthalle Düsseldorf. I have known him since 2005, when he was the curator in charge of a residency program sponsored by the German Federal Cultural Foundation in Beijing. It was in Beijing that I started writing the book* Umbauland, *and first drafted the Great Pyramid—a gradually growing burial place for potentially everyone on the planet. Jansen suggests I begin my search for the future of art precisely there.*

And what interested you about it?

I was actually fascinated with it on the same level that had interested me about mathematics: How do I find a beautiful solution? How do I solve a problem that previously held no significance for *me*—Gregor Jansen, the person—whatsoever?➡Tobias Rehberger, 248. And in that, there is suddenly this significance. That it is some-

thing that ultimately represents power or has a power function.

What was your first project as a curator?

The Ludwig Forum in Aachen opened in 1991, and the director at that time asked our professor if the art history department wouldn't be interested in curating a show for the opening. It's easy to forget now, but back then there were hardly any private collectors. Okay, maybe it wasn't all that extreme in '91, but the Ludwig Forum opening really was a great thing. So we, as very young students—the show was called "Von gleich zu gleich"—invited students from the Düsseldorf academy to do an exhibition with us.

You say there were hardly any private collectors back then—that's changed quite a bit.

Yes, they were around, but there was none of this public recognition or hype and feuilletonistic ranting about collectors. One collected quietly, enjoyed his or her own rooms, but there wasn't this need to open a showroom or a huge hall, assume these museal dimensions. ➡ Harald Falckenberg, 73; and Thomas Olbricht, 145. That only happened with Ingvild Goetz. Her Herzog & de Meuron building in 1993 ... that was a kind of break.

But later on, they started donating to museums after all?

Sure, private collectors have always loaned things to museums, whether it's for exhibitions or permanent or long-term presentations, which, I believe, has a lot to do with tax law. Which is why there are many cooperations with private collectors willing to loan work for ten years or more. ➡ Harald Falckenberg, 83.

How do you explain this urge collectors have to make their own collection public?

Yeah, what kind of an urge is that? For me it means a regression to absolutist forms. I, as a prince, spread my personal territory out into the public and shall be courted accordingly—whether it's through media, friends, colleagues, or also politics—and provide an added value to the infrastructure of a certain region. You can let yourself shine, in the art sense. Peter Ludwig is really a tough phenomenon in that respect. The Museum Ludwig in Cologne emerged from his Picasso donation to the city. It used to be the Wallraf-Richartz-Museum, but with his donations, Ludwig managed to chase Wallraf Richartz off. Nowadays,

Peter Ludwig would set up his own Museum Ludwig in Cologne. He wouldn't be giving Picassos at all—he would write his name over some similar thing and keep the stuff for himself.

Whatever real estate he builds also remains his property. Everything.

That's why I keep saying we forget these things so quickly, but it's really only in the past fifteen years that this has become hype. What was once the glamour or whatever of the fashion world now belongs to the art world. ➡ Philomene Magers, 69.

You could also say the reverse is true: how is it then if you collect all this art, collect all these treasures, and then just put them in storage where no one sees them?

That's the question. A lot of people say collecting only begins when I can no longer show everything I have. But today you just go and build a showroom. There's also something dealeresque about it in my opinion. Giving up artworks was completely frowned upon ten years ago, I would say. A private collector didn't do that. He—as Wilhelm Schürmann so nicely put it—had

to stand by his mispurchases for the rest of his life. Today, a private collector is someone that actively intervenes in the market, who works with gallerists to build up artists that they then offload the minute they become expensive, because he or she can then go on and build something new.

How do you explain the growing interest in art?

Art really has become a mass phenomenon. That's just our event culture. ➡ Harald Falckenberg, 78. Someone came up with these Long Night of the Museums eight or nine years ago; in Düsseldorf we have about 50,000 people come in on this one night, people that really push themselves through these buildings, get pushed but never see art. You want to take part in this event, you *have* to be part of the gallery tours, I *have* to go to documenta, I really *have* to have seen the Olbricht collection. Those things start to sell themselves. Wherever a lot of people are standing together, that's where a lot of people seem to feel comfortable.

People used to go to a bar. There are fewer and fewer bars, so now they go to openings?

So it would seem. [*Laughs*] It's buzzing. The bigger events keep growing in number. I think there were only four biennials in the world until about twenty years ago, now there are 200. Who can even see all this output any more? All of them are struggles, efforts, and also goals, hopes, utopias, desires. Who can take it all in? Comprehend it? Is anyone concerned with content anymore? I think it is actually only about the social component, by and large.

I just met this artist, Gabriel von Loebell. How did he get into art? He went to a lot of openings. Stood around there, there were drinks for free. He hit it off with a few artists who happened to be Gelitin, and now he's an artist. ➡ Gabriel von Loebell, 58.

Sure, why not? My professor says the reason he got into art was because he could look at pictures of naked people with no inhibitions whatsoever. He studied in the 1950s and that was the allure for him. But he is a very brilliant art historian. I mean, on the other hand, we also profit from this boom, from all of this interest, this money that's being pumped into it. But then again we—as institution people that naturally should/have to/ want to uphold a certain independence—are the victims and

also somewhat of the bores of the industry. So when someone like Christian Boros brazenly says, I feel sorry for every museum man because he can't buy what he wants whereas I can just go and buy forty Elizabeth Peytons. I mean, that really is brazen, right? But it's also true. Of course he can do what he wants with his money. We're not allowed to do that. We can offer an attractive program, but it's never our own money. It never has this authenticity, this automatic credibility a private collector has because he puts his own money into it.

But that's also why you're not suspected of speculating.

Exactly.

Does the money for the Kunsthalle Düsseldorf come from the city?

Yes, it is well endowed. There is an annual budget of more than 300,000 euros set aside for exhibitions. But one problem, for example, is that the insured value of artworks has massively, exponentially increased in recent years, almost ten times what it used to be. � Friedrich Petzel, 201. The lenders are often private collectors. I can't imagine they have their work insured for so much, but you can be sure they'll have it insured for millions the second they hand it over to a public institution, without batting an eye. The cost is immense. My predecessor could still put on, say, ten exhibitions a year. For me, that will probably boil down to four because I don't have the budget to do any more. Of course, these days you also rely on catalogues, which are supposed to have a lasting value. You don't do these nice little booklets anymore or just quickly throw some catalogue together—now they're coffee table books with hundreds of pages. You have to have a lot of staff, a lot of money, if you want something like that. And if I want to do something like that, I can only do so by generating sponsorship or aid money.

We are currently experiencing enormous technical development, which results in more and more areas of life becoming digitalized. Could you imagine art moving to the Internet sometime in the near or mid-future?

Puh. Hard to imagine. Because there isn't any art on television, there isn't any art on the telephone, either. There are formats, of course. You could make a screensaver. That could be art, why not? ➡Olafur Eliasson, 38. That depends on me, whether or not I market it as a limited edition and with that also put an art term

behind it. There will be art for the iPhone, too. ➡ Hans Ulrich Obrist, 139. We've seen it already: the first artwork anyone saw on a computer screen consisted of black and white bars. And that looks different today, because media art, of course, also works through these innovations. Like a new toy: I'll play around with that, I'll test that, and try that out and see a lot of bright colors, but it loses its appeal pretty quickly. Or today I'll see computer art, its very beginnings, as a historical document. But I can hardly see that that as being especially appealing, aesthetically speaking. Who's talking about Bill Viola anymore, for example? Is anyone really looking at that work anymore? Or will I, as an exhibition maker, be needing these pieces at some point, if only to show people, look *that* was relevant media art in 1980, '90.

So does good art have to be lo-fi? Is this the time to be making art with Atari computers for example, because then no one would suspect you of being innovative?

Right. Yes, that's what I think.

Now light bulbs.

Yes! Now light bulbs. ➡ Philomene Magers, 66. Working lo-fi is indeed more difficult because it can concentrate more on the matter at hand. On the other hand, of course, you can stand spellbound in front of one of Andreas Gursky's latest works, these satellite montages, and feel like God. You can say, wow, that is only possible with advanced technology. Before that, painters or who-knows-what would have had to dream it up on their own or risk their lives in a balloon to gain the necessary distance to earth. Now I just sit at my desk and make the pictures.

If you look at the development of artificial intelligence, robot research—what if machines become smarter than we are?

Yeah, that's the question. Honestly I don't dare to picture it. As far as today is concerned, I don't see it as a development that makes much sense. But who knows. I am thinking about a robot exhibition now, to be honest. These various automatization processes are also part of creative ones. Then comes the question, what is the creative process? How do artists deal with the most uncreative things, the controlled processes of an assembly line? These employ robots because they are cleaner and more effective workers. But they could also be used on another level,

one that produces something very different, maybe unproductive—something art can always afford to do.

You talked about how your interest in art stemmed from mathematical thought—from the search for solutions. I feel the same way when I think about art. And what I came up with is that I'll have to think of a really big conundrum for me to solve, because I don't see it in the art that exists right now. And that is to create an artwork that will continue to be relevant beyond the twenty-first century. ➡ Boris Groys, 216. Just like Michelangelo's David will probably still be there and still be appreciated the same way it is today, even by people that have long been optimized and are much, much smarter than we are. One that can still somehow be appreciated as a kind of primitive art form handed down from their ancestors.

So basically you're looking for a recipe that will guarantee that you remain famous—and not just for fifteen minutes.

These days you can surely make it fifteen years; that's pretty maneuverable. But how do you get beyond that? It isn't enough to be as good as Michelangelo; more than anything you also have to do something new. Variation doesn't cut it. That's how the art world works today, that you do an incredible amount of variation of modern standards.

That, I believe, is a problem that began with postmodernism, or anyway the revision of the modern age. I expect nothing new from art. Takashi Murakami really clarified that for me in his *Superflat Manifesto* when he said, we're always looking for the newest things. But we also like to be taken for a fool. We see a great accomplishment in the way of media transfer and right away we think it's something new, just because it's faster, more colorful, more beautiful, or because suddenly there's a variation. I think we're still on the level of variations. I also think we're never going to get away from it.

Never?

I don't believe so, no.

What's never? Until humanity is extinct? Or what period of time are you thinking about?

Yeah. [*Laughs*] So long as we can still produce something. No, not like that. At some point there will probably be a shift in the way people think about it, too. The frontier that was crossed when photography was suddenly 100 percent accepted as an

art medium—same with video—really a revolution. That also changed exhibitions. Before that, the only time I had to go into dark rooms to see images was at the graphics cabinet. Now I have to go into a dark room to see a video with any kind of quality. The black-box routine. And that of course also changes the architecture of an exhibition; it changes the perception of space. Alfons Hug recently did a show at the Akademie der Künste in Berlin where he showed around eighteen videos, all of them running at the same time, all of them with sound. It was about natural disasters. Gorgeous. I have never seen that before. Where everyone would say, you can't do that—that's horrible, eighteen videos playing at once. And it works! It is a wonderful spatial situation that is completely new to me. But then again, you could also say that it's just the salon-style way of hanging pictures. And that's where I always end up. I could say, it's new to me. But when I'm honest, it's also just another variation. Just like it was new, of course, when Damien Hirst ➡Damien Hirst, 105. encrusted a skull with all those jewels (*For the Love of God*, 2007). But there I'd also have to say, a variation on the cabinet of curiosities, this is a *vanitas* but with an appreciation of value nevertheless and blah blah. ➡Thomas Olbricht, 150. I am always doing the variations routine. Still I can manage to open up something new with this skull, for example, because suddenly I'm on the cover of all the magazines all over the world. *That* is new. The skull isn't at all. Or maybe the kind of power behind it is new—that I have to pull a consortium together to finance the thing.

Nah, it bought it.

[*Laughs*] Yeah, but Hirst belongs to the consortium as well. Something like that is new. Or the auction where he sold work directly from his studio ... all of that is new and of course also conceptual thought. Then again you could say conceptual art is still maybe the most radical in the way of innovation. Nothing will ever be new again—of course that isn't true. But I think this variation thing is so dominant that we'll never get out of it.

So now I'm going to look at the twentieth century as a dilettante, a non-art historian. I'm blinking and looking around at whatever milestones there are. I see Malevich's *Black Square* (1915), I see Duchamp. Then there's conceptual and performance stuff. Then I pretty much see to the end ...

But don't you see Eisenstein's *Battleship Potemkin* (1925), for example? That's cinema of course, but it's also crazy what happened there and what it meant for art. A black square is simple, I'd say, an icon, but the real innovation came from cinema. And to this day, cinema hasn't made it to the museums.

Black Square was also only part of the backdrop for the opera *Victory Over the Sun* (1913). *Black Square* was actually the dungeon for the sun.

But then I could also go back to the seventeenth century, when Robert Fludd packs the black square into his cosmology and says, that was the beginning of the world. So is Malevich actually a variation on Fludd, an innovation in stage design, or am I suddenly pulling life into a ...? Because it was actually also a painted-over Madonna, in other words a sacred image, etcetera. And that's where it gets interesting.

So, now we're at the end of the century. You just mentioned Damien Hirst—actually started by Andy Warhol and over Jeff Koons. There I see the reflection or play on capitalistic rules—especially when it comes to the specific rules of selling unique artworks. Namely that only two people have to want something if the price is to become astronomical. ➡Philomene Magers, 65; and Hans Georg Wagner, 274.

Would have to be two really rich people, though! [*Laughs*]

I can be just completely overwhelmed by art, but there is also this analytical approach that draws me in in a different way and where I can suddenly imagine creating an artwork myself.

And I don't think it will work. You know this from being a student, these nightlong discussions—what do you want to do with your degree? And at some point I also thought, I could be an artist. Because it's really easy. I'll just go and make art. I'll define whatever it is I am doing as art or I'll just get started. I don't even have to do the painting myself anymore. I can tell a painter what he should paint. And I think if you don't do whatever it is you want to do, then all that analysis is for nothing. Of course, everyone has an analytical approach to things, but artists that only approach things in an analytical way never get very far with it. They make it to the conceptual level just fine. But if you take a purely analytical approach to making yourself immortal, even while you're still alive, or prepare for these hundred years—I

think it's preposterous. You're living now and have to do that now and you want to make a difference. And whether or not your kids or grandkids think all that is great shouldn't be the issue.

Then I'd say that is just another one of the riddle's constraints.

No!

Yes! The other constraint is that it has to be important to me.

[*Pause*] All right. Okay.

And I can't just go and do that with some nonsense.

No, but you did it yourself. Your Great Pyramid ➡ Appendix, 303. is a great idea. It's also only a variation on the old tombs in Egypt. There I could say, all right, it's nothing new. But the fact that you had it there, in that place and with that background … there you could say, okay, that thing—who knows if it will ever be built or not—but as an idea and in terms of the way it was formulated, it really is great. And whether or not that will be important in a hundred years also depends a little bit on whether someone at some point will put on a big exhibition, or pull out the Ingo Niermann concept or who knows what. At some point you have no more control over that. Of course, you could always think of a clever strategy as to who you do that with, who writes about it and so on. That's where you lay the groundwork. And then, of course, you'll have to do another pyramid project right away, so that your name … and on and on. You can set it all up like that. And it would work for your lifetime. But we're talking about these hundred years.

I was also thinking about the pyramid. It has to be built.

Yeah, break a leg! [*Laughs*] I think it's great.

It has to be built as an artwork, which means by a collector.

Why a collector? Because they're the only ones left with money or what?

Because they're the ones with the necessary funds; because they are prepared to execute it according to my instructions. That way, I can escape all the underlying capitalist pressures that would be there oth-

The Great Pyramid in situ, rendering by René Eisfeld, 2007.

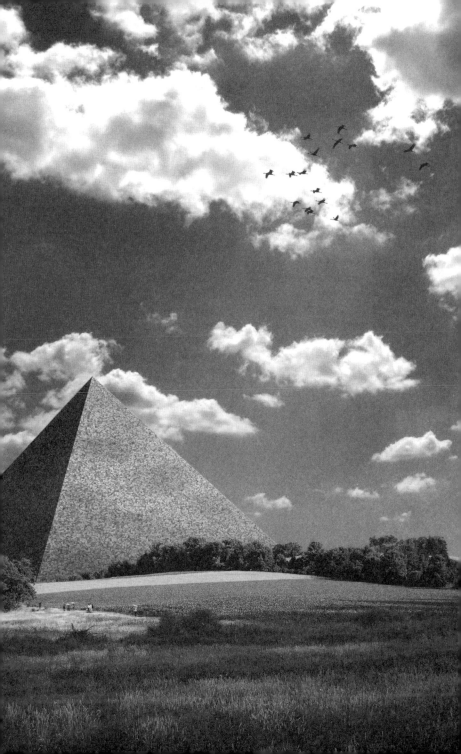

erwise. Where there's almost a masochistic element on the part of the collector. He submits himself to rigid conditions and it makes the work even more valuable. All of these collectors and their curating and building of museums, all of it goes to show that to them, accumulating art just isn't enough anymore.

But why did they do it before? That was actually the selling of indulgences. They knew if they had it, they'd spend fewer years in purgatory. [*Laughs*]

That's why they collected art?

No. But that's why they put up a lot of money, so the church could commission art. Or eventually the prince, of course. In that sense, it's as you said already, they want to live on, virtually, after their death. And you can only do that if you have a good court that would also produce art, art that you know will last. So I have to get the best people. Which means, you *now* have to give the collector a promise of salvation, one that they couldn't get anywhere else. That would have to be your strategy.

That's already inherent in the Great Pyramid.

But then there's this thing: is the pyramid new or is it a variation on the Egyptian tombs? [*Pause*] We're really going to have to start thinking strategically about that one. Because then you really get to the question, how can I do it then? In other words, it's like an architect would maybe proceed and say, actually everything is getting in the way. I can't do a lightweight construction because the structural engineer says it has to be earthquake proof, and I can't do anything great with the room structure because there have to be fire escapes and all that crap. That's how you would have to proceed. That's how everyone with an objective goes about it. They'd have to weigh the pros and cons or develop strategies, approach sponsors. So then it's not all that different from my job.

No, the collector has to do it.

Fine, if you even find a collector.

But we were talking about something else, namely the question, is the Great Pyramid only a variation? And I don't think so. It contains this idea of the infinite, that more and more people can be buried there, that it continues to grow, that it is no longer a limited structure and has no target size. That alone makes it a radically new idea for a three-

dimensional object—not just in art, but in architecture as well.

Hmm.

The problem I have, though, if you think about a structure that continues to grow infinitely—assuming the pyramid becomes a total success (everyone wants to be buried there)—but at some point the collector runs out of money. He might be able to set one hundred thousand tombstones, maybe even a million, but once he gets to ten million, he runs out of money. Or I start off by limiting the circle of buyers *so much* that I would say, for this work of art, at least one or even ten billion dollars will have to go to a foundation. And even then the foundation could run out of money because of inflation and so on.

> I'm going to be mean now and ask you, is it about the artwork for you? Meaning the pyramid as such? Or is it more about this mass effect? Because the fact that there could be a pyramid for all of humanity is a very social concept. But an artwork is rarely social. Why should this social utopia, you could almost say, find a collector to finance it as an artwork by Ingo Niermann?

You could also think of the pyramid as cynical because it says, all human beings are the same, but only once they are dead. Actually it only realizes that old, laconic saying: in death, we are all the same. And that will be financed by a collector, of all people. But if you say art is never social, then I say, yippee, so I've invented something new! Finally a work of art that is truly social. There is a huge amount of art that flirts with the idea of being leftist, where participation takes place on a micro-level and remains irrelevant to society at large. ➡ Boris Groys, 230; Antje Majewski, 102; and Gabriel von Loebell, 51.

> No, what was behind it for me was the fact that art is actually a gesture of authority. I can undermine this, I can take it apart, I can look for other locations. But in the end—once it's comes back into the system and is perceived as such—there's no getting it out of the loop. [*Pause*] But going back, would a social vision of a tomb for all ... let me put it more idyllically: I could set up a country park where anyone can be buried. And the park is designed by artist X and the premises belongs to farmer Y. And anyone wanting to be buried there will pay the usual burial fees or less. I underbid every funeral home. So it would have to be a success, because dying is expensive.

It has to be free. That's the point.

Fine, it could even be free.

For me, the thing that's critical to the idea of the Great Pyramid is this notion of the infinite. The infinite tomb. The base of which grows slower and slower as it increases in size. The problem with the field is also, what happens when humanity is no more?

> But no one cares. Do you believe in reincarnation or why should the pyramid ... ?

Not at all.

> Because the Egyptians believed in it. Actually it was about a transformation into another life. That's why I think if you don't believe in it, you don't really need a pyramid, either. Then the idea of decomposing is much nicer after all. That there is art that is *not* forever, that there are also aging processes, and that I—as opposed to restaurateurs—will have to say farewell to a work of art.

Nothing is forever. Even the Egyptian pyramids aren't forever. They were also built during a lifetime. They were there to impress—even while the pharaoh was still alive.

> Yes, but only as a memento mori in the desert. They had nothing to do with life.

People knew they were there. You could go there, you could see them. Think of all the workers that toiled there and experienced how the pharaoh could wrest this monument from their sweat.

> We built cathedrals. Today we build museums. That is also a social accomplishment. What I don't see is why we can't also do this last farewell. It would be nice if the pyramid were like a game of Tetris ... the lowest layer would sink down into the field. That means it wouldn't be infinite, it would just disappear. And if there aren't enough people dying that want to go into this pyramid, maybe at some point you'll be standing up there on the field and you know, like in Walter de Maria's *Vertical Earth Kilometer* (1977)—so and so many people are resting down there in that pyramid form. I'd think that would be more beautiful than if you still had this symbol. But there's no way you could manage that, of course. You can't push a pyramid shape into the ground. [*Laughs*] But like I said, the idea and project as such are beautiful.

Hans Ulrich Obrist

EXPANDED CURATOR
THE ART WORLD AS SALON
THE FOUND PYRAMID

*Private archive, Berlin. The smell of dusty books. They're oozing out of book-
shelves and cardboard boxes all over the five-room apartment, leaving only
narrow passageways to walk through. It is pouring rain when we meet
Hans Ulrich Obrist (*1968) for the interview. He has come down with
a combination of a cold and allergies. At several points in the inter-
view, he asks if we can take a short break. Obrist is co-director
of the Serpentine Gallery in London, has published count-
less books and is considered one of the most influential
curators in the world. At the time of the interview,* Art
Review *magazine had placed him at number one on
their list of the one hundred most powerful art
world figures.*

The apartment we're
sitting in now, how long
have you had it?

I live in London. Most of
my work revolves around
there because of my job as co-director of the Serpentine Gal-
lery. My books—I have around 20,000 books—were always at
the university in Lüneburg. The idea was to make it so that
students use my archive as well. Then we did *Interarchiv*
(1997–9), this project with Hans-Peter Feldmann, where my
archive was connected to several other archives. This whole
discussion surrounding the archive is a very important one in
the current course of the twenty-first century. Time capsules.
Protest against forgetting. As Rem Koolhaas also said, maybe
the amnesia at the very center of it can also be found in the
digital age. The fact that more and more information is being
produced doesn't necessarily mean that more memory is being

produced. And that is why I think so many artists and curators are interested in the idea of the archive. We dealt with it very playfully at Lüneburg University. Hans-Peter Feldmann organized the books by color, by weight, by smell—a little in the Aby Warburgian sense. In other words, there were also panels with all the contents of the various boxes—all of them were in these cardboard banana boxes—spread out. And then at some point there was a new president at Lüneburg University. I think he was from McKinsey. And the first thing that was decided was that my archive had to go, because using a room for books no longer fulfilled standards of efficiency at this new university. I think it was turned into an office, and I looked for an apartment as an emergency solution. Since then, this has been the place that I write, the place books are made, the place I retreat to from time to time. But mostly it's the books that live here.

So you probably already have a huge library in London as well?

Yes, of course. If you keep moving ... I lived in Paris, then in Rome, then in Paris again, then in London, then in Paris again. And every time I start out with no books and soon the entire apartment is filled with books again. These archives exist in all kinds of cities. And the idea is, could they be combined at some point?

So every time you leave a city, you leave your archive there?

They're also archives on the move. As you can see here, the books are very often in banana boxes, and that has to do with movement. The archive is neither here nor there. It's the inter-archive.

You never really lived in Berlin, did you?

I was often here in 1998, when we were doing the Berlin Biennale. The first Berlin Biennale with Nancy Spector, Klaus Biesenbach. That was a situation where we, along with Jens Hoffmann, visited quite a lot of studios—hundreds of studios all over the city. It really was a kind of mapping. The biennial was called "Berlin Berlin." And that's really what it was about. It was plotting a map of Berlin, a cartography. I did actually spend a lot of time here then. I have been back many times, but never for any length of time. It's a place where a lot of the artists I work with live. But these days, the avant-gardes are everywhere. Or

artists, I should say, are everywhere. We have a real polyphony of centers. We have an especially large number of new centers in the east, in the south. Brazil has an incredible art scene; Argentina has an incredible art scene. There are the most unbelievable art scenes in Asia between China, Korea, Japan. Beirut, Teheran, and Cairo all have very important art scenes. There are the Emirates; Istanbul is also a real center. And that list is nowhere near exhaustive. It's almost like a polyphonic novel. There's no longer just this one character. There's no longer just this one city. You could say that all of it is very time intensive. And there is relatively little time left to come back here and write, which was always the idea.

How do you think this polyphony will continue? Think twenty, thirty, forty, fifty years ahead.

I never went in for futurism. Artists define the art of their time, as the saying goes. I think it's very problematic when curators start speculating on what the art of the future looks like.

I'm asking about the art world, the whole system. Do you think at some point there will be fewer biennials again? Or something else will come up besides museums, biennials, galleries?

The problem with institutions is often that we don't know how the art of the future will be. When we build a building, the building often dictates what can or cannot happen in there. That is the big problem of architecture. That's why there were these big projects in the 1960s—Fun Palace by Cedric Price, Yona Friedman's museum ideas—which had to do with considering ways that a museum could be flexible, how a museum could be open to the possibilities of art, also in the future. People ask me again and again, what about the future? The future of the museum? At some point I started asking the artists, what is the future? That's one of these projects I often do—what is the formula for the twenty-first century? What are maps for the twenty-first century? We started this list three or four years ago. Perhaps I can read it to you.

Rirkrit Tiravanija says: The future will be chrome.
The future will be curved, says Olafur Eliasson.
The future will be in the name of the future, Anri Sala.
Tino Sehgal: The future will be so subjective.
Douglas Gordon: The future will be bouclette.
Nico Dockx: The future will be curious.
Tacita Dean: The future will be obsolete.
Pedro Reyes: The future will be asymmetric.
Cao Fei: The future will be a slap in the face.
Loris Gréaud: The future will be delayed.
Philippe Parreno: The future does not exist but in snapshots.
Dominique Gonzalez-Foerster: The future will be tropical.
Trisha Donnelly: Future? You must be mistaken.
Simryn Gill: The future will be overgrown and decayed.
John Baldessari: The future will be tense.
Hans-Peter Feldmann says: The future is delicious.
Carsten Höller quotes Helmut Kohl: The future is more important than freedom.
Matthew Barney: A future fuelled by human waste.
Paul Chan: The future is going nowhere without us.
Doug Aitken: The future is now—the future is it.
Tomas Saraceno: The future is one night, just look up.

Didier Fiuza Faustino: The future will be a remake.

Lawrence Weiner: The future is what we construct from what we remember of the past—the present is the time of instantaneous revelation.

Bruce Sterling: The future is this place at a different time.

Cory Doctorow: The future will be widely reproduced and distributed.

Jacque Fresco: The future will be whatever we make it.

Arto Lindsay: The future will involve splendor and poverty.

Immanuel Wallerstein: The future is uncertain because it will be what we make it.

Raqs Media Collective: The future is waiting—the future will be self-organized.

Nancy Spero: Dum Spero / While I breathe, I hope.

Jordan Wolfson: This is not the future.

Jacques Herzog & Pierre de Meuron: The future is a dog / l'avenier c'est la femme.

Hreinn Fridfinnsson: On its way; it was here yesterday.

Yang Fudong: The future will be an armchair strategist, the future will be like no snow on the broken bridge.

Martha Rosler: The future always flies under the radar.

Peter Doig: Suture that future.

Richard Hamilton quoting Shakespeare: Tomorrow, and tomorrow, and tomorrow.

Cerith Wyn Evans: The future is overrated.

David Askevold: The future is a large pharmacy with a memory deficit.

Tay Kheng Soon: The future will be bamboo.

Koo Jeong-A: The future will be ousss.

Vito Acconci: The future will be grains, particles & bits. The future will be ripples, waves & flow. The future will be mix, swarms, multitudes. The future will be the future we deserve but with some surprises, if only some of us take notice.

Allora & Calzadilla: In the future, the earth as a weapon.

Joseph Grigely & Amy Vogel: The future is our excuse.

Marlene Dumas: The future will be repeated.

Jimmie Durham: Okay, okay, I'll tell you about the future; but I am very busy right now; give me a couple of days more to finish some things and I'll get back to you.

Yung Ho Chang: Future is instant.

Zaha Hadid: The future is not.

Anton Vidokle: The future is private.

Liam Gillick: The future will be layered and inconsistent.

Matthew Ronay: The future is a piano wire in a pussy powering something important.

Daniel Birnbaum: In the future perhaps there will be no past.

Julieta Aranda: The future was.

Carolee Schneemann: The future is menace.

Molly Nesbit: The future is a forget-me-not.

Sarah Morris: The future is a knowing exchange of glances.

Walid Raad: The future: Scratching on things I could disavow.

Liu Ding: The future is our own wishful thinking.

Edouard Glissant: Le futur est un étoilement.

Maurizio Cattelan: The future is now.

Thomas Demand: The future has a silver lining.

Yona Friedman: The future is now and here.

Gilbert & George sent the future via fax. They were the only ones that did not send it by e-mail: The future? See you there! As artists we want to help to form our tomorrows. We have always believed in the past, present and future. It's going to be marvelous. Long live the future with lots of love always and always.

Damien Hirst: The future is without you.

Pierre Huyghe: The future is a season.

The future is a poster, by M/M.

We have repeated the future out of existence, Tom McCarthy.

Jonas Mekas: The future has two large beautiful eyes.

Stefano Boeri: Less, few tours in my future.

Huang Yong Ping: Future is what it is.

Grant Morrison: The future is the very few years we have remaining before all time becomes one time.

Jan Kaplicky: Future must be here, today.

Xu Zhen: My art is very free, I don't know what to do in the future. But I am positive.

Jia Zhangke: Future is more freedom.

Shumon Basar, Markus Miessen, Åbäke: The future is inside.

Thomas Hirschhorn: No future—punk is not death!

Morgan Fisher: The future will be grim if we don't do something about it.

Olafur Eliasson: The future is reflexive and coming together.
Shilpa Gupta: The future is listening.
Ann Lislegaard: The future lies in the unknown.
Peter Sloterdijk: What the future is, you only know next morning.
Peter Weibel: The future is a disease.

What is actually limiting art now? What do you think—how will art in the future, with all of its subsystems, define itself apart from the rest of the world?

Do you mean, whether or not there are limits anymore? Mario Merz always quotes the Vietnamese General Giap: what we gain in territories, we lose in concentration and vice versa. I think there's always this back and forth: wherever there is expansion, there is again the desire for concentration; where there is pure concentration, there will be a desire for expansion. The question of course is how all this linking and de-linking, networking and de-networking is going to continue. Paul Chan, one of the visionary artists of our time, always says, linking is great, but de-linking is sublime. A further point that might be important is that the expanded notion of art has also resulted in an expanded notion of the curator, which leads to the fact that art or curating is no longer limited to the white cube; it can happen in a number of different kinds of contexts. The question is how that will develop in the future. I think curating is almost the opposite of futurism. You curate the present and you curate the past. In this respect, your question about the future is an interesting one. What would it mean to curate the future? That is something I'm very interested in: as a possibility of impossibility.➡Boris Groys, 216. Erwin Panofsky shows us that we very often build the future out of fragments of the past. I think it is no coincidence that so many artists are working with archives at present. I believe that in the end, we will build the twenty-first century and the future out of fragments of the past. The fact that there is more and more information, the fact that we are more and more bombarded with information, the fact that we consume more information every day does not necessarily mean that we will create more memory—quite the opposite. To contribute to this resistance or protest this amnesia. But the archive is only one aspect of the art being produced today. You

also have this longing for non-media transmitted, directly conveyed experiences. Tino Sehgal's exhibition at the Guggenheim Museum in New York was one of the most influential shows of our decade. It has absolutely nothing to do with objects, there are only intersubjective experiences. ➡ Thomas Bayrle, 267. In that sense, you could say the twenty-first century is intersubjective. With Sehgal it's not about performance, it really is these intersubjective situations. Right now you can also observe another point: the generation that grew up with the Internet is also making heavier use of montage, fragmentation, disruption of the linearity of narrative and the time-space continuum. And that is also interesting because it isn't new, per se. ➡ Genesis and Lady Jaye Breyer P-Orridge, 177. All of this fragmentation is part of the history of the avant-garde. Only now it's suddenly a daily practice in the Internet. The twenty-first century is a polyphonous century. We have the shift to the south, the shift to the east. What we are seeing now is a very strong backlash to homogenization. But that does not mean it is a local battle of retreat. It will continue to be a global dialogue, though it may create a discrepancy. With a lot of artists you see daily life, local conflict again. Self-organization is also an important concept for the twenty-first century. Maybe there will be a renewed interest in political matters. It's interesting that the idea of social sculpture is coming up again.

You also attend a lot of scientific conferences and are active in fields that have very little to do with art. When scientists speak of the twenty-first century, something like the notion of singularity will come up. Sentiments like, we will be taken over by machines. Or, mankind is taking over itself, is optimizing itself. That would also have to take over art at some point. ➡ Genesis and Lady Jaye Breyer P-Orridge, 182.

Can you name a few examples from the sciences?

The sciences also have a lot of linear or exponential projections into the future. But they are also very aware of the fact that there will come a point—in twenty or thirty years according to Ray Kurzweil, for others maybe only in eighty or ninety years, but still in the twenty-first century—when everything will change radically. What that means is singularity: where there is this wall that we can't look behind because we're too dumb. Whereas the feeling in art, it seems to me, is more like, there was a lot of experimentation in the twentieth century. Many of these experiments can be continued, there are still blank spots on the

map, but it will stay pretty much within the confines of what was set up in the twentieth century.

So you think there's a paradigm shift in science?

Ray Kurzweil says that at some point, we will rule the universe.

[*Laughs*] I was just thinking about Kurzweil.

Either we or our successors will alter the solar system. The last level is influencing the constants of nature itself. It gets more and more cosmic. An interesting point of comparison is that there have been all of these expansions in art, but my feeling is that there's always either a spatial or a temporal barrier. There is no attempt to make art as big as possible. Damien Hirst systematically tried to make it very expensive. One might try to make it very short-run.

I have always been interested in unrealized projects. Your Great Pyramid→Appendix, 303. is a concrete utopia, but a project that has a lot to do with what you're describing, with this scale of a project. I have always asked artists about what these unrealized projects are—projects that are too big to be realized, that are maybe completely unrealizable. And through that, a lot of projects have been made public: an archive of unrealized projects, some of which really do connect planets. There are a lot of unrealized artist projects like that; it's just that they're unknown. Architecture has managed to create a lot of awareness about unrealized projects. They become visible, while in art they remain an unwritten history. That is a huge concern for me, my big project for the twenty-first century. My main project for the future, besides building the Fun Palace by Cedric Price, is the idea of an immense space, a palace of unrealized projects. All of these are projects that would not fit into the existing art world structures. There are self-censored projects. As Doris Lessing says, there are projects you don't do because you don't dare do them. All of them are projects that do not fit into the existing art world structures. If we're inventing the future, it isn't always only the case that we consider what could the future be like? Instead, our commitment hopefully produces reality. I think there is a lot of potential there. Suddenly we have Edi Rama, an artist and friend of Anri Sala. He is mayor of Tirana and has many, many buildings painted throughout the entire city, almost like Bruno Taut at the beginning of the twentieth century. In the

1990s I did many interviews with John Latham, the legendary English artist who died a few years ago. He and Barbara Steveni founded the Artist Placement Group, the idea being to create situations for artists in large businesses and public administration. The artist could have an office and show up from time to time, and in doing so help change the reality there. That is actually no different than what is going on in Manchester now. Politicians appointed Peter Saville creative director—Saville really is one of the most important graphic designers of our time—and he is changing the city. *Those* are big projects. In Tirana, it's almost like Mayakovsky said—the streets are our paintbrushes, the squares our palettes.

What I'm just now realizing with the Great Pyramid is that at first I didn't see it as art at all. I described it in my book *Umbauland*, and there it was about structural measures for Germany. But that is only one way of looking at it. If you just switch your perspective and look at it as art, then this also appears possible. That would mean, for example, a collector buys the pyramid.

That a collector [*long pause*], that a collector will buy the pyramid? I'll have to think about that. I believe [*pause*], you could say there is an art history that has primarily made itself known through objects, that through objects has also traveled through time. It's been around since the 1960s—Lucy Lippard called it the dematerialization of art. ➡ Lucy Lippard, *Six Years: The Dematerialization of the Art Object from 1966 to 1972* (Berkeley: University of California Press, 1997). Today, Tino Sehgal talks about how we have reached an intersubjective paradigm. With Sehgal, there isn't even a certificate anymore. There's an oral agreement. There was a period in the 1960s when the Dia Art Foundation, for example, completely redefined what was possible for art institutions. La Monte Young was given a building for sound experiments that he could use for decades, right in the middle of New York. Work like Robert Smithson's *Spiral Jetty* (1970) or Walter de Maria's *Lightning Field* (1977) was made possible. The question is what a Dia concept like that could be for the twenty-first century.

The Great Pyramid is the complete opposite of dematerialization: it stands for a long time, it is large, it is really massive. You just said, there is globalization, which continues to happen, and at the same time there

is localization. Actually there's a countertrend to everything. The most radical antipole to Tino Sehgal would then be to say, we're going to do something that is designed to be much bigger and keep much longer than previous sculptures and panel paintings.

There are a lot of possibilities when it comes to the way art travels in time and also lives on over time. Painting continues to exist. As long as pictures are made, then painting is not dead. Of course it is very difficult to define new rules of the game in painting because so much has already been done. But nevertheless, there are artists who manage to do it. Paintings remain a very interesting way of standing the test of time. We can look at paintings that are several hundred years old. Today, they still have a complete presence. The same is true of sculpture.

Those artworks demand a great deal of care.

Yes, they have to be protected. It still takes a museum. It takes the encapsulation of time on the one hand and the laboratory on the other. Those are two opposing forces that can coexist very productively. A long period of endurance can be attained through an object, a painting, a building, a sculpture. But endurance can also be achieved through other things. One of the first artists I met as a student was Eugène Ionesco, the French theater writer and co-founder of the Theatre of the Absurd. And he told me, right now, as he's sitting here with me in this restaurant, *La Cantatrice Chauve* (1950)—*The Bald Soprano*—is being performed ↪ Since 1957, at in Paris. Just as it had been for thirty years, Theatre de la Huchette. and as it continues to be today. There has been a performance of this theater piece every night in Paris for the past fifty years. You could say this work has attained just as much permanence as an object. It is always there.

It takes people.

That is a very good sentence: it takes people. That's also what I meant by this intersubjective dimension.

And with that, you can always imagine this antipole, which is then no longer intersubjective, needs *no* people; it doesn't even need machines any more.

Do you mean a post-apocalyptic situation? That would be the end of time, as Julian Barbour calls it.

Thank you very much. Or if anything else comes to mind …

[*Pause*] It will also be interesting how in the future, the Internet … I mean, it was a relatively long time after the invention of the television that Nam June Paik really produced relevant art with it. Whenever a new medium emerges, there is always this delay until you can really use it for art.➡ Gregor Jansen, 117. And that's something we're starting to see happen now with the Internet. I think Cao Fei's *RMB City* (2008–), this virtual city where she completely reinvents the relationship between the individual and society—that could be something we see more of in the future. [*Pause*] Another thing that's interesting is the idea that

there's a moment where there ceases to be a predominant medium, but art is a context where everything comes together. Be it philosophy, literature, or music—every field wants to work with art. Surely that has to do with the fact that there's this freedom in art. Art is a gateway of possibilities. It is no coincidence that from Agnès Varda and Chris Marker—to name two great filmmakers—to many positions in music, all of them overlap with art. It is interesting to think about what salons for the twenty-first century could be. Markus Miessen and I founded the Brutally Early Club, a brutally early club that meets in London at 6:30 in the morning. Elena Förster now has the salon in Engadin. There's more and more of this idea of creating salons for the twenty-first century.

What you're actually saying is that art as a whole is a giant salon where various disciplines meet.

I believe that art is *not* a salon. Art continues to be a very concrete practice. You might say that the art world, the art context is one big salon. There are no Athanasius Kirchers today. Nevertheless there is a desire for a new moment, one in which pools of knowledge can occur. In that respect you could say that art is a situation of encounters. That also has to do with the exhibition as medium. I believe the exhibition medium will become more important in the twenty-first century. When I started working as a curator in the late 1980s, early 1990s that was a relatively obscure term. It was seldom used outside of the art world. Today, twenty years later, we have a situation where hundreds of thousands of blogs are curated. Where Chris Anderson, director of the TED Conference, calls himself a curator. A curator of knowledge. The word curator is omnipresent. The question is what that means exactly. Whether this concept of selection—because it often has to do with selection and with bringing things in relation to other things—is something that is becoming important for many other areas. That suddenly these once socially marginal curatorial pioneers, from Walter Hobbs to Jean Lérin, are important to many more people. [*Pause*] How can you curate the future? I've been trying to explain how it's not about the curator playing a futurist. But I do think it's possible to develop new exhibition models. "Do It" (1995–) was one such attempt. [*Pause*] We, along with Boltanski, discovered this

little booklet, a set of instructions for a Singer sewing machine, and that triggered this "Do It" project. The idea was that we invited artists to write sets of instructions that can be interpreted in museums but also at home. Like a musical score that you can keep interpreting differently and in a new way each time. I have nothing at all against objects. I believe that there continues to be a lot of very important art with objects. But we have come to a point in time where there are more and more limited resources, where questions of sustainability are also forcing us to consider whether it's really about continuing to add more objects. The object is only one way in which art can continue to exist. And it is surrounded by many other possibilities that are worth investigating. On the one hand that means building these kinds of utopian projects that bridge between art and urbanism—unrealized artist cities from Constant's *New Babylon* (1959–74) to the new city by Olafur Eliasson that we are working on now.➡ Olafur Eliasson, 39. And there is another possibility of how art can travel, and that is through quasi objects. Michel Serres describes a situation where you have a football and two teams. If it weren't for this football, there would probably be this incredible tension between the people on the field. But the football creates an intersubjective field.

This uneasiness about the object, I feel that too—in a very, very intense way. I know, for example, that I could never hire anyone to build a building. For me, that was always the paradox with the Great Pyramid: that suddenly I want to build the biggest—in terms of volume—structure in the world. That's why the pyramid has to be reconceived. The pyramid shouldn't be built. The pyramid would actually have to be freed from a larger mass, like a sculpture. You just take a mountain that already exists, carve the pyramid out of the peak and then build these graves inside of it.

So it's like Peter Smithson: as found. The found pyramid.

Yes.

Wonderful. Let's do it.

Erik Niedling

PYRAMID MOUNTAIN

Autobahn A9. Gregor Jansen is right; a pyramid cannot grow downwards into the ground. ➡ Gregor Jansen, 126. *But you can pare it out of the earth and have it disappear again below. The only thing is, there will then be a limit in terms of size. So I continue to develop this new idea I discussed with Hans Ulrich Obrist. Erik Niedling reports this to our cinematographer, Christian Görmer, on the road to our next shoot in Berlin.*

Ingo called yesterday and has once again pretty drastically modified his idea for the pyramid. What was once a pyramid that grows step by step—becoming a tomb for potentially all of humanity—is once again a monolithic work consisting of *one* piece, and which is also only a burial place for *one* individual, namely the person who buys it. This means that the collector buys an artwork that is also his tomb, but then it will be sealed and filled up again. Quitting time! I'm looking forward to seeing what other turns the project will take. I might end up with some wholly unexpected impetus for my work. Unlike Ingo, I have a certain artistic practice. Ingo might have a more theoretical background—even though he always looked at it from the outside, of course, and now his perspective has totally changed as he's moving little by little into the center of it all. But it's also changing other people's perspective on what Ingo is doing. Because now, of course, he's really putting himself out there.

Thomas Olbricht

COLLECTING AS ADDICTION
COLLECTING AS ART
THE INVERSE MAUSOLEUM

*Me Collectors Room, Berlin. The private collection of Thomas Olbricht (*1948) opened just a few days ago, directly next to Kunst-Werke. Unlike the showrooms of other private collections in Berlin, it is opened not only one but six days a week and is located at ground level on a busy street. Hanging resplendent on the facade is a red "me." The pathway to the collection leads through a cafe and a museum shop. The first exhibition, "Passion Fruits," shows a colorful potpourri of figurative contemporary art. Thomas Olbricht is a professor of internal medicine and heir to the Wella cosmetics fortune. Worth an estimated 650 million euros, in 2009 manager magazine listed him as one of the richest Germans. He arrives to the interview unshaven, wearing a black leather jacket and threadbare jeans.*

How did you begin collecting?

Yeah, I can't say for sure anymore, because it goes far back, all the way into my earliest childhood memories. Who knows if I was born first or was already collecting before that [*laughs*], but I was probably about five years old. I collected everything that crossed my path. That included the stamps that fluttered into the house with the parental post. They evidently fascinated me so much that I continued to do it.

At the entrance of your collection there's also a showcase with toy fire engines.

Those are relatively new. One of the most recent things I starting collecting are toy models of ambulances, I've been doing that for about fifteen years. Right around the time I starting practicing

as a doctor, I got the idea that I would put these little Red Cross vehicles in the practice. That turned out to be a very good ice-breaker. I really became interested in that because there are so incredibly many of them. It's just endless. And then I thought, at some point I'll have to expand the emergency line. So then there were the fire trucks, but those have come in pretty recently. I think police cars are next.

Did you systematize your stamp collection?

It was a natural development—like in all the areas of my collecting, it became more focused. When I was a kid, I thought you could collect anything. And even as a student, I had a subscription to all the stamps being produced throughout Europe. But that really ate up a lot of money. I finally realized it was worth it to give that up and only collect the best. Which means, in the case of the stamps, rarities and curiosities.

In the beginning, you really had the idea that you would collect all the stamps that had ever been printed ...

... in the entire world. That's what I wanted, yes.

So you continue to expand your stamp collection today?

Yes, yes, yes, very intensively. Of course there have been some ebbs and flows over the decades. They once spent ten years just sitting there in the corner. But that's just how it is; it's a wonderful thing to collect if your pocketbook is slim. [*Laughs*] In that case you can still collect stamps, but you can't collect art anymore.

How many do you have now?

I don't think you count them. I've never counted. The best you can do is count in albums. I don't know—thirty, forty albums. But that's not saying anything. It's more about which rarities you have. I collect the first editions for different countries. The first stamps in the world, whether they're from Great Britain (1844, if I remember correctly), or the first German ones—1849 and '50, from Saxony and Bavaria. And then you can specialize even more: on letters, in block form, mint, and so on.

When did art come into play?

When I was thirty-five years old, in my late thirties, through an acquaintance with regional galleries in Essen, in Ruhr. The

thought of collecting art had crossed my mind before that—I just didn't have the opportunity or the guts to do it—because my great uncle Karl Ströher was a great, well-known collector. The rest of the family caught the bug from him and also bought an artwork or two.

How did the collecting start?

After I got over my initial anxieties, I went into galleries to begin looking at things and I asked about prices. My very first purchases were from local artists who didn't really gain any notoriety in the years since then. I figured that out at some point and so I began collecting not only local artists from the region, but also nationally—German abstractions after 1945: Baumeister, Nay, Winter. Then the German Informals. It was at the end of the 1980s that—with my financial means, which, thank God, were increasing—I was able to branch out into international art or internationally recognized German artists. Then the purchase of my first Gerhard Richter piece came along. Then came American art, especially photography. Suddenly, requests came in

from museums, artistic societies, to borrow something—which affirmed that perhaps I was not just collecting the wrong stuff. That spurred me on to keep collecting and to expand. And from there it snowballed. I received invitations, was selected to be on committees, and before you knew it, there was no more escaping the whole mess! [*Laughs*]

Your collection is not just Western art; you also have a lot of Chinese and Japanese art.

Yes, I'm interested in broadening my horizons, to spend time learning and getting upset. For example, that Chinese art—Chinese Pop art—is regarded as, well, they're just making imitations and stuff. When I was in China, I noticed that we shouldn't use our Western views, our criteria, any more. We have to recognize that Chinese collectors like what is made there. Critics here say it is kitsch. I completely object to that.

So, you like it?

Yes, I have broadened my perspectives on artistic quality. I accept that criteria and people in other parts of the world can be different. I have integrated that perspective into my collection and am thrilled—obviously not with everything, but with a lot.

You said before that you can't collect everything.

Nope.

Can you say what your criteria are?

You can't collect everything. That also means that you can't keep everything. In the end you can't keep anything, that's for sure. You can't take it with you, and therefore you don't need to have everything. But as a collector, you first have to come to that realization and then you have to try to really *live* it. That's difficult if you collect seriously, even enthusiastically, almost a bit addictively. For me, it still goes somewhat hand-in-hand. There are different areas of collecting. But today I am convinced that over the years you develop a certain intuition that leads you to know that some things obviously don't fit with others in the collection, but at the end of the day they actually fit unbelievably well and can be exhibited. And that's the main principle that I want to bring to life here in Berlin: I want to show things beside each other that would likely never be shown together in another place, because no one would ever have the idea to do so. I

like to draw a comparison from my medical specialty: I learned ultrasound medicine early on, practically at the beginning of ultrasound medicine itself. And after many years, I began to see things that couldn't be *seen*. Then I said, something is here! It's different than normal. But I can't say exactly what it is, but there is something. Only after further investigation did I know which structural changes meant what. You can only do that when you have been working on something for a long time. After a while you just have it. It cannot be about having something by artist A or B from every phase of his life work. That would be boring. Or *just* one subject. I see more. I see the exhibition. That is why this building came to be. Because I am worried that our next generations will have no desire to go to a so-called "museum." They don't have to. They can see everything at home on a computer. That is why more has to be done. It has to be a new experience. Haptic, acoustic, but also something amazing to see, at least around the next corner, you'll find something unexpected.

For that you would have to collect other art, or do you have it already? Art that you can experience haptically?

Yeah, oh God. Of course haptic art turns out to be difficult. Because art has a value, it has to be insured. And if everyone fumbles around with it, no insurance company will ever want to get involved. ➡ Antje Majewski, 98. But maybe, if I can lie on the floor in front of a picture or on a pillow I see it differently than usually in a museum. Not like ticking off a checklist. That is why I call this place a laboratory—it is very far-fetched, but maybe it comes from my first career as a chemist; I worked day and night in a laboratory for three years. Something will come of it eventually.

You want to continue conducting experiments here?

Definitely. In spite of all incomprehensible press. [*Laughs*] What do I care about yesterday's gossip? We have to make a difference here and now. We want to make a difference. And we are going to push through the so-called art canon. Whether or not it has staying power, I don't know.

And the rest of your collection, is it stored in such a way that you can see it?

In my mind, I can see it all in front of me.

The things are all wrapped up?

Yes, they are stored in an art storage facility. I rarely see them.

You buy something and it is delivered to you. Do you unwrap it first or does it go directly into storage?

It used to be a must to have newly acquired art works at first around me. But today that is not so much the case. Everything is decorated with art so that I'm still satisfied even after years. So it was a nice thought to constantly switch the house around, but that is pretty tedious. And then it became enough to know that you had it. In your mind you can assemble and arrange it as you want to show it. And now I've created the opportunity to arrange everything as I already imagined it.

When viewing your collection, you first go through the cabinet of curiosities.

That is a revival of my earliest collecting. There are totally different parts—like different motifs on the stamps—from different countries assembled together, unlike stamps, not just from the last 150 years, but much further back in time. That is to say, the beginning of collecting beyond the parochial field, after Europe's discovery of the world. It started with memento mori: skulls of all types in small format that, again, may have something to do with my profession, with the thought that the largest part of my life has passed. And then the idea came to expand on that in a type of cabinet of curiosities, like those that originated in the Renaissance-Baroque era. It brings me great joy to see that people can still marvel at things they see directly in front of them and wonder how they were created—also a narwhal tooth or an especially big rhino horn—and from there draw a bow with topics of love, life, and death right up to contemporary art, which is plowing through these subjects up and down, left and right, because that is just life.

It could be seen as a paradox that you use collecting and conservation as a way of preparing for death.

Yeah, I don't want to see it quite so strictly. I'm still alive. But you shouldn't neglect anything. As far as neglecting death is concerned, that is indeed happening in our society. Violence and death are shown in all forms of media, but we act as though we have nothing to do with them. That is wrong; you should deal with it—I know that as a doctor. I have accompanied many

people through to their deaths and feel actually quite comforted. It works out well in the end. You don't have to be worked up about it. At some point you let go.

Can you imagine that art will accompany you into death?

Oh, I don't believe that! If I am supposed to give a short quick answer, I can't imagine that now.

But the idea of your grave, for example, as art ...

No! For heaven's sake! [*Laughs*] No. You have to imagine, there are so many people, you have a whole mountain of sand in front of you. And you are one little grain. Take that away. Nothing happens. Nothing at all. So much for that. I hate the word mausoleum. Everything is temporary. But not art. Art must stay. ➡ Boris Groys, 217.

How do you envision that? Should the collection be preserved after your death?

I call that a mausoleum, because it would always be connected with my name in some form. I don't want that. For me it's fine if one day my collection enters into circulation again. First into the market, then to the collectors who may have waited for exactly that piece and say, he's finally dead, now we get a chance at it! [*Laughs*]

You say it would be a mausoleum, but you could consider your work in itself as art.

My work? I do not consider myself an artist. But, with regard to my collection, I see it as my job to put the works of art together in a very special way. The whole thing is then, at least for me, a work of art.

Then it could remain intact beyond your death.

No. It is a work of art that is totally fluid. It can go in all different directions and be combined and arranged differently. That is what's so interesting about it. ➡ Boris Groys, 234.

Now you could say the other way around: a mausoleum is actually not the problem as long as it isn't filled. One could erect a mausoleum—an inverse mausoleum—that disappears the moment that one dies.

Yes, but then it's not a mausoleum. That contradicts itself.

Well, disappearing doesn't necessarily mean that it disintegrates. It

could just become invisible.

> A mausoleum is always tainted with a name, even if it were invisible. It shouldn't be like that. The art should speak, not the collector.

But then it would be the art.

> [*Laughs*] Well, this is getting very philosophical!

Just imagine, the biggest mausoleums in the world are the Egyptian pyramids, I assume.

> Yes.

If one were to build such a pyramid …

> … there already is one, in Paris. [*Laughs*]

Yes, there are pyramids everywhere. Even in front of home improvement stores. But a really big, massive pyramid, with a burial chamber. The world could visit it. But the moment that the collector dies and goes into the burial chamber, the pyramid would simply be covered. It disappears under a big mountain.

> So, like a safe that couldn't be opened any more. So that everyone knows what is inside, but no one can see it anymore. That's not fair. No, I wouldn't like that either. [*Laughs*] The works of art would then truly be dead, in a special sense. They would only live in the Internet and virtually.

The art wouldn't have to go in there. It would only be your ashes.

> [*Laughs*] No, that's going too far! Ask me again in ten years. It looks good for the time being, as long as there are no accidents. We can't predict our individual fates. But statistically, we can meet again in ten years. Then we can do this again.

3:

Incubation

Olaf Breuning

MONKEY BY THE COMPUTER
ART THAT EVERYBODY UNDERSTANDS
BASE CAMP

*Thomas Olbricht and Harald Falckenberg would like to be appreciated for their expertise, not their wealth. Maybe I've just been meeting the wrong collectors, or maybe my artwork is not yet ripe. So we travel to New York, the center of power for modern art since the mid-twentieth century. An old building in SoHo. A steep staircase leads up to the top floor, where Olaf Breuning (*1970) lives together with his girlfriend and two cats. Apart from the bedroom, the bathroom, and the storage room, there are no doors in his apartment. Standing around the ca. 300-square foot studio are several large Macs. Breuning gratuitously recruits assistants from his fan pool. After the interview he is expecting another two applicants to come by and introduce themselves.*

How did you get into art?

I was seventeen, eighteen, when I started taking pictures of my family and of myself. At that time I was looking at a lot of books, like Henri Cartier-Bresson. I was extremely interested in black-and-white photography. I was trying everything out.

When did your artistic career begin?

I'd say in 1995, when I finished art school. That's when I started developing what I'm still working on today.

Could you name the first piece that really mattered to you? Where you can say, that is me as an artist.

Yes. If you look right over there [*pointing towards the photograph,* Sibylle *(1997), hanging behind him on the wall, upon which is a half-naked woman lying down on a*

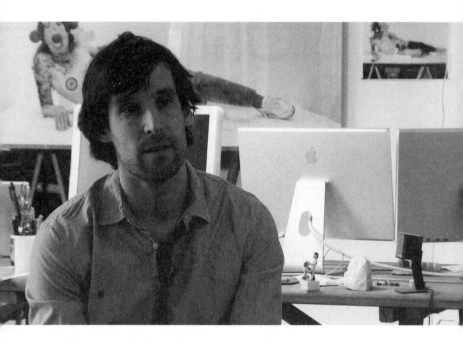

worktable with a devil's mask, a red-haired bun wig, furry shoulders, and a sawn-off leg], that is one of the first pieces. A piece where I felt, wow, I hit the nail on the head. For me and also considering how others reacted to it.

That piece reminds me of Matthew Barney a little.

Of course.

As a reference.

Exactly. This piece is in fact an art-historical reference. Matthew Barney is in it, Cindy Sherman is in it, Vanessa Beecroft, and quotes from Inez van Lamsweerde are in it. Plenty of quotes. That was actually the idea behind the piece, to cram artworks that interested me at that time into the character on this table. People were still talking about pop culture back then, which is not so much the case these days. Transgressing boundaries is more common now than it was ten years ago. ➥ Harald Falckenberg, 78.

How did you go on after this piece? You could have just said, now I have compressed everything that I appreciate about recent art history into a

picture, I have added my own approach and that will do for now.

It would have been great [*laughs*] if I'd been able to make a picture and could then say, that's it. But no, unfortunately ... I mean the world is a little bigger than just a couple of art references. And I was always more interested in the everyday things around me than I was in art. Art only interested me conditionally. And yes, the works I made after that were talking about different things. They were talking about horror films, about human, universal themes. Something that I still try to do today— be extremely contemporary.

How come you decided to move to New York?

I got a grant from the city of Zurich. And then I came here for a year and enjoyed the city so much. I gave up my flat in Switzerland. It would have taken the same amount of energy to continue my life in Switzerland as it did in New York. So I decided to stay here.

Did you already have a gallery here at that time?

Yes, Metro Pictures. ➡ Friedrich Petzel, 194. They came to my studio here in New York. Naive as I was—I had no idea who these two, nice older ladies were. They said to me, come to the gallery tomorrow. And they invited me to do a show straight away. That was nine years ago. Since then I have done around five or six shows at the gallery. That's pretty good. I'm happy about that.

The first photographs you became known for always included several people. Something like a small tribe or gang. It's a collective that resembles each other in certain details. Sometimes their hair, their clothes, their weapons. Does it fascinate you, this ganging together?

When all of a sudden five people symbolize the same thing, it makes it all more intense. All of a sudden it becomes believable. You *believe* these people have black hair, carry chainsaws.

At one point you stopped making group pictures. Is it difficult in the art world to keep asserting oneself with something new?

In the end of the 1990s—at a time when you had Doug Aitken, Matthew Barney—I was with the same group of people who were trying to compete against the media. I had to change that because it was simply no longer en vogue, let's say in 2005. Times change a lot. And if I was still making photographs with

long wigs and people standing around, I'd probably have cut my own head off. I might have been more successful, but I just couldn't. I still want the same thing I did when I started out, to make explosive pieces that fit the times. I cannot be indifferent about how the art world thinks because I'm in it. But I'd like to free myself from that a little. There has been too much pressure in the art world in recent years in terms of the way they think that whatever sells is good art.

If being up-to-date matters to you and if selling is of major relevance, then why not be consistent and say, I'll now try to produce the most expensive artwork? ➡ Damien Hirst, 108; and Gregor Jansen, 120.

Yes. Unfortunately, I'm not such a strategist. As long as I can pay rent, I'm satisfied. It's okay, and I won't even give it a second thought.

But what does being contemporary mean to you? What have your main concerns been in the past five years?

I don't have an objective point of view. I'm a human being who's getting older and is already forty. The latest work was about these questions; being in the middle of your life and returning to the same questions I had when I was a teenager. They are personal motivations. And regardless of how they develop, I have no plan. I'm happy if I can be sitting at a table and make art and feel like there is still a fire burning. For whatever reason it may be, that doesn't matter to me.

What kind of questions are they?

Why are we here? It's the question to end all questions. [*Laughs*] They're often the questions nobody's able to answer. The meta-questions. ➡ Boris Groys, 233. These questions come up automatically when you're a teenager and leave the safe nest of your parents' home and see the brutal world around you. I don't think they're depressing. I'm not interested in finding an answer to them, either. I just like the energy in asking. It sets off fireworks in my mind.

The creative process, how does it take place? I see a couple of drawings here. Do you start out by drawing, or is it all in your head?

Yes, with each work I look for the snowball that will trigger the avalanche. It can be a very small idea. And it can come at any time—when I'm sitting on the toilet or on the subway. One place

I end up making a lot of my work is Balthazar, a restaurant here in SoHo. I have been going there Monday through Friday for breakfast for the past ten years. I bring my notebook and write or make sketches and think about things that I'd like to realize. This is maybe my most creative moment, in the morning between eight and nine, with the first cup of coffee.

What is special about Balthazar?

A lot of people go there. It's a nervous place. Still you feel absolutely safe because everything is so red. Red leather. And the light is very warm, yellow. Even when it's loud, I can focus very well. I feel alone in a very public space.

And then you come back and the practical part begins?

Yes, that is when the unattractive part starts. I'm not sure if it's the same with other artists, but it's quite mad. When my assistants are here, I don't do anything else but send one e-mail after the other. It's also nice to organize exhibitions and all that, but [*sighs*] sometimes I get nostalgic and wish I were living in the 1960s. Take Andy Warhol and the Factory as an example, he only had one phone that someone would pick up and would say, oh, what do you want? These days you're invited one month before the exhibition opens, and then you have to send a picture, send an interview, and then you have to blah, blah, blah, blah. In fact I'm a monkey by the computer all day long.

I spoke to a gallerist in Berlin, Philomene Magers from Sprüth Magers, and she painted a rather dreamlike picture of her gallery: there is an assistant for each artist, they take care of everything. ➡ Philomene Magers, 64.

That is a gallery with a turnover of millions. Most galleries cannot afford that. They have thirty artists on their list and three people working there.

But Metro Pictures is a big gallery.

It is, but they are still quite moderate. Allison, who is responsible for me, has five or six others she's in charge of. Of course it would be a dream, a dream come true, to have a gallery that takes care of everything. [*Sighs*] On the other hand it's also nice to do things by yourself. By now I'm involved with hundreds of other small things: something for a magazine, a T-shirt in collaboration with a fashion designer, etcetera. I think it would be just as stressful having to do that via someone else and always

having to ask, is it ok to do it like that? The freedom to manage things by yourself as an artist is great. I love art. It's where I feel at home, but making a T-shirt with a fashion designer is also great. Then my art can escape this really small contemporary art island.

Did you ever think about just dropping out of the art world and going into mass culture?

No, no, I won't be giving up. Maybe you can think of it as a mission. You don't have to be a William Wegman and dress up your dogs to be popular. Andy Warhol, for instance, was very popular. And when you think about what he did today ... All right, times were different. It was the 1960s, the 1970s. ➡ Terence Koh, 167; and Boris Groys, 223. Still, with certain things people do perhaps address a wider market, without losing their faith in something. I went to see the Marina Abramovic show at MoMA ("The Artist Is Present," 2010). Everybody understands that. It's great. She really makes art. My grandmother would understand it. I talk about these things that really interest people. Because they are universal, because they move them. And not because you see something and then have the feeling that, oh yes, this young artist is doing something, that someone in the 1970s already did but with different brushes. That to me is just *boring*.

Recently you said, ten years ago, I reached the base camp of Mount Everest.

I still think of the base camp as a good comparison. I was never super hot, like Doug Aitken or Damien Hirst. I never got so far up the top. But in the past twelve years I have been making solid shows, at a similar frequency. And in a way, I feel good about that. The air is much too thin up there. [*Laughs*] I'm glad that I'm still at the base camp.

You said, I'll still be there in the next ten, twenty, thirty years.

Unless there's a big mistake, I don't see why it wouldn't be that way. There is plenty of space at the base camp and I think, with the support and the fans that I have, that they won't all just be ... krrrck ... gone. Things could always shift, of course. That can be brutal in the art world. You're hot for some time and then comes the next. Someone pops up straight out of nothing: schooouuu! ➡ Philomene Magers, 68; and Harald Falckenberg, 80. Often I

meet young artists and they tell me the lists of where their next shows will be, and I could only dream of that. Tens of thousands of new artists are flushed into the art market every year. It's a giant market. And being there as an artist makes you nervous, once you get the feeling, shit, now I have to pack up my tents, climb back down, and do something completely different because I just can't afford to be an artist.

Terence Koh

ART SUBSTITUTING MAGIC
BETTER LIVING THROUGH CHEMISTRY
99% POPULISM

*Terence Koh (*1977) is an artist who, shortly after the turn of the millennium, seemed determined to burn as brightly as possible and burn out even faster. Too excessive was his drug consumption, too drastic his performances of being fucked by prostitutes, too kitschy the mostly powder-white objects he exhibits in stacked glass boxes. Greeting us at the door of his building in Chinatown, he comes across as exceedingly shy and polite. He is dressed in a white button-down shirt, white leather pants, and white-rimmed sunglasses. Earlier interviews were sustained with copious amounts of tequila and cocaine. Yet he says he quit drinking alcohol and eating meat some days ago. The ground floor, formerly a store, is freshly covered in white bed sheets. Koh wants to invite friends over soon, but the storefront needs to be better isolated first. The noise from the streets gives him anxiety. Koh is petting a plastic cat; his tomcat Hans Mayer soon takes up residence on my lap. By the end of the interview, the back of Koh's shirt is soaked with sweat.*

How does this house work? You use it as a studio and as a gallery and as a home?

That's right. It's a studio, a house, and a gallery.

And the different floors are for the different ...

They change depending on the day—like a Chinese wedding cake. So you can switch them around.

You use it as a gallery only sometimes?

I would say all the time, because it's a gallery right now—for me anyway.

But now it's not open to the public.

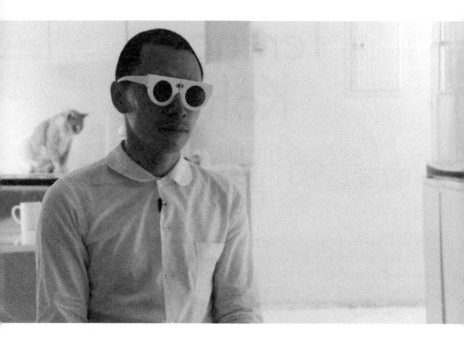

You guys are here, so it's open to the public! I think everybody else besides me is the public.

Is there still a black basement? Everything is white and the basement is black?

How do you know my basement is black? [*Laughs*]

At some point you said that you had the idea of doing a porn production down there.

We did a porn production down there already. So we did it and have done it.

You're working mainly with white and then some black?

Yes, lots of white and a little bit of black. I can never explain this; it's karma to me. And my favorite flowers are white chrysanthemums.

The way you make art, it seems very close to a ritual, like a magical practice.

I personally can't do any magic. I wish I could. I wish I could

change time. But I can't. So art is the closest to magic for me. ➡ Antje Majewski, 92.

You would like to change time—in what sense?

Probably backwards.

What's the time that you are particularly keen of?

[*Koh's cat comes nearer to my cup of water sitting on the floor*] Hans Mayer stop drinking from the golden cup. You gonna go back in time. You gonna go back to the baroque period.

Would your favorite time be baroque?

I would say so. Because of the intercourses of mannerisms. I believe in that time.

But maybe the future could become baroque, too. Even more baroque than Baroque.

Even more baroque than Baroque. You say that with such beautiful flair. I love that, but I am not a philosopher. That's why I prefer history. For me it's easier to define. [*The cat jumps into my lap*] Hans Mayer, you gonna hurt somebody! Oh no, he's a very sweet cat.

We met Olaf Breuning today. He said, oh, Terence Koh, he is filling the void that Andy Warhol left.

No. [*Laughs*] I don't think so. I think I'm just filling the void of being human.

There is a void of being human?

[*Laughs*] That's why we go on living, I guess. [*Pause*] Because we wanna try to see this emptiness in ourselves. The emptiness of being human.

Is this related to Buddhism?

[*Pause*] It could be. I mean, I've been reading *The Art of Happiness* by the Dalai Lama every day, and so I'm trying to feel this happiness all the time.

Do you have daily routines?

Yes, I do. I wake up. I put water into my microwave and microwave it for one minute, because I like drinking hot water in the morning. And when it's microwaving, I brush my teeth. And then I put on my contacts, because I'm quite blind. And I need to put on my sunglasses, because lights scare me. And then, when it's

finished, my water is ready and I drink it. And then I have to put on my moisturizer, that's important, cause you need to moisturize your face. And then I read the *New York Times* online, as the first thing, because you never know when half of New York is on fire or something. And then I eat a grapefruit, usually, almost every day. Unless I'm stuck in a plane somewhere. And then it's mostly thinking. I don't really do much.

In which position do you think? Do you walk around, do you sit, or do you lie down?

I like sitting down to think. Like the Buddha himself. I think the best way to think is lying down on your side. Because the blood either goes down or up, here it goes horizontally. And because it's going horizontally, it increases your thinking.

Why is lying on your side better than lying on your back or on your front?

Because from the side you can see the front. And being on the back reminds me too much of being in a coffin. And that's terribly frightening.

You could regard your vitrines as coffins, too.

You could. A lot of things could be coffins. A vitrine is a six-sided box—I wouldn't consider that a coffin. My definition of a coffin is a five-sided wooden box with an open top.

So once you put on the sixth side it's no longer a coffin, then it's a vitrine.

Exactly, yeah. You need to leave a little gap—even if I'm dead—but no chutes so that squirrels or people don't get in and eat my face off, or something like that.

Do you have more routines or rituals later on in the daytime? Or is it just thinking?

In between the grapefruit and the thinking I take off my contacts and go to bed and put on my glasses and put on my earplugs and read a book. Oh, and sleeping pills. I need sleeping pills to sleep. And then the cycle goes on.

For a while you were wearing a lot of furs. Do you still do this?

No, I just became vegan two days ago.

Two days ago?

Yeah. I wanted to say, I am vegan. Cause I like the sound of that.

And what happened to your furs?

I will still keep them.

But you won't wear them anymore?

>I haven't got into that part yet. I could be a fur-wearing vegan. But maybe not. All the tofu and all the beans are making me feel more compassion.

And that's good?

>I think it's great. I think it's very good that you feel compassion. Because we need more compassion in this world.

So you want to be compassionate?

>I would hope to be compassionate. I think we're all born to be compassionate.

Doesn't it fill you up, being compassionate? Thinking of others all the time?

>When you're busy thinking about others you forget that you're feeling empty. I think it helps. That's my philosophy 101.

But you still feel empty, even when you're compassionate?

>I guess so, yeah.

Do pyramids mean anything to you?

>They scare me, pointy objects. Like knives and bullets and stuff. If pyramids could walk, if it was running towards me, I think I'd be terribly frightened.

They don't have legs. At least until now.

>I've seen them with legs sometimes. That scares me.

Where did you see them with legs?

>In … I'm not sure. In the past.

In your past or before you were actually born?

>No, I've seen them in my past. I don't think I've seen anything before I was born. So it must have been in my fuzzy past.

You don't believe in reincarnation?

>I would hope not. That's a terrible idea. I think there should be a point. That sounds like hell to me.

On your blog there is a photograph of two elderly men and the caption says: DRUG ABUSE IS GOOD ABUSE. Do you think drugs help?

>I always say, better living through chemistry.

Why?

Because you can combine chemistry and change things, because they help me sleep and they take my allergies away.

Do they also help you to be more awake, to be more alert?

Yeah, I guess so. If you go to my motto—better living through chemistry—then, I think, everything works better that way.

So today it's not so bad, because we have chemistry. Imagine the combination of [*sneezes*] ...

God bless you!

I have a cat allergy, unfortunately, but I really like to have Hans Mayer on my lap.

You could resolve it through chemistry.

Imagine a future, the combination of baroque and chemistry.

It could be a very happy future. I would hope the future would be happy. That's one of my biggest wishes. Cause there's so much suffering and violence in the world today. I was just looking at images of Myanmar and the monks and stuff like that. If I was an artist, and there was a scientist as well, I would invent happy chemicals.

Do you have images in your mind of such a happy future?

It's a very cliché view of a happy future—with lots of trees and less humans and equal amount of animals and petting lions. It's almost a biblical future. Rabbits running around, and deer.

So the animals would also be changed by the chemistry?

Yeah, in my happy future everybody would be vegan. Plants are fine. They are not sentient.

You said that unfortunately you are not a magician or don't have magical powers.

No.

But sometimes you use magical practice. I saw a video of you on YouTube where you were sitting with Lady Gaga and you were putting pearls into a cup, and it was about the number eighty-eight.

I'm not sure where eighty-eight came from. I think I just like the number eighty-eight because I'm superstitious and they look like infinity loops. And the idea of a double infinity loop makes me feel pleasant.

You also did a performance with Lady Gaga in Tokyo?

> That's right.

And what did you do?

> I'm not sure what I did. [*Laughs*] I dressed her. We sang together. I'm not a great singer. She's a great singer, but I can't sing.

What did you sing together?

> We sang one of her songs, "Speechless." So she sang and I sang. Like children, I guess.

And how did you dress each other?

> Just like kids. With lots of fabric. Like just planting it on ourselves and gaining fabric and wrapping it around ourselves, like children would do.

Could you imagine becoming as popular as her?

> [*Pause*] No. I'd rather be a little more obscure.

Being so popular means that people really understand your work.

> That's true. I would hope everybody would want to understand my work. So I would like … just the 99 percent populism of a pop star. Maybe 99.5, I'm not sure. 99.8, I think. Because I like the eight. So let's do that. ➡ Olaf Breuning, 162; and Boris Groys, 223. [*Laughs*]

Thank you.

> You're welcome. My pleasure. You are covered in cat fur. [*Laughs*]

Genesis and Lady Jaye Breyer P-Orridge

DECONDITIONING THE PANDROGYNE DNA MYSTERIES

*Ridgewood, Queens. The streets are filled with almost exclusively Hispanic and black faces. Not a trace of gentrification. Still, Genesis and Lady Jaye Breyer P-Orridge—as Genesis P-Orridge (*1950) has called himself since the 2007 death of his second wife, artist, and dominatrix Jaye Breyer—is moving to a smaller apartment because he can no longer afford the rent here. Last weekend, he organized a sale in his basement. We chose a drinking-horn from among the leftovers and paid five dollars. A Balinese chicken cage P-Orridge and Breyer used to squeeze into to intensify their ecstasy trips has already been sold. P-Orridge was part of COUM Transmissions, the performance group whose explicit sexual imagery in the 1976 exhibition "Prostitution" at the ICA in London caused an uproar. COUM Transmissions became Throbbing Gristle that same year, and the industrial music genre was born. The band dissolved in the 1980s, after which P-Orridge started the band Psychic TV along with the spiritual fellowship Thee Temple ov Psychick Youth. Hanging over the red sofa I am sitting on for the interview—Breyer P-Orridge takes a seat on the desk chair—is a photograph of Jaye Breyer with a raised middle finger.*

That picture over there is the last that Jaye ever took—on the day she died. Then we stayed awake all night and it got to about six in the morning. Then we went and got breakfast at the local diner. And she said, remember how we used to go to get breakfast at the diner when we were first together all those years ago? Yeah, she said, it's just like that. Then we came back and made love. And she said, I'm just going off to the bathroom and when I come back, we go to sleep. And we dozed off and woke up. The minute we woke up we knew something was really wrong. Instantly. We felt sick. Oh God, what's happened? Then we got out of bed and walked through, and she had collapsed in the bathroom. We tried to give her CPR but she just died in my arms. Breathed her last breath into my mouth. Unconscious within about two minutes. Very strange.

When did you start, when you speak of yourself, to say *we*?

When Lady Jaye dropped her body two years ago, we had already started training ourselves to say we, because we considered ourselves to be two halves of one being, which we called the Pandrogyne. We decided to continue saying we for several reasons. One was to continue that project, of course—pandrogyny. Another was, that it's very easy—even now in the West—for partners, especially female partners of artists to be dismissed as only of interest because they're with the male. We didn't want that to happen. And another one was just to maintain a sign of respect between the two of us, that she was absolutely part of me forever. So now we also say Breyer P-Orridge instead of P-Orridge. We were thinking about whether we should say I for before we met Lady Jaye. But we decided that somehow she's always been a part of what we've done, even before we knew each other. Because the sum total of our lives before we met is what created the new being. So it's just we. We sometimes make a mistake and still say I. After nearly sixty years of saying I, it's quite an interesting discipline to switch—which is also another good reason to do it. To stop and hesitate and remember it's not just me.

But this is something you did already in the 1960s, right? This deconditioning of yourself?

Always.

You were in different collectives at that time and trying not to fall into any routines.

Correct. That's true. We also tried to change the subjective. Instead of saying I we would say E to represent ego—even then, back in the 1960s. And in '69 we joined our first art commune, art collective, which was known as the Exploding Galaxy. David Medalla was the sort of key, the center point. He is a Filipino artist who made kinetic sculptures. And it was in the air, in the late '60s. People were all experimenting with ways to break down routines, break down traditions, break down social norms. There was a tremendous disenchantment with the powers that be with government, with so-called adult society, with Western culture in general, that being in two world wars—the last one had been ended with the atomic bomb—and it might seem, now that we had lived with that for so long, odd to think how sort of severe the fear was, but people were actually terrified. In the 1950s and early 1960s the idea of obliteration was always present. And the younger generation like mine, we were

convinced that it was because of the status quo—the people who were running the world were obviously idiots and sadistic and bound to destroy themselves because they seemed to be in these violent, economically driven loops. So the only way to try and do something was to break every possible rule and see if there was any other way of doing life without it being based on money, without it being based on power and without it being based on territory. And territory became not just clans or nationalities or religions. Perhaps even the unit of the family was the issue, the problem, the basic building block. It was all built on power: the husband with the power, the wife to mediate, the children to do what they're told as a resource, and so on. And that repeating over and over. So we wanted to break all those systems and see if there could possibly be anything better. It certainly didn't seem it could be worse.

At that time you weren't searching for something else, the main goal was to break off?

Well, to break and see what happened, yeah. We didn't have a specific goal. I mean, people hoped it would be peaceful; people hoped it would be more conductive to create creativity instead of economics, instead of materialism. That every human being has within them some kind of genius factor; everybody could be an artist or had more potential than they were told they had. ➡ Harald Falckenberg, 77; and Boris Groys 220. But to find it, you had to strip away the layers of the onion that society had put on. For example, in a lot of communes the children were never raised by their biological parents. In the Exploding Galaxy we slept at a different place every night, all the clothes were in one box, so who ever got up first got the clothes, whoever got up last wore what was left. The walls were knocked out in the bathrooms and the toilets. That was quite common in communes, too. They did that in Germany as well. So privacy was also seen as connected to property. By putting stress on all these things you will, at the very least, start to identify what the real issues might be, why things were wrong, why things were becoming more totalitarian even though people were discussing freedom.

So you tried to avoid every kind of routine at that time.

Yeah. It was pretty hard! [Laughs] But we had a game we would play, too, which was you could just stop somebody at any point

during the day and say, how come you are doing the washing up the same way that you always did it? Does it have to be done that way? Why is your hair the same as it was yesterday? Do you have to walk? Could you skip? And why do you use a pencil? Could you use something different to make a drawing? Why do you use the alphabet that you've already got? Can you break the alphabet down and do it differently—which we actually did. We started to design our own typewriter that would be more flexible. And we still use that way of drawing which basically takes the verticals and the diagonals of the letters to make the words break down into what looks much more like calligraphy, much more decorative, and in a way it's an early form of cut-up or permutation—always that process of the cut-up.➦Hans Ulrich Obrist, 135. Burroughs used to say, let's cut it up and see what it really says. By breaking it, by cutting it up, by stressing it you can start to isolate aspects of yourself that you didn't realize you had. You don't even realize that you're doing whatever people wanted you to do. And so the first step of all is to break enough habits to actually identify what your character is. Where does it come from? What is it that makes you behave the way you do? And if you can isolate that, then perhaps you can start to look at ways to change it. And if you look at ways to change that, then you can also change the people around you. It's a dynamic ongoing process of change—for its own sake. Change is a matter of principal. Human beings have such deeply embedded behavioral loops. For example, a very prehistoric one and a very key one is: something is different, therefore it's threatening. If we are afraid of something new or different, we should attack it. We protect ourselves with violence. Or we protect ourselves by excluding it, by making it go away. And those basic dynamics, those prehistoric responses are actually also built into the political structures of the West and into the gender issues of the human species. So the either/or difference is one of the key issues that as a species we have to resolve or we have to destroy ourselves.

But isn't this a part of human nature, looking for routines?

[*Laughs*] The human species, hopefully, isn't finished. This isn't the final design. This is just almost a larval state. But certainly it is stressful. When we were in the Exploding Galaxy we saw

CAN WE DO IT ?

that at least one person had a severe nervous breakdown and he became catatonic. His nickname was Lemon, because he shaved all his hair off to look more like a clown and used to rub lemon into his head. And for him it was too much. He was confronted by such terror of the unknown that he just collapsed, imploded. Other people would just become really violent. For me ... we thrived on that. We found it really exciting to not know what was going to happen next. Still do. For all the risks involved, the human species is finally being forced—mainly by the reduction in basic resources—to address some of its behavioral issues. We would propose that it's time for everyone to think about the human species as one species, as one large organism, of which each of us is just one part, like a cell. To think of ourselves, if you like, as a coral reef, one great big complex interrelated organism. There is no separation between you and me or anyone else. Everything we do, we're all responsible for.

You worked on yourself to overcome the binary world.

That's right, yeah.

So what did you do?

Well, what happened was, from living in different collectives. First, there was the Exploding Galaxy, then there was Thee Temple ov Psychick Youth which was a worldwide collective network. And with Thee Temple ov Psychick Youth we were basically using the idea of shamanic and magical ritual to see if there were more effective ways to break behavior, to cut up behavior. And interestingly with ritual there is a combination of repetition—not exactly routine, but repetition—in order to reach, if you like, trance states or other states of consciousness. ➡ Thomas Bayrle, 260. But then, by adding in—as we did—a sexual aspect of orgasm, you also have this moment of explosion, that can rip apart from the expected, and the unconscious and conscious mind can both blend. And when we were working with those sorts of ideas, we were also using quite a lot of psychedelic drugs. And one of the things that started to seem apparent to all of us was that the picture was wrong. In certain more mystical, magical schools of thought, it tends to be said that the original Divine being has to be in both male and female, has to be hermaphroditic. Because to be the ultimate being is to include everything. So, if we are fragments of something that started

with that Big Bang—whether that was God's divine will or just an accident of physics—then some part of our mission as conscious beings is to return to that original state but having experienced sensually and mental events. In other words, the divineness, it—we call it "it"—was not self-aware. And now, for it to become whole, it has to reassemble itself, now being conscious of itself. And we are its consciousness. All of us are fragments of the consciousness of our potential at the end of the cycle. And that is, too, a hermaphroditic, non-gender specific being that encapsulates every option and possibility. So, for us, to start to project the image of the Pandrogyne, the hermaphrodite, into the culture, is to say, it's time for us to take responsibility for our return to a more divine state. Some people feel they're a man trapped in a woman's body. And some people feel they're a woman trapped in a man's body. But we just feel trapped in a body. You know, our ultimate aim would be to let go of all biological attachment and maintain a sense of self, and for myself and Lady Jaye it would be to become one form of consciousness created from the two, to actually let go of Genesis and Jaye and become the Pandrogyne—absolutely and for eternity.

So, for this you modified your bodies?

It was funny. We were thinking theoretically about the human species and our ever-ongoing quest for ways to change behavior. But we were also just totally and completely in love. You know, how when you fall immortally in love with somebody, you sort of say things like, I wish I just could eat you up! I wish I could just get hold of you and swallow you and we could just become one! And that's one of the reasons that making love is so amazing. Because when it works and when it's supreme, you actually *do* become one and absorb each other and have this moment of sharing a form of divine union. That sensation was so powerful for us, that we—partly just out of sentimentality—wanted to try and act out what we were feeling, and trying to look more like each other and be more like each other, rather than just say it. So we started dressing the same and doing our makeup the same and doing our hair the same. And we found that that resonance really reinforced the other ideas that we were having that were more theoretical about the Pandrogyne. And so we thought, let's take this a bit further, what would that

do? So, in 2003, on Valentine's Day, we used some money that we'd saved up and both got the same-sized breast implants with this friendly plastic surgeon that we met. And we both woke up together, holding hands in the recovery room, and we looked down and looked up again at Jaye and said, this is our angelic body. [*Pause*] And then, we were wondering about why we said that. So we checked and of course angels are hermaphrodites. They also don't have belly buttons and genitalia. So we came up with these issues. We actually talked to some doctors about it being possible to cover up our navels or belly buttons. But so far they can't do it safely. There's too much risk of infection.

And what about your penis? You got rid of it?

No. We wouldn't want to get rid of anything. We want more options. So if they could build a really workable vagina and penis, we would certainly have gone for that. But we wouldn't lose one in order to have the other. Between the two of us we have one of each, so as we are one being, it still works—theoretically. One of the dangers is if people get obsessed with the gender aspect and they forget about the archetype and the evolutionary aspect. Because once we started looking at that, that the body is malleable, it's just raw material for us as artists to play with. We had other procedures. Jaye had cheek implants and a chin implant and her nose done and her eyes done—to look more like me. We've had cheek implants done and other things ... between us about twelve or fourteen procedures each. But then we decided that it was DNA that we were really concerned with. Why should this program, this prerecorded software called DNA, have so much power over what we become biologically? A long time ago, Burroughs said to me, how do you short-circuit control? Where is control hidden? And Jaye and I came to the conclusion that control—in terms of the human species—resides in the DNA, that it's quite possible that DNA is the primary life form on the planet. It has a far more continuous existence than any particular individual and contains within it a recording of everything that's gone before. From one perspective you could look and say that we are almost like cattle or sheep or some kind of farm animal that DNA uses for its own ends to maintain its existence. And that perhaps DNA's program is so sophisticated, that once it managed to get the human beings technologically advanced

enough, it could get us to build its system, like the Internet, and it could maybe then make us redundant—who knows. There are lots of different ways that we could see the whole picture. But what we did decide was that DNA should not have ultimate control over the way that the human species evolves. So we started talking to some genetic engineers and scientists about possibilities. One solution to the overcrowding and the infinite consumption of the human species would be of course to colonize space, which at the moment is really difficult. But if you could hibernate like a bear or a frog, which are not that sophisticated creatures, then you could travel through space far more efficiently. If you were cold-blooded you wouldn't even have to heat the space vessel. Perhaps you could grow fur or scales or have extra arms. Basically, a human being is just consciousness. And the human body is just a container that makes that mobile, that takes that around and—to some degree—protects it. So, once you take away the idea of the human body being sacred and see it purely and simply as material that can be redesigned, then possibilities really open up. We could colonize the sea by having gills. We could eventually have wings and live up mountains—who knows. Anything! Suddenly, any kind of dream would be within our grasp. As a species, we are really good with technology and invention. It's our greatest asset.

Once we change our DNA we get rid of ourselves.

Ultimately not ourselves—the self is consciousness. But you have a freedom of choice to separate from the biological.

But isn't consciousness just an instrument of DNA?

Well, this is the interesting part that we're trying to look at—where does DNA end and the individual person begin? That seems to be one of the key areas to really investigate. Is our consciousness actually DNA talking to itself?

Following the idea that to enhance ourselves we would have to change our DNA, isn't that mainly a matter of science and not of art anymore?

Art began as magic. ➡ Antje Majewski, 92; and Terence Koh, 166. It is the shaman. People didn't know that day and night would always come. They didn't know the sun would come back. So they would make small drawings, they would make small rituals, they would make little objects. Some would be in charge of trying

to maintain the repetition of the seasons and food and so on. Eventually, women discovered linear time through menstruation. And it was only in the last couple of hundred years that patronism let away from art's connection with magic and with devotion and with the psychic hygiene and health of the species into this neo-modernist cynicism, which is now become neo-modernist stockbroking really. Art has lost its way. And one way back to its function is to reintegrate with whoever has the skills, to move our way of perception forwards. Art is basically seeing something familiar as if you'd never seen it before. And it's also a devotion to possibilities. The first book of the Bible is "The Book of Creation." The first thing that God does is create. So creation is the greatest energy, blessing, and skill of human beings. And how that's supplied—whether it's apparently scientific or philosophical or purely aesthetic doesn't really matter. It's still creation. So certainly science is going to start to integrate with the more exciting art. ➡ Antje Majewski, 102; Gregor Jansen, 117; Hans Ulrich Obrist, 135; and Terence Koh, 169. There's already Orlan, who has been working with surgeries. There is Stelarc from Australia, who's been building machines and doing experiments. He has extra skin and wants to have extra ears. So art is moving towards the cutting edge of possibility. And it doesn't matter where that is. It's just taking the resources and pushing the envelope. People might not come as far as you in terms of their vision but they get dragged—sometimes screaming and complaining—away from wanting to stay stuck in the past and in the status quo. Our opinion is that a future is always better than the present. As a matter of principal we should be moving forwards—anywhere.

If art evolved from magic, why not a return to magic, to rituals?

Oh, we did for ten years. That's what the Psychic Bible is about.

So this was Thee Temple ov Psychick Youth?

Yeah.

But you stopped doing it?

We stopped doing Thee Temple ov Psychick Youth as an organization and network, but we never stopped doing rituals.

How did you evolve these rituals?

Some of them came from working with Native American shamans that we met. Some of them came from friends who had

an offshoot of what had been the Church of Scientology, which was called The Process Church of the Final Judgement—a sort of strange, small psychotherapy cult from London in the 1960s. Some of it came from John Lilly and Timothy Leary, some from Tibetan Buddhists that we knew, some from Aleister Crowley—basically from all over. Our feeling was that hidden away in all the different cultures, if you took away the mystification and the special names and all the initiatory requirements—usually there just to make money for different organizations—were some really basic techniques. That repetition of chanting will affect the breathing, which will then eventually put one into a particular mental state. That at the moment of orgasm you can trick the consciousness into allowing messages through into the nervous system and you can re-program, to some degree, your behavior in the future, your desire to have something happen.

How do you do this?

Different ways. The way that we tended to do it at the beginning was to write down, to try and think what you truly, truly wanted to have happen. A lot of people occasionally say, oh, I just wanna be rich. But when you actually get them to be more specific, they'll say, well, I would like to be a race car driver and win the Grand Prix and get sponsored and have a lot of money and buy a house in Monaco. And suddenly they tell you an entire story that they'd been too lazy to say when they just said, I want to be rich. So you try and get people to learn to write down the real story of what they desire. And then they would use some form of ritual, lighting candles maybe. Whatever it was that made them focus and concentrate to just think about this one message to themselves, and then, at that point—either with someone, a lover, or on their own—to reach an orgasm. And as they reach the orgasm, try and either read that message or just stare at it, so that it's imprinted in the unconscious at that moment. [*Pause*] And the number of people who said that that worked for them is phenomenal. But what they're really doing is nothing mystical or mysterious—they're programming themselves. It's an ancient form of neuro-linguistic programming. It's basically talking deeply to yourself, the inner self. ➡ Marcos Lutyens, 209. And as you do it more and get more relaxed with it, you'll become actually accurate in terms of what you want. So you're

programming yourself, day by day, month by month, to make all the choices and decisions that you make with this one particular goal in mind. And of course that makes you highly efficient in achieving the goal. So, it's a stripping away of unnecessary trappings and distractions until that thing that you truly, truly wish to become is the center of everything that you do and everything you choose—what you eat, why you eat, when you get out of bed, when you go to sleep, and so on.

Did you use psychedelic drugs?

Sometimes. It depends how deep you want to go and how much you trust somebody. If you use psychedelic drugs, people can say anything—when you're in a very, very suggestive state— and they can program you into doing something they would want. Look at Charlie Manson, for example. He's a good example of someone who misused the technique of deep hypnosis on psychedelics with the people that were following him. And that's one reason why Thee Temple ov Psychick Youth wasn't a pyramid power system. It was very democratic. And as soon as people started wanting there to be someone who was, if you like, the guru, we immediately disbanded it and stopped, because that wasn't the point. The point was for people to become autonomous and to not need someone else and to not wish someone else telling them how to be. So it was kind of an anti-cult.

You mentioned Aleister Crowley. So you were aware of evil forces as well?

We didn't really look at the world in terms of good and evil. We looked at the world in terms of what works. And he was just one of dozens of people that we were looking at and was probably less important than the Lord Buddha. We found Tibetan Buddhism far more helpful. And in fact, Crowley got a lot of ideas from Tibetan Buddhism anyway. We're not interested in good and evil. This is a distraction. It's just a minority Western Christian propaganda technique. It has nothing to do with the natures of reality. Evil is bad choices.

How did you actually arrange the gatherings?

It varied. It grew much quicker than we expected. So we were improvising as we went. Initially people would do things alone and then send in the results and we would store them and look

at them and then they would comment on whether things were changing for them or not. And we would write back and give them ideas and see what things we could suggest. So by the time we were about five years in, you would have meetings, gatherings. In America, once a year, they would go on a camp out in Colorado. Maybe twenty or thirty people would go and do two weeks of hanging out and camping and maybe creating some kind of one-off ritual that they all felt would be interesting to do, sometimes to do with endurance, to see what would happen if they stayed awake for three days doing something. It would vary according to everybody's whims. In England, we would meet once a year at a stone circle called Arbelowe in Yorkshire, a very ancient, pagan site, on a farm. The farmer would let us stay there for a long weekend and we would have a tent for all the children and we would have music and discussions and people would talk about all things that they'd been considering over the year. And then we'd maybe have a big hippie feast with drumming and dancing and stay awake till dawn. Just gatherings for a sense of unity, unity of purpose, in a sense of belonging to a bigger family, a chosen family. Nothing particularly will-shattering or secret.

You did this for ten years?

Yeah. We started in 1981 and stopped in 1991. So, twenty years later the *Psychic Bible* is coming out. We feel that time enough has past that people can just look at it for what it is—without any emotional attachments or reactions—and see whether or not they feel some of it is useful.

Could you imagine becoming part of a revival?

No. Not really. [*Laughs*] People have suggested it, but to do something twice wouldn't be very exciting.

I see your rings and there's still one with the logo of the Process, right?

Mhmm. Yeah. Well, in my private life we still adhere to a lot of the basic techniques and the concept of evolution and change and the search for change.

How did and does the death of Lady Jaye affect your practice of being a hermaphrodite?

Actually, the first thing we did was after six months. We got breast reduction surgery, so that my breasts were the same size

as hers when she died. And then, on the first anniversary, we got her face tattooed, so that my body is still reminded of the process and the project all the time.

Do you still feel in contact with her?

Yeah. We talk a lot. We discuss lots of things. In a way it's almost just another step. We said earlier that we were eventually hoping to not have a body at all, to maintain a sense of consciousness *without* a body and then the two of us would become one consciousness and surrender into each other. So at this time, Lady Jaye represents us both in the immaterial world—wherever that is—and we still represent us both in the material world. She is doing advanced research. [*Laughs*]

This means that consciousness exists independently of DNA?

We're hoping so. We're not sure. [*Laughs*] Howard Bloom wrote a book, *The Lucifer Principal*, where his theory was that single-celled slime mold became huge blobs floating in the water on planet earth. And those huge blobs began to send these tiny little chemical electrical messages back and forth that were the beginning of what is now consciousness. That it was completely and utterly biological and random and had nothing to do with anything divine, spiritual, or anything else. And that our consciousness is just an extension of the slime mold and then in a sense, if the human species again saw itself as one great big blob of sophisticated slime mold, that if we saw ourselves as a species and worked as a species, then we wouldn't be able to do anything but use our resources to the best advantage of everyone.

So our consciousness was captured by DNA?

It's a mystery. Timothy Wiley, who was a founder of the Process, told us that there's a mystery from the very beginning to what that DNA does and where it came from. Did some extraterrestrial super beings seed the universe with the viral form of information that triggers the DNA if it's ever in the right place at the right time? Just as an animal going to a forest picks up a seed on its fur and moves it along. Maybe the universe was just sprayed with this viral package that was the trigger to intelligent DNA life when the right circumstances occurred. That's another possibility. In which case that DNA was somebody else's program.

William Burroughs said that we made the first recording in a prerecorded universe.

Why are you moving away from here?

Can't afford it. It's too expensive. We're moving to a little house in a co-op on the Lower East Side, it's just a one-bedroom apartment, two really small rooms.

Do you sometimes think that it's unfair that there are some really rich artists and you have to downsize?

[*Laughs*] And we're still struggling to pay the rent month to month. No ... would be nice, not to ... gosh! We're sixty now and we still have to struggle to pay the bills every month. But there you go. [*Laughs*] That's where everybody has to live. There's only a few people who don't live that way. ↪Boris Groys, 222; and Gabriel von Loebell, 51.

What are you working on at the moment?

A volume of the collected poems and lyrics. Somebody just asked me to do a book on breaking sex and pandrogyny for Atlantic Books. Collaging all the time. We've had four art exhibitions this year and we're in several touring museum shows. And music ... we just started to talk with Gary Lucas, who co-wrote a lot of songs with Jeff Buckley and Captain Beefheart. He wants to do songwriting with me. We do violin duets with Tony Conrad, a violinist, composer. [*Pause*] Endlessly busy! And we teach sometimes, too. We give lectures at universities: NYU, Columbia ... can't remember them all. Oh, and we gave a talk a few weeks ago at MoMA. It was sold out. They turned away 200 people for an art lecture at night—400 people came and paid. So there is a lot of interest.

But isn't this unfair? The MoMA, they invite you for a lecture, they could buy a piece.

They could, couldn't they? Maybe they will, eventually. Who knows.

What do you think, why hasn't it happened so far?

That big museums don't buy the work? They're beginning to. The archive went to the Tate. So ironic, that after all the times that we've had fights with the British government and the British establishment, they've now bought our archive for the na-

tional collection. There's been a reassessment, in the art world anyway, of the 1970s. For a long time they just didn't know what to do with people who weren't making art to be bought and invested in. Who were making art for other reasons, for ideals and to comment on society. So now somehow they've started to think of ways to integrate the avant-garde of the '70s with the official narrative. ➡Boris Groys, 230. And as a result of that, they've started to be a little bit less afraid of us. But we tend to always be right on the edge of what they can tolerate. [*Laughs*] Just when they could get used to things like, well ... making sex, we've moved into pandrogyny and something a little bit more theoretical and also, in a sense, very devotional and spiritual. And there's nothing the art world is more afraid of than spiritual meaning. ➡Boris Groys, 218. [*Laughs*] God forbid that people actually mean what they say and want the human species to be a happier kind of creature. There's been a very cynical sort of overlay in the art world for quite some time. But that seems to be changing, based on the way that people receive our talks and lectures. Clever jokes and cynical art references just aren't enough. That's not going to look very impressive in a hundred or two hundred years time, assuming there will be anyone to look. The talk at MoMA was specifically about COUM Transmissions, and people were really surprised that we were doing that kind of work so long ago, because they thought that people doing work like Terence Koh ➡Terence Koh, 165. is kind of new and avant-garde and radical. So to suddenly see that people would do things that were even more intense in 1972 really changes how they perceive what's happening now. This is a repetition of something that was done forty years ago. So we are quite confident that we'll get our respect when it's time.

Are you already working on the next essential step?

No. Pandrogyny is the last one.

Are you sure? Why?

I just know. It's such a big one. It's about science and art and politics and survival of the species and space travel. That it a lot of work. [*Laughs*]

When you started it in 2003, were you aware already that this would be your finale?

Yeah. It just joins all the threads together in a really perfect way. It is as if all the other different things were just steps, baby steps and research steps and necessary lessons to learn in order to see through the veil and see that this was really what we were always trying to talk about.

Do you have followers?

[*Laughs*] We hope not.

Why?

Where would they go? [*Laughs*] There are people who say things to me like, I'm a really big fan. We're very honored that people after different events often come and say, we just want to say thank you, you've changed my life. You've inspired me. There are people out there who truly trust us. Trust us to try our best, to be as honest as we can about what we're thinking. And that's an amazing responsibility and really, quite beautiful blessing, too.

But there aren't any people who have said, because of what you did I became a hermaphrodite, too?

There's a few.

You've met them?

We've met a few, yeah. It's a big step, though—not just physically, but financially. [*Pause*] And that's not really how we would expect them to react. It would be much more that their way of perceiving the possibilities and the options of being human have expanded, that they don't have limits anymore. They don't think about gender being a limit, they don't think about the physical shape inherited because of DNA as being the limit. They can change that. They can change the way their body looks, their face looks. They can change the way that they react sexually. And so it's an empowering liberation that they experience— more than wanting to be a hermaphrodite or a Pandrogyne. And it's probably that sense of empowering liberation that they say thank you for.

I have the impression that there are a lot of she/males. Of course, in Bangkok on certain streets there are just hundreds all around. For them it's something they do when they're eighteen.

That's right. We've always said that the projects we do tend to

be based on something inevitable that's already happening in culture. Observing it and then separating it out and having a look at it more carefully. And when we first came to New York from California, back in early 1996, in the back of the *Village Voice* there were all the sex ads. And they were basically biological women offering their services. And in the times since then, in the last fifteen years, it's something like sixty percent she/male offering their services. Now, the clients are basically the same: primarily heterosexual men. That's huge! And people are even shrugging when trannies are on television. So the whole culture in the West is catching up with the Far East. As cultural engineers, we were seeing that this was in the culture already. That there was somewhere within the species a drive, an urge, an attraction towards a more hermaphroditic identity. And it was being expressed in the way that plastic surgeries became something to boast about instead of hide. So we would argue that that's a reinforcement and indication of our view. That in fact, the human species will inevitably move towards a pandrogynous way of seeing itself. And the reason is survival. The human species tends—almost against its own will—to move towards a survival mode when necessary. It's gonna be an interesting time, the war between the future and inertia. The return to the polarized posturing of organized religions is the real guard action of the status quo. That's just camouflage for those who have power trying to maintain it. If we stick with the old system, the best we could hope for it is *Mad Max*, really. And that would be kind of boring. So we'd rather have a glamorous future, where we go out into space with big green feathers and extra arms and explore all sorts of other dimensions.

Friedrich Petzel

THE MASTERPIECE
GALLERY VS. AUCTION AND FAIR
THE CAREER CHANGER

Friedrich Petzel Gallery, Chelsea, New York. Jorge Pardo is currently showing a large-scale nude-colored grid structure pasted onto specially-made surfaces consisting of thousands of round pictures from the Internet. The exhibition is connected to a private showroom, and then to a squarish 300-square foot office with a skylight. Petzel is back from a long weekend in the Hamptons. The stock market prices he just finished looking at are not exhilarating, but he seems relaxed and in a good mood.

How did you get into art?

[*Laughs*] I got into contemporary art pretty late. I was mainly interested in classical painting from the fifteenth/sixteenth and into the eighteenth/nineteenth centuries. Starting at the age of thirteen, fourteen, fifteen, I used to visit museums and was always running to the new central library. Painting or art was a field that no one in my family had ever dealt with—archaeology, yes, also literature, a wide spectrum of languages, but never this niche. And then I was working with music and other things for a long time. So I only came by it later, through my girlfriend at the time, her father was a gallerist. And then at one point I was running around with the Mülheimer Freiheit boys, Walter Dahn, etcetera. They were also interested in music. And then I was hanging out in their studios a bit. It was never about painting, but about music.

Were you also in a band?

Sure! Everybody was. [*Laughs*] And then I tried to hit the road

and started studying at twenty-two, twenty-three. At that time it was art history, philosophy, and literature in Cologne.

How did you become involved with galleries?

I started working at a gallery because one always needs money. I at least needed an afternoon job. In the beginning it was still Roncalli Circus and bars or modeling jobs. And at some point Martin Kippenberger said, there is a gallery opening. Which meant that Thomas Borgmann—the father of my girlfriend at the time—was closing his, but this other gallery, Gisela Capitain, was opening. And then I went there to introduce myself and was working two, three days in the afternoon. I had no intention of becoming an art dealer, but rather this way I could get closer to the artists. Around 1990 I had finished my studies in Cologne. Then I wanted to do my PhD here in New York at Columbia University. And that didn't work out. I would have needed a job here as well. And just as it goes, three days turn into five. And at some point it was more fun working for galleries. This whole financial framework became clear to me in New York. That you might be able to have more influence within contemporary art by *not* sitting in an academy or writing books—no offense!—but through developing something with the artists on a day-to-day basis. So I never completed my PhD.

Where were you working?

I started working for a well-known art consultant, Thea Westreich. Back then she was looking after ten or twelve big collections. I said, I don't want to be hanging around a gallery again all day long, show me how America works! And then I flew with her to Chicago and to San Francisco and to Miami, in order to supply collectors with artworks. I was not familiar with this in Germany. This type of art consulting does not exist there—at least not since the Second World War. It was interesting for one year, and then I started noticing that I missed being in touch with artists. That is when Metro Pictures—who are still my best friends—hired me as a gallery director. I was twenty-six or twenty-seven, and there was an air of change at the gallery. It was this mega-recession in the beginning of the 1990s, when almost nobody was interested in art. My job was to assist Cindy Sherman, Mike Kelley, and Martin Kippenberger, who stayed with me during all those years. [*Laughs*] But also

to help build the gallery a little, to have a look around studios, and see what the next generation was up to. I did that for three years and at some point I opened something like an art salon gallery in my own name. I was also living there since, naturally, I had no money at all. I had to work at Metro Pictures between ten and four—they were not so far apart—and I was available at my own gallery on 591 Broadway, fifth floor, until eight. The space had an elevator in which you could barely fit three people. But almost everybody attended my opening: Jeff Koons and Bob Gober and Cindy Sherman and the entire league I'd been working with before. And then the younger artists I'd started to work with, who, in case of any doubt, are still showing with me. It wasn't easy because there was a major recession and times were changing. People were just not interested in art. Nobody knew how it would go on in 1992, '93, '94. ➡ Philomene Magers, 63; and Harald Falckenberg, 79.

Who were the first artists that you exhibited?

The first artist was Paul Myoda; the second was Keith Edmier; the third, Jorge Pardo, whose work I am currently exhibiting. Al McCollum might have produced the fourth or fifth exhibition. Cosima von Bonin was already with me at that time, so was Nicola Tyson and Charline von Heyl. Sarah Morris joined a bit later.

How were the sales back then?

Nothing! [*Laughs*] You might sell a sculpture or a small picture from time to time. That would barely be enough for the next month, for paying the artist. During two or three years I could not afford to go to Basel to have a look. It was just too expensive. I was unable to go to the Venice Biennale for years.

How do you establish contact with the collectors?

Collectors ... well, that is a mystery. I was also unable to understand how this works—mostly by way of hearsay. Artists talk about something and a collector might get lost and wander in your space on the fifth floor. But you can't count on that. Of course I was hoping that the collectors from Metro Pictures would stray to my space one day. But that never happened. I had to start pretty much from scratch. Luckily there were already three, four Europeans at that time who came from the Netherlands or Germany and said, Keith Edmier, oh, that is interesting. They would buy a bigger piece once in a while. By "bigger" I mean 7,500 dollars minus discount. But that would be enough to help me out for a while. And then I realized early on that I would have to go to one of the Basel fairs. It was a fair that was not very well visited by the Americans at that time. It was a more or less a European affair. And then they offered us young ones a statement booth, it cost 7,000 or 5,000 Swiss francs. It was so much money that I had to borrow from my dad. And then for the first time collectors came by that I was not yet familiar with and who were really interested in my program. The first Basel fair was incredibly important to me—1996, '97 or so. Nicola Tyson was extremely important, since MoMA had purchased two, three of her drawings. Because of that I got to know a couple of trustees, who also bought something for themselves.

As a gallerist can't you just contact the collectors, call them up ...

What are you supposed to talk to them about? I learned form

Metro Pictures: you cannot force wealthy people to like or buy art. It's like a virus. Either you have it or you don't. I never fully understood it. But you have to be agile in the beginning, and go to every opening, to the museums. You're very much like a kind of permanent billboard those first few years. You go to Larry Gagosian's to see if there might be someone there you could convince to come to SoHo. [*Laughs*] A funny thing, but it works after a while.

When did you move to Chelsea?

Oh, that was much later. I didn't move here until 2000. At that time there must already have been seven, eight galleries on 24th and also here on 22nd Street. I wanted to leave SoHo, but couldn't afford anything spacious. I had bought a piece of real estate with three partners on 26th Street for not so much money. But the ground water was so contaminated that we had to sell it off again quickly. In fact Pardo wanted to build the gallery for me, we had already developed the plans. And then luckily the Dia Art Foundation, ➡ Hans Ulrich Obrist, 137. the owner of this building, offered me the ground floor. The prices between SoHo and Chelsea shot up to five times what they were—at least for me. But I also knew at that time, if I didn't dare take the leap now to become bigger, the artists would have left and gone to someone else. It is a bit like soccer. If you don't offer Ronaldo the reasonable salary and working conditions he believes he can demand, you will not manage to keep him. You must always work towards improving yourself. It never ends. The competition is huge.

What does that mean? Do you have to open an even bigger gallery at some point?

No, I opened the gallery next door some three, four years ago, which allows to exhibit younger artists or to host a dance performance or let a video by Christian Jankowski run three weeks at a time—without the same financial implications as this space. It was a huge success. It became a company of its own, the small gallery. Many of the artists that have become famous now, Wade Guyton or Seth Price, for example, started there. And one and a half years ago, I opened a space in Berlin. Now I would be able to move uptown, but why would I? It is much more interesting to do something in a different in my old culture.

Is the small gallery its own company?

> Yes!

That means it's registered and …

> … registered and everything.

How come?

> Because I would also like to see this company bring in profits at the end of the month, and then you are able to control it better. It is not just a write-off project. The small gallery has three or four employees and has to be able to pay for itself. I am very financially conscious in that respect.

You don't have a partner?

> In Berlin there is Gisela Capitain, my first boss. But no, not here in America.

How many employees do you have in the three galleries altogether?

> I think around eighteen, nineteen working full-time. And then there are people working part-time in storage. It always depends on the type of job.

I remember that online galleries were emerging around 2000, the time of the New Economy boom, but that disappeared again.

> Well, artnet still exists. But I think sales are rather modest.

In the years following the new millennium, auction houses entered the contemporary art market.

> Naturally I have also been involved in a lot of art dealing, not only with artists that I am currently exhibiting. That is to say, I buy and sell pieces by artists who I either know very well or whom I already have a customer for. And in the past five or six years the auction houses were so desperately after the same "material" as I was, that they nearly obliterated me. � Harald Falckenberg, 80; and Boris Groys, 221.

And will it stay this way?

> At the time of the crash, collectors were more prone to saying, maybe I would prefer to buy something privately through a gallery than run the risk of having it served up at Sotheby's. Things like that fluctuate all the time. But it is true that they were very much after the artists in our program. They would say, if you put it up for auction, it will bring in five times what you paid for

it. And that is very aggravating for us of course, because I am not stupid. I can also buy my own art and put it up for auction. If it were only about money, I wouldn't need to engage in all this nonsense. But if an artist's auction results happen to be low twice, then the verdict is, this is a slump. And that is why we try to bring in a bit of calm. And to be honest, I managed to do this quite well. My artists are not really objects of speculation. There will always be some, but it is not as aggressive as with others.

How do you calm people down?

By selling to a collector where you can be a little bit more sure that it will not pop up at auction the day after tomorrow. ➡ Philomene Magers, 65.

Do you believe there will still be collectors in the future, the good collectors, who refrain from speculation? Is that still in tune with the increasingly faster-paced times?

I am not naive. You can't fight off a flood like that. You can only do your best. And I think we are all a bit responsible here. The problem is, naturally, when artists want to show their work in France and in Spain and then there is an Italian gallery—they will not mind so much. So it's an ongoing issue. [*Laughs*] I try my best to keep my artists from being huckstered.

Can't you exert any control over that, in saying, before the second gallery sells to a collector, the first gallery will find out who it is?

That is exactly what I do. We know very well who the work is sold to. For our own sales we have a type of sales contract that allows the objects to be offered back to me during the first five years, and to then pay fair market value for them. It doesn't work in 100 percent of the cases, but let's say in 90 percent, and the collector can safely assume that he will still be offered pieces in the future. These sales agreements are not legally enforceable, but most, that is to say the better collectors, follow the agreement because they would still want access to a Troy Brauntuch or something later on.

Is there anything else that might endanger galleries like yours?

I think our job is always changing. Every two years, we have to at least acknowledge new axioms. And one of the axioms I am seeing at the moment is that once again there is plenty of art being sold, but fewer people are coming to the galleries, because

collectors can often assume that they will get the masterpiece of that *one* artist that I am exhibiting at an auction, at Art Basel, or the Frieze fair. The exhibition is an embellishment. But whatever Petzel brings to Basel, *that's* the masterpiece. The audience doesn't understand that an exhibition is not just a collection of seven pictures, but that the seven pictures together are something quite different than an individual piece. I mean, of course everybody has to make an effort to even be able to participate in Basel. You do sell what's best and hold onto one or the other good pieces.

You make a show, but do not sell everything …

… or you tell the artist, make an eighth one to keep, and we'll not offer it up for sale before Basel. I mean, I understand the psychology behind it—that a lot of people believe that the essential picture can only be seen *there*.

In that way it may be similar to music, where you buy fewer and fewer albums and instead you download individual songs on iTunes.

The comparison falls short insofar as the price for individual pieces is steadily increasing. You will get a Warhol for twenty million, fifty million dollars. The auratic qualities of a work of art are still glorified, whereas Warhol the artist is nearly forgotten.

But there are an infinite number of pieces by Warhol, not just the one …

You will not believe the preoccupation today regarding the blue on a silkscreen, and whether that blue is better than the other blue. Twenty years ago they spoke about the mechanical aspects, also the fact that he didn't use his own brush—or sometimes did. These days people really talk about color. Color in Warhol. ➡ Philomene Magers, 67.

Tobias Meyer, the Sotheby's auctioneer, says that he can observe exactly how much this and that color will bring in. If there is a lot of brown and gray, then it is only worth half. If there is a lot of red and blue …

… then it will go well. But as I was saying, I'm looking to do something different. I am looking to highlight the exhibition as *content*. And most artists see that. Or else they wouldn't need me anymore. They would bring the pieces to the auction house themselves. I mean, why are artists even working with us? Because they want to make exhibitions. And that was obscured a bit by this auction-mania and above all by the fairs. Every three

weeks there is another fair. I could in fact close my gallery and just hoof it from one fair to the next.

That could be a model. You would cut down on expensive, impressive spaces.

Yes, but that takes all the fun out of it. What's fun for me is sitting here for one whole week with Pardo and thinking about the complexity of this exhibition, to laugh, and then something new will come out of it again. Each exhibition is in fact only a springboard for the next.

Someone like Pardo might say, why should I keep showing in a gallery? I could focus on making good institutional exhibitions.

Institutions cannot even afford what we galleries sometimes show. Even in this respect the balance has shifted in the past three, four years. If you want to make a Warhol exhibition today, basically only Larry Gagosian can afford to do it because the insurance values are too high. ➡Gregor Jansen, 117. And that is how five, six, ten, fifteen galleries in the neighborhood here in Chelsea are putting up exhibitions that only museums were able to make ten years ago. No gallery would have managed to do it, neither in terms of space nor publications.

And what role do collectors play? Is it also common in America for collectors to open up their own private museums? ➡Philomene Magers, 68; and Gregor Jansen, 114.

I am dealing a lot with those kinds of people and was an advisor for many of them. Museums are unable to sustain the financial possibilities private people have here. Just think of Eli Broad at MoCA and that entire Los Angeles story. The man has free reign with his billions. The community is unable to keep up with that.

The collectors opening up private museums, what kinds of prospects are they looking at? Starting a foundation at one point?

Exactly.

So they are they hoping their collection will carry on after their death?

Emily Fisher Landau, who used to have her own foundation in Long Island City, her collection will now be integrated into MoMA's. I think of that as a prime example for what this great lady said some thirty years ago: I am now doing what the museum doesn't want to or cannot afford. And she was very active

for maybe fifteen, twenty years. Then her interest petered out a little, the financial means were perhaps no longer there and now it will be integrated. I think it is a tidy solution. Instead of putting everything up for auction, make it publicly accessible again, with a real scholastic apparatus behind it. But then you have a problem when Elaine Dannheisser, one of the greatest New York collections of the past thirty years, donates the best works to MoMA and you never get to see them! They're not exhibited: the Gobers and the Koons and the Struths and one of the most beautiful installations by Bruce Nauman, *Learned Helplessness In Rats* (1998)—that, I think, is one of the best artworks ever. They don't have the space. MoMA cannot exhibit it. And out of this frustration many private collections say, let's build our own thing. I could write entire novels about this. As an art dealer one is naturally interested in one's artists being exhibited in public collections and that their work is accessible to a wider audience. And then the director changes, the curator leaves, and *everything* ends up in storage. What can you do? The thirty, forty, fifty million-dollar donation is done for. It is now in storage. That is a huge problem. ➡ Harald Falckenberg, 83. What happens to all the art? I don't know.

Could you imagine this ever going into reverse? That it would create a crack in the interest in art? It doesn't just end with the purchase of a piece, it comes with responsibilities, a sense of having to care for it.

Yes. And the caring for it outlives the people. They would like to care for it, but then there are the grandchildren and they don't feel like it anymore. I don't know how that can be dealt with in the future. I do know one thing: in this country it is not possible for everything to take place in either New York or Los Angeles or perhaps San Francisco. One forgets that this is after all a big country and one could also do something interesting in St. Louis, for example. In the individual communities of Louisville, in Kentucky, in Miami there was a lot going on in the past ten years and that should be developed further. The collectors who buy these pieces with much of their own capital should slowly start thinking about how this is to continue. And you can only do that with public institutions. I am dead sure about that. It cannot be done with private means. But you have to make sure that there is money for it, the money has to be in an endow-

ment, the endowment has to ...

That brings up huge conservational problems as well.

> And they are often not solved accordingly. Or we as gallerists will have to fill something out ten years later or certify a report stating that this oil painting will actually last. [*Laughs*] Three, four, or five days ago I was in a huge meeting at the Whitney Museum, that was about a piece in eight parts by Wade Guyton. We must have thought about it for three hours—whether or not this picture will still look the same twenty, thirty, fifty years from now.

You spoke about the Mülheimer Freiheit, Kippenberger ...

> He was not a part of that. Antagonist! [*Laughs*]

There was a comma in between those. That is—Mülheimer Freiheit, comma, Kippenberger. How can you compare them to artists these days?

> Martin is the one I was closest to of that entire generation. There won't be another one like him [*laughs*]—neither in this generation nor in the next. He was an exceptional character.

But wasn't he also really exhausting?

> Incredibly exhausting. But I think I learned more from him than from any other person ever. Don't be boring! And above all, never be afraid of anything. The way he was around other artists was sometimes not so friendly, but *incredibly* intense. And also tolerant, when it was about another artist working in an entirely different way. With Andrea Fraser, the hardcore feminist and filmmaker, he could interact as intensely as with himself. As an artist, Kippenberger would say, you have to open doors. You can do anything! You can make books, distribute records, print posters, curate exhibitions, teach—anything! I don't think that artists these days are in any way more stupid or refined. The conditions are different. As an artist you may perhaps be in the position of having a career, so you will be aware that if you do go to the right university, Columbia University, and you do meet the right gallerists, with say twenty-seven, twenty-eight, you might be able to afford a certain lifestyle. This was not the case twenty-five years ago. ➡ Philomene Magers, 68. Even though Martin always led a good life! [*Laughs*] Money is for spending. And for moving something. I hate it when people say, yes, everything was better back in the day. If you would read the articles on

how Kippenberger was butchered for every single exhibition. Regardless of what he made, *everything* was torn to pieces. It was all rubbish. The ignorance was worse than it is today.

You quote Kippenberger: you can do anything. You can make books, music ... Let's try it the other way around. If I, as a writer was to say, hmm, I think this is all very interesting, I would like to be an artist, too.

I'm afraid it wouldn't work out for most. The web of references is altogether different. Nothing is impossible. But I think as a writer you would get very bored in the art scene. I have noticed how little interest there is for literature among my artists.

But you just said that that was the great part about Kippenberger.

Kippenberger—there are truly exceptional figures—and Kippenberger did it differently. He didn't write a book himself, he asked somebody else to do it in a style that would make it seem like his.

The same way he let others paint for him.

Martin is a prime example of someone who allowed himself everything and who succeeded in that, where so many others would have failed. There are some who get in through the back door, even in pop music. Movie stars who go on and start some band. *Horrific.* That doesn't work. Maybe only in very rare cases.

It only works in very rare cases anyway. You only notice those who fail, because you know them from a different context.

Exactly.

Equally great is the fear of failing.

[*Laughs*] Yes. It would be as if I asked, could I make it as a book publisher? I can tell you, I would fail big time, because I missed the last thirty years. I missed the discussions, the way in which books are mediated these days vis-à-vis, let's say Suhrkamp 1985.

I think you would catch on pretty fast. I'm friends with David Lieske, a younger artist ...

He was also in one of my group shows.

He was in his mid-twenties, already had a long history as a DJ and thought, mhmm, I think art is pretty interesting. I'm going to get into it. Of course you can't just start, but he socialized, found some good

artist friends, institutional contacts. And it worked, I think within one year he was in a show at Hamburger Kunstverein and was represented by Daniel Buchholz.

> That has to do with Cosima von Bonin. I think it was through her that he was in the group show here. I also bought one of his pieces once. That surely has to do with the fact that of all things in the Cologne scene—Cosima and Co.—they do reach out beyond their tiny area of interest. I know, her and Lowtzow …

… Dirk von Lowtzow …

> … are close friends. She makes his album cover and he then has a title from her and so on. There is this kind of fertilization. But I can't imagine Dirk von Lowtzow getting into painting now.

He had an exhibition recently.

> Oh God! I have to call.

He showed a video piece.

> Oh well, that can be done. I don't mean to put it down. In fact I think it is great if there were more of those things. But specialization has become more advanced in the past decades.

My impression was always that it's done too cautiously.

> Too cautiously because we don't want to make any mistakes …

So if you really want, pack a wallop! Then it should be a masterpiece.

> There is this Norwegian … Faldbakken. In his case I find it astounding that the literature is very decisive and uncompromising, whereas the art tootles along undecidedly. It has a bit of everything.

What will happen to artistic autonomy? I think of how art is dealt with at MIT. We have a problem here, maybe a global problem, and we approach it in different ways. We try to find a chemical solution, and then we'll go and look for an artistic way of executing it. ➡ Antje Majewski, 102. At biennials Rirkrit Tiravanija is doing the kitchen, and Tobias Rehberger is doing the café. ➡ Tobias Rehberger, 250.

> I mean, first of all that is a very specific generation of artists. Many of my artists are part of it. For years Andrea Fraser did nothing but accept services, assignments.

True. She even slept with a collector once (*Untitled*, 2003).

> That came much later. She was having a little crisis and said,

the problem is not the institution, it is me. I'm an accomplice. And this narcissism, having to constantly expose yourself as an artist, that's basically what it boils down to. But with Fraser this is not just carried out but reflected, questioned. It was not a matter of lust! [*Laughs*]

You could also see that piece as a new take on the collector-portrait.

She came to a point of conclusion with this piece. Once you've commissioned yourself, there's nothing left to do. Within two days I found a collector who wanted to do it and wired the money. And then a hotel room was rented. This way she wanted to show her role as an artist in a very declamatory way. It signaled the end of this service thing, which lasted from the beginning/middle of the 1990s until 2002 or 2003.

I thought she already knew the collector.

No, it was entirely anonymous. She asked me if I could do it. I said, yes, I guess, I already know of one or two. [*Laughs*] You already mentioned one of them before, by name. But that never happened. Quite early on, someone from America called me and said, yes, I would love to do it, what is the price and what's in it for me? We made a contract and he received one edition of five as an artwork. It was treated just like any other commission. ➡ Appendix, 306. Like a mural for some bank by Sarah Morris. There is an entire generation, Rirkrit Tiravanija, for example—and also Tobias Rehberger to some extent—whose point of departure was to create social spaces where art could be a hybrid game. It's a sculpture, and then again not. ➡ Tobias Rehberger, 250. And that art is only realized by way of a dialogue. That is to say, the art is not in the matter itself, but in whatever takes place in between. The act of cooking. The kitchen per se is not so interesting, but the fact that thirty people from Iceland, Thailand, and Germany or wherever would meet and talk about the possible future of art. We have these terms like Nicolas Bourriaud's relational aesthetics. This was very exciting in the mid-1990s. Away from sculpture, away from the pencil. And now there is an entire generation of artists that went back to their studios and are making oil paintings. Not bad either! But it doesn't interest me so much because I don't think the problem is really all said and done. There's more to be had there.

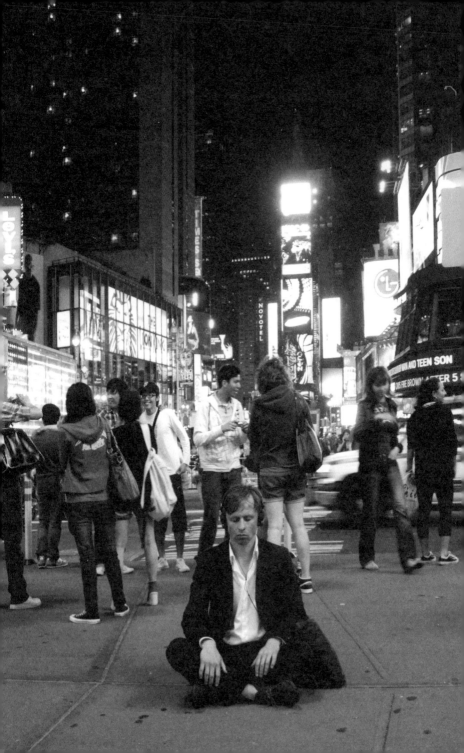

Marcos Lutyens

HYPNOSIS

Marcos Lutyens employs hypnosis as an artistic media and has repeatedly hypnotized other artists in performances, particularly Matt Mullican. I visit Lutyens in Los Angeles in late 2009 and allow myself to be hypnotized for the first time. The cumulative effect of concentration is so strong that I ask him to let me think about the future of art in the hypnotized state. Lutyens sends me a recording that I listen to many times. Though my idea for an epic artwork of the future is already largely developed by then, Lutyens helps me to continue spinning the scenarios of other artists and I see—inspired by Genesis and Lady Jaye Breyer P-Orridge—torso creatures with no arms and legs floating through the air. ➡ Genesis and Lady Jaye Breyer P-Orridge, 182. *Erik Niedling becomes hypnotized on his couch at home, at the end of which he develops ideas for his new work cycle, The Chamber.* ➡ Epilogue, 281.

My name is Marcos Lutyens. I'm an intermedia artist interested into the unvisible and unknown, both within and around us. And whenever you are ready close your eyes and relax, and as you listen to the sound of my voice you may notice a sense of relaxation descending now through the top of your head beginning to relax every nerve and muscle and fiber of your body, and as you take a deep breath just let yourself relax more and more as you listen to the sound of my voice. I'm sure you can feel a sense of relaxation now coming down through your shoulders and arms, biceps, and triceps, down to your elbows, forearms, and each and every one of your fingers. Feeling more and more relaxed now. Feeling a sense of heavy relaxation descending through your torso and all the way down your back to your hips, thighs, and down to your calf muscles and feet. Perhaps you can feel a sense of heaviness in your feet as they are resting there so relaxed, so heavy and relaxed. And as you listen to the sound of my

voice, any other thoughts or feelings from outside just drift off as you are relaxing here taking another deep, deep breath—so relaxed.

And in a few moments I would like you to imagine yourself at the top of a set of stairs. You are feeling very comfortable and relaxed and I'd like you to visualize those steps in your mind's eye, and when you are ready I'm going to count down from ten to one and with every number we are going to go down one step. Ten: taking the first step down now, feeling so incredible. Nine: taking another step down now, just letting all your thoughts drift off as you listen to the sound of my voice. Eight: relaxing more and more and more. Seven: dreaming and drifting. Six: dropping and falling. Five: and with each number feeling more relaxed than you've ever been before. Four: going further down now, so relaxed. Three: almost all the way down. Two, and one: all the way down now.

And as you're sitting there relaxing, listening to the sound of my voice, I'm sure you could imagine yourself being here or perhaps being somewhere else at another time and another place. It's actually quite unusual to be in the here and now as we drift off to another point of view. Perhaps you can allow yourself to think about the future for a moment by allowing the present to recede backwards more and more just as it is now doing, going further and further back as we stay still, gliding effortlessly from moment to moment into the future.

Dreaming and drifting.

10, 9, 8, 7, 6, 5, 4, 3, 2, 1 ...

And in your mind's eye I'd like you to choose a number, a special number to you. I'm going to count down from three to one, and when we reach one you are going to have that number flash up in your mind's eye. Three: focusing intently on the idea of that number. Two: concentrating more and more on that number. And one: seeing that number now. That number is a combination lock that opens your presence here in the future, having a special significance to you and marking this moment. That number remains embedded in your conscience.

And through this number you now begin to have access to the presence of art in the present, which is known as the future for those of whom you have left behind, so far behind. Savor what this feels like to have the vision and the hindsight, to be immersed in the evolving zeitgeist.

Capture this moment in your consciousness and enjoy the sense of your work breaking down the boundaries of past artists, making your own work so relevant to tomorrow's now. The ultimate Art of the Mo-

ment. Tomorrow's moment, tomorrow's now.

I'd like you to take note in your mind's eye of all that you are aware of, as I'm sure that those you have left in the past would love for you to guide them in your own tentative, shortsighted, fumbling efforts as an artist, blindly drifting by default into the future that you now occupy as your present.

And as you listen to the sound of my voice, you can imagine yourself to be there in that future of art, so poised, so balanced, so knowing or you could start to drift slowly back into the here and now dreaming and drifting slowly back all the way back.

And I'm going to count up slowly from one to five and when we reach five we will be wide awake. One: coming slowly back towards the present. Two: feeling a normal state returning to you. Three: stretching and yawning. Four: beginning to open your eyes. And five: wide awake, wide awake …

Presentation

Boris Groys

WHAT IS ART?
EVERYONE HAS TO BE AN ARTIST
AFTER THE END OF MASS CULTURE
EGYPT AS A QUICK RUN

*New York University, New York. Boris Groys (*1947) is the contemporary art theorist of choice for many artists and curators, particularly those of a younger generation. Groys is an expert on socialist modernism and holds a post as Global Distinguished Professor of Russian and Slavic Studies at New York University. We conduct the interview in a seminar room with artificial light and a noisy air conditioner.*

I've just been speaking with a number of artists, gallerists, and curators. There is one question that I have never asked, which is that of what art actually is. Could you answer that for me?

Art is everything that serves as art in our society. In this respect, art cannot be defined because every definition stops short—or actually goes too far. There is, on the other hand, an arrangement of practices and institutions, exhibition spaces, private activities. All of that adds up to something like an art scene. Art is whatever the art scene brings into the world. Whatever is manifested in these practices.

In other words, it is defined socially via the art scene. But how far does it go? Where does it cease to be the art scene?

That is a good question. Since Duchamp we know that everything can become art. There is no object at all, no practice, no situation that cannot become recognized as relevant to art. But

the fact that everything is art and anything can become art does not necessarily mean that all of it is *good* art. The term "art" is applied very ambivalently. On the one hand, it is used as a neutral description of certain social practices. On the other hand, art is something we perceive as an elevated thing, something interesting, something good. In other words, something better than not-art. In that sense, many different kinds of practices—social practices and whatever others—can be understood as relevant to art. But doing that, one notices that it isn't especially good art. For example, Duchamp brought the urinal into the museum. Nevertheless, there are still many urinals in restrooms. If I were to appropriate this gesture, take down all the urinals and bring them into the museum, then that can be described as an artistic act. But it wouldn't be interesting, because it repeats a gesture that has already been integrated and has established itself in art history. Which means that on the one hand we have an art scene, and on the other we have art history, the memory of this art scene, basically, telling us what is interesting, what is relevant, what means something in historical chronology, and what remains trivial and banal. There is also a certain projection into the future. Modernism has trained us to believe that much of what is not understood or was not understood before may be accepted and understood in the future. That means, in other words, art is something that is made with the future in mind. ➡ Antje Majewski, 88; Hans Ulrich Obrist, 134; Genesis and Lady Jaye Breyer P-Orridge, 183; and Gregor Jansen, 119.

If I think about other parts of society—religion is centered around faith, economics around trade, sports around activity—for art, you have said only that the moment the art world understands something as art, then it is art. Is there anything else that distinguishes it from other areas?

If we're talking about the economy, then there are certain economic interests. They are always partial interests. The same is true of sports. In all of these areas of practical life, it is not about the whole. Religion is different. Religion speaks to the whole. Philosophy is different. And art is also different. Inherent to art is an aspiration to go beyond the time in which it is produced—in the two respects I attempted to describe earlier. That means falling in line with a certain historical tradition. This would not be something that an economist's subject would do, for exam-

ple. And at the same time, making something that is relevant to the future. That does not happen in that way in sports or economics. But we do know, however, that everything technical is beholden to the notion of progress. In other words, every technology basically becomes obsolete the moment it is made. Our life in the economy, in technology, even in the everyday is—through the modern age and in the modern age—subject to the principle of progress, meaning the principle of constant obsolescence and abandonment. We expect of art that it will outlive its own time. That it has significance that goes beyond the immediate situation in which it is made or disseminated. And that is an expectation that art shares with religion—perhaps philosophy, as well.

Nevertheless, in the twentieth century there were many radical artistic avant-garde movements where they said, everything that has happened before now is irrelevant. All artistic production is obsolete. What we are doing is the only thing left that counts.

[*Pause*] I don't believe I remember them saying that. They said that their art is the true representation of their time—the modern age, the twentieth century—as opposed to other times. One of the key factors in the emergence of the avant-garde was nineteenth-century historicist thought and the emergence of museums. If the old art is around in the museums anyway … They didn't want to burn the museums—or only a very few.

Some did.

Some did. But nevertheless, they immediately said they would have to archive this burning itself. That means that the artistic avant-garde presumes that different periods in time demand different kinds of art. And that one should not make something now that has already been made before; you can see that anyway. Why should we paint classical portraits if we already have enough classical portraits in our museums? So we need something else.

You compared art to philosophy and religion. What makes art different?

The difference is certainly smaller than you would think. Still it is there. The most important difference with art is that it thinks in very materialistic terms. In other words, in the end, art produces things. Art does not believe in the soul's transcendence— despite what artists claim from time to time. ➡ Genesis and Lady Jaye Breyer P-Orridge, 190. They do not, de facto. Art does not believe in pure reflection, in pure thought. Instead, our art, in the relatively new form we know now—art, in the current understanding of the word, only began with the beginning/mid-nineteenth century—believes in the materiality of the world and creates things. And in that, it suits the current intellectual makeup very well—which is one of the reasons art has become so popular. The fundamental question of art consists in how one can continue to be transcendent—transcendent with regard to one's own situation—in other words, how we can continue to speak about the whole thing but on the condition of radical materialism without presuming the existence of a spirit, a soul, reason, and so on. That is the problem that began with Nietzsche and the early avant-garde, and which continues to be urgent and relevant to us today.

Advertising also very often revolves around the promise that if you

buy a product, it will have some further significance for you. You buy a consumer object, but also something that transcends it. The promise of advertising, is that art?

> Advertising as advertising is not art insofar that it is functionalized. The moment advertising fulfills its purpose—meaning it compels the customer to purchase a certain item—it becomes redundant and loses its advertising function. It is part of this process of progress, which—as I said—does not allow us to entirely transcend our situation. If we buy an object, then we also consume it. And then I'll go and buy another one. You could, on the other hand—as Andy Warhol and many others have shown us—also see advertising as art. That means, in negating this promise and saying that advertising is not actually promoting anything, but is only advertising nothing when it comes down to it—what we're buying is a big nothing and not an object. Under that condition, advertising suddenly becomes art or can be interpreted as art.

I was actually thinking more about the act of buying. Someone buys a luxury object, for example, he is fascinated by the advertisement, cherishes this thing, and takes care of it, keeps it, intends to will it to his children or hopes to auction it off for a profit on eBay at some point. Surely this promise of art is being fulfilled there, too!?

> No, no. Absolutely not. Art does not hold any expectation of usefulness. Art is made to be admired in itself, for what it is. It has no purpose beyond that in the modern age. Which is why I am saying that art as we understand it today has only been around since the nineteenth century. Before the nineteenth century, there were only luxury items—including icons, including portraits—and these were in fact used and consumed.➡ Philomene Magers, 70. They held a certain meaning in the context of ordinary life. Art emerged the moment certain objects—paintings or statues, for example—were removed from this ordinary life context and were placed in museums, where one was only allowed to look at them. They were not regarded as private property either, but rather as part of the public realm. Meaning, they were accessible and available as objects of contemplation. But they were not accessible and available as objects of purchase and sale. The classical museum is not allowed to sell its holdings. Art emerged out of this gesture of distancing with regard to

the consumer context. So long as I remain in the economic and consumer context, then it's not about art, it's about life. ➡ Thomas Olbricht, 151.

That reminds me of Kant's definition of uninterested pleasure.

No, I wouldn't say that. Because the pleasure Kant was referring to was actually with regard to nature as the object of contemplation. He didn't appreciate art as such. I would be much more inclined to say that the current understanding of art is more Hegelian. In other words, where Hegel says that art gives us the occasion to understand a certain period in time, a certain fundamental disposition of humanity. ➡ Harald Falckenberg, 76. We look at certain artworks from the eighteenth century and believe that we understand what they are communicating. That's an illusion, obviously, but the manufacturing of this illusion is part of the history of art, of the way art functions. It is only with the Hegelian understanding of art history and the art museum as a site where this communication takes place that something like an art system is born.

You have mentioned that basically everything can be called art so long as it is accepted by the art world. In your essay Boris Groys, "Obligation to Self-Design," "Obligation to Self-Design" ➡ e-flux journal 0 (2008). you start with Beuys, who said at one point—I can't remember exactly—that anyone can or anyone is allowed to be an artist.

Everyone is an artist.

And you take it a step further to say, everyone *has* to be an artist.

Exactly. Everyone is forced to become an artist and be an artist. ➡ Harald Falckenberg, 76; and Genesis and Lady Jaye Breyer P-Orridge, 176. Because we are victims of the twentieth-century aesthetic avant-garde, who demanded something like a human right to aesthetic self-representation. In other words, this process by which we create images that others understand—which, for example, is eighteenth century—now applies to everyone. We are judged and evaluated on our ability to produce this image. And everyone does it more or less—with fashion, with their choice of words, by working out, by maintaining a certain lifestyle, by the furnishings they choose for their apartment, and so on. We live in an entirely aestheticized society, one in which we are entirely

forced to inscribe ourselves on this image or add our own.
How can the art world define itself as apart from that?

The boundaries aren't as clear as they used to be. It's rather that we do something and present an image of ourselves at the same time. And professional art consists only in representing oneself. In other words, an artist is someone who does nothing more than cultivate his own image. ➙Antje Majewski, 91. In this respect, he makes a profession out of something that essentially everyone does. And that is something that is characteristic of modernity in general: everyone does everything. We economize a little, enjoy ourselves a little, eat a little, cook a little, etcetera. But there are cooks and there are artists and there are mathematicians and there are economists. Which basically means the professional artist is no longer specialized in the production of whatever artworks—that's long gone—rather he specializes in the process of self-representation. What he makes, in the end, is his own image. And that includes not only what he made, but also how he is perceived by the press, by the media, by society as a whole. And the good artists are the ones who can control that. Beuys was very good at that. Very, very good. He manipulated the media perfectly. And basically, all this stuff he produced— these things are relics of his existence, more than artworks. His whole—and only—work of art consisted in the creation of his own image. If you teach at an art school or have a lot to do with young artists, you notice that they—especially the interesting ones—hardly produce any art at all. Instead they participate in certain practices, certain projects that began at some time or another and are heading in whatever direction. In other words, what you get from them in the end is a website and a biography. Because we can produce things now—we know how that works. Which is why, for maybe the past fifteen years, so-called contemporary art as the sum of certain objects is becoming more and more a part of auction house practices. ➙Harald Falckenberg, 80; and Friedrich Petzel, 198. That means that at some point the auction houses understood that contemporary art, as the sum of certain objects, is unlikely to change. Why did auction houses sell only old Chinese art, whatever carpets, and Greek vases before? Because they keep being the same and always carry the same price tag. No one believed that of contemporary art before, because they thought everything goes in waves and what is true today

is probably not true tomorrow. They were unsure. Now, they're selling modern contemporary art and are sure that the criteria of evaluation, art historical rank, and prices will stay intact for a long time. And that means all of art production is heading in the direction of (a) relics and (b) luxury goods—as you said. What is more relevant for me are these self images the artists create. That basically began with Duchamp. It's not about readymades, it's about himself as an artwork. And this turning of oneself into an artwork, that is basically the same thing artists are doing today—if they're interesting. Nietzsche, by the way, said early on that it is better to be an artwork than an artist. And we've realized that. [*Laughs*]

The art industry still very much lives from this enormous reliquary market—relics of artists who are still alive.

The art industry, yes. But there is a certain limitation in the term *art industry*. Art industry, that basically means the art market.

I have the impression that when it comes down to it, the majority of what museums show—whether it's in temporary exhibitions or in their permanent collection—is actually the same as whatever is being praised by the art market.

I wouldn't say that. There is a lot of overlap, that's true. But there are also a lot of differences. There are art practices that make artists famous where there is almost no art market behind them. ➤Genesis and Lady Jaye Breyer P-Orridge, 188. I can give you names of artists that are very well known but sell practically zilch, have never sold anything and live very, very modestly. I don't want to do that now.

It's strange that you wouldn't want to name anyone. There's something shameful about it. You could also make them into heroes for the fact that they're not dependent on the art market.

Yes, you could—but you shouldn't.

Why?

Because I think it's neither good nor bad. We live in a world with many options, you see. When you choose a strategy, then it is how it is. It is no better or no worse than any other.

But how hard would it be for an artist, who …

Look at Art & Language or Martha Rosler: they are artists who are established figures in greater art history, still they live from their teaching or the fact that they receive compensation for their projects. Wages, basically. They don't sell anything. They do not participate in the art market. And there are many, many more of these kinds of artists than you would think. In other words, places and strategies are very different. And art not only sets itself in relation to the art market, but also in relation to the audience, the public, which consists largely of people who do not have the money to buy art, nor has it ever occurred to them to do so. They just go to exhibitions, they participate in certain projects. There is only a small circle of moneyed elite— Jeff Koons and Damien Hirst among them—that is really doing big business. And the media report on that. But that is only one, particular strategy in the art world, and it is not the dominant one.

We just heard the names Warhol and Beuys. Both of those are artists who—charismatic personalities as they were—also produced enormous bodies of work.

Yes, they were able to maintain that balance. But you see, what was possible back then might not be so possible today. Besides being an important philosopher, Jean-Paul Sartre was also a commercially very successful author. An analogous figure would be impossible to find these days. I do not believe a person can have a career like Sartre's today. Or Picasso's.

Why is that?

Because the audience has changed. We now have a global public situation that can only be reached with massive financial means. You cannot expect that all the *same* people who saw *Titanic*, saw *Avatar*, would also read Sartre. One shouldn't forget, though, that Sartre was writing in a different time and that the same audience that saw movies by popular filmmakers like Fellini also read Sartre. Now the situation is completely different. The middle class is vanishing, and the middle levels of cultural activity are vanishing, too. Even Hollywood, I would say, is on the verge of bankruptcy. The music business has already collapsed. Mass culture was the prevailing foundation of the twentieth century. Sartre and Picasso and Beuys and Andy Warhol were good, artistic natures, and they played with this

mass culture at the same time. It was that game that brought them such fame and commercial success. That kind of mass culture doesn't really exist anymore. It has parceled and fragmented itself. Where we once had a single, homogenous mass culture, we now have little groups, little milieus, most of which connected over the Internet. And this parceling and fragmentation of mass culture will also be financial downfall. Today, if you look at successful artists like Jeff Koons or Damien Hirst, they are famous within a very small coterie of professional collectors. I wouldn't say that they give off as much as Beuys or Warhol beyond that tiny milieu. They play a completely different role in the mass media, in mass culture. Now and again someone will write about how they sold something for a lot of money, but that's more or less it. What they represent, what they're actually trying to say, what their program is, is largely unknown. The mass phenomena that came about in the twentieth century are impossible under the current conditions.

But there are an incredible number of museums opening up, and there are always exhibitions that attract massive audiences, even contemporary art ones.

Oh yes, all of that continues.

If you do an Andy Warhol exhibition today, there would be more visitors than there would have been while he was alive.

Sure, of course. Because he's already established. I wonder what will happen with the next generation of artists, though. I have the feeling the larger public doesn't know them any more. Even the milieus within the art scene are very different and do not communicate with one another. We say *the* art scene, but actually it has lost all semblance of wholeness and the artists, critics, gallerists, and curators that belong to one group have zero interest in what is going on in other parts of this art scene. Sure, when documenta happens or something, then you might have the feeling—the illusion—of an overview. That is a *yearning* for an overview! The fact that there is a yearning only shows, actually, that there is no overview anymore. Otherwise people wouldn't be yearning for it. And then they go to documenta, see about 150 of what for them are completely unknown names and never get any kind of impression, only a certain feeling of helplessness. And that is more or less all that they get out of it.

Olafur Eliasson's *The Weather Project* (2003) ➡ Olafur Eliasson, 37. at the Tate Modern drew over two million visitors, many of them surely people that had been in the Tate anyway. But people could intuitively relate to it. There was a devotion. Eliasson has an exhibition in Berlin right now, and five-year-olds are enjoying it just as much as the adults are. It has a kind of mass appeal.

> Oh yes, but this mass appeal tells us nothing about how accepted Eliasson is within the art world. I mentioned Andy Warhol and Picasso because they were accepted by both the mass public and the informed part of the audience. You could not say the same of Dalí, for example.

Why not? Dalí also did a rather extreme job of cultivating an image, using all the tricks.

> He did, that's true. He tried to go in that direction. But today, we tend to think that he might not have been that successful. Today we think Duchamp was much more successful in that regard. And we know Warhol was very obviously drawing on Duchamp's example, Beuys too. Dalí was not a great role model for them because he overdid it, lapsed too far into poor taste and did not stand in any central tradition. I would compare him to Gabriele d'Annunzio, for example. D'Annunzio had already done that by the end of the nineteenth century. There are very clear parallels between Dalí und d'Annunzio—this is very obvious if you visit the d'Annunzio residence on Lake Garda. He is not a baseline for European art because this overstatement, this poor taste—all of it is interesting and attractive—isn't what we would call the great tradition of the twentieth century. And as sad as I am to say it, Eliasson, by my estimation—although I like his art and so on—does not belong to this tradition. There have always been artists that were interesting to the masses. There have always been artists that were interesting only to small circles of people. There has often been overlap. And as I said before, I have the feeling that this kind of overlap is hardly possible in the time period we are living in now. Not because something has happened in so-called high art—less has happened than usual, actually— but mass culture and mass art really have undergone a major transformation. The Internet and digital media have completely changed the structure of mass culture. It has changed insofar that people watch and read less than they write and show. The

premise for mass culture had been the passivity of the masses. Guy Debord and all the others that wrote about the society of the spectacle, including Adorno, made this assumption: the masses are masses of recipients, and then there are producers who delude or create illusions for them. Now there are no more of these kinds of producers. Everyone posts their own videos and photos and so on on social networks, Facebook, etcetera. Everyone writes, nobody reads. We have a complete reversal of the twentieth-century situation. It used to be that we only had a few producers, many recipients. Now we have billions of producers and hardly any recipients at all. And if you look at this total reversal, then you realize, okay, yes, the Tate is less expensive than a big restaurant. And the Tate is less expensive to get to than going on a big trip to Switzerland. And the coffee is good, it really is. I always eat there when I'm in London: not so expensive, but very high quality. And if there's some kind of effect that will fascinate children too, then you go there with the whole family. You take an excursion. That's normal for a big city where everything is so expensive. But by no means does that mean that Eliasson has gone down in a certain history or has created positions that are respected and related to other milieus. Those are two very different things.

So museums work best if they have a good infrastructure around them: good coffee, maybe even a dolphin show.

Yes, absolutely. We're living in capitalism. Everything that's public is basically collapsing and the people living in big cities have practically nowhere to go. Everything is either expensive or private property. Which means museums assume the role of the church. And why did churches survive? Because they have these relics. They have treasures. And they could organize everything else, too: concerts, readings, this and that. Look at the museums of today. I just saw a new one in Boston, about nine stories high. The collection is one floor; another floor, temporary exhibitions; everything else, ballrooms, two theaters—one for children and one for a general public—a huge lecture hall, a huge cinema, and so on and so forth. It looks like a museum but what it really is is a socialist palace of culture. And they're being built like that everywhere. That is the place where people can go and eat for relatively little money, but under civilized condi-

tions. Where they can see films, can communicate, where they can sit. That is the future of the museum. Then we have the art market, which is largely dictated by the big auction houses. That is the future of the art market. And then we have the new information technologies. Why are artists—en masse, almost all of them—making videos? Because it's easy to produce, easy to distribute, easy to show, easy to reproduce. Photography, but then only digital. Lots of projects that require technology. Lots of projects with sound.

There were the socialist culture palaces, and in the West there were utopian designs like Cedric Price's Fun Palace.➡Hans Ulrich Obrist, 136. A place of activation, of engaging with art. Could that be part of the picture as well?

I think people only start to become active once they're home, in the sense that they participate in all of theses social networks. But all of that could change. An example of something very widespread—in America more than in Europe—is creative writing. Anyone who can write—grammatically speaking—is starting these creative writing classes. They're booked in no time. Everyone wants to write but nobody knows how. It could be that this new wave of relatively accessible art production—in other words, photography, video, interactive art, multimedia, and so on—leads to more and more people becoming interested in doing something half-professional like that and deciding to move in that direction. And that would indicate that art as a tradition is going the same way religion and literature did before. What was once religion became academic theology. What was literature became academic creative writing, and I think what was art is becoming Masters of Arts, of which American universities are giving away more and more every year. This academization of art is advancing very, very quickly. Take someone like me, who gets lots of invitations to participate in this and that event—conferences, publications. In the 1980s and 1990s it was always Art and Commerce, Art and the Art Market. I haven't been getting any of that for years, but what I have by the ton are Art and Knowledge. What does it mean to teach art? What does art mean as an academic subject? Could you speak of a tradition of teaching art in the modern age? Was the art of the modernist era really a break with the academy? Or was it the professionaliza-

tion and schoolification of art through methods like those of the Bauhaus and Vkhutemas? Those are the dominant questions. It shows that art is—at least partially—migrating out of the museum and the art industry and into the academic system.

Which is a loss of significance when seen against society as a whole?

Hard to say. It is very, very difficult to tell. On the one hand you could maybe say yes. On the other hand, masses of people have to be taught how to make images and self-images. That would be the practical effect of art on society. Besides that, academia has a certain ability to guarantee something like historical tradition and transferability. I do not believe museums are capable of doing that. These days they are too insecure, also economically insecure. But academia can do it.

More and more people are producing artistic relics. They do it on every vacation. They're not just taking a few pictures, they're taking conceptual photographs. They may photograph their bathrooms or their girlfriend from only one angle or wearing only one certain cap. That kind of thing happens all the time, without them having to major in it in school.

Oh no! All of these projects would be impossible if these people had not been going to large exhibitions fairly regularly or known whatever famous artists. I know a milieu that does something like that. All of them are somehow tied into the art world in one way or another. Then certain standards start to emerge. If you, for example, were to invite your acquaintances and see these acquaintances' vacation pictures, then you're going to want to compete with them. And because you want to compete with them, you study a little. That means, this teaching of art has an effect on all of society. The anchoring of art in academia will continue to change society more and more in this direction of self-aestheticization. And the artists themselves will become professors. This process is happening everywhere. Look at what's happening in Germany. All of the interesting artists have some kind of appointment or professorship. ➡ Of the interviewed artists living in Germany, all either currently hold profes-

Won't that mean losing something of their charisma?

They've already lost this charisma. The charisma sorships or have been professors Picasso and Warhol had is long gone. The times are in the past. changing.

But you're saying it has less and less to do with the artwork; the artist as a person is the real art. So the charisma is how they teach?

> I would almost say so. Looking back at the history of modernism, the thing we massively underestimate is that the influence of almost all of the artists—Malevich, Kandinsky, Gropius, Mies van der Rohe, Klee—was spread through schools, through institutions like Bauhaus, de Stijl, and so on. Which means that in the 1920s and '30s, charismatic artists were the ones with students, who taught art and tried to establish something like a new way of seeing, found a new intuition, suggest new methods. Then, after the Second World War—under the influence of Pollock and all these people, under the influence of American art—we saw a public figure of the radical, innovative artist develop. If you look back at the '20s, '30s, the avant-garde artist was a professor at the avant-garde academy. And it is no coincidence that that academization of art today is taking a massive cue from that. The most successful exhibition in recent years among the intellectual art and educated circles in New York was the MoMA exhibition on the Bauhaus. Everyone said, finally an exhibition that shows more than whatever boring art no one cares about, but art teaching, methodology, practices, programs, how they did the classes—that's what we really want to see.

Bauhaus aspired to design the world.

> Sure, okay, that's what they aspired to do. But what they did is this: they designed themselves. Which means they trained students in aesthetics, how these students could carry it further into the world. They did not change the world. But nevertheless they established a style, a post-Bauhaus style, all over the world, especially in America. Which means we cannot achieve any kind of global change. But the schools can broadcast into society.

Postwar art—didn't their drawback also consist in that it didn't really want to reach that far? Maybe as a differentiation of the capitalist world against the socialist world? Here you have a product you can buy, and there art only serves a total design.

> Yeah, okay, if you're talking about Pollock or Gerhard Richter then that is true. On the other hand—I've already named several artists from that time, like Martha Rosler, Lawrence Weiner,

Art & Language—in the 1960s they were trying to make something like a Western socialist world and propose projects that were socially committed, that discussed social life as a whole, that understood conceptual art as projects in a new world beyond the commodification and commercialization of art. All of those are approaches that are now being reactivated on a grand scale. ➡ Genesis and Lady Jaye Breyer P-Orridge, 190. Many, many artists understand their projects as the design of social spaces. This entire discourse on participation, on the installation and the place of installation—if you look around a little, there are very interesting art projects working with illegal immigrants, etcetera. I really liked this one project, Fallen Fruit. They distribute maps among poor people and immigrants in Los Angeles indicating which trees are in public space, so the fruit doesn't belong to anyone and you can eat it. On the one hand, it's a joke because de facto it doesn't help anyone. On the other hand, it's a project that suddenly puts an urban space and nature and the people that live there in a completely different context. ➡ Gabriel von Loebell, 51; and Antje Majewski, 102.

What makes a project like that art is that they are limited in terms of both time and space. If you were to say to someone, I'm going to try to do a map like that for the entire world—in that moment, it becomes just another social project. The moment it starts to really help people and becomes more than a symbolic exercise with an especially original idea, then it is no longer art.

I would turn it around. I would say that is a total artwork. Then the entire world becomes a work of art. ➡ Gregor Jansen, 125; and Harald Falckenberg, 77.

But that's not how the art world sees it.

Oh yes it does. It just can't cope. Those are universal projects, per se. They're about changing the whole world. But all people make are models of this change. Our time reminds me very much of the beginnings of Romanticism in the nineteenth century. In other words, in the period after the great revolutions, after the Napoleonic wars, after the Enlightenment, and after the terror of the French Revolution, which was awful and very, very traumatic for people at that time. People talk about the terror of the twentieth century. But the guillotine, that was an image no one could forget. And then we had Romantic art at the be-

ginning of the nineteenth century. This Romantic art practiced something like a total design for the world and for life—but this was restricted to the art world, because the social realm was already closed off by the Restoration. That was an aftermath and at the same time a reflection and transformation of the great cultural, political, and social projects of the eighteenth century. And that's exactly what we have now. We have the art scene as a site of the revitalization of political and social projects—which were also artistic projects, to a certain degree—of the twentieth century, where they are reflected, demonstrated, partially realized, and transformed. It is an experimental field in the time of a certain social, economic, political homogeneity that we are experiencing now and that we also experienced in the nineteenth century.

Criticism of the great reliquaries or their loss of meaning has resulted in a revaluation of performances, installations, interventions. But you might also say that the problem with Pollock was not that he made such biggies but that he made so many, over and over again. That is the capitalistic thing about it. One way out could be the reactivation of the masterpiece as the one masterpiece. In other words, if an artist says that he only wants to make one thing and it can be much bigger than a sculpture that would even fit into the public space. ➡ Philomene Magers, 67; Damien Hirst, 108; and Hans Ulrich Obrist, 136.

> I understand what you're thinking. But I'm somewhat skeptical, because if you create something like that, then what you create is a tourist destination. Something like Graceland. And you also become integrated into the capitalistic economy—only it's in the tourism industry. And we have very often experienced something like that in recent years. We experienced it with Eliasson along with many others.

But the problem with Eliasson's *The New York City Waterfalls* (2008) was more that they were so puny.

> Okay, true. [*Laughs*] But if you make it bigger, then what we get are artificial Niagara Falls, so to speak, and then these artificial Niagara Falls are integrated in via the tourist industry. I don't believe there is any way of escaping commerce. That is totally impossible under the conditions of capitalism. I agree that this overproduction has almost ruined American art. But then again, if you're talking about things like performances, projects, and

installations, then the prospects look a little better. The reason being that what is distributed is the documentation. Documentation doesn't need to be painted over and over again. There is absolutely no demand for the individual artwork's authenticity whatsoever. Once we give up this demand, then this urge to accumulate basically comes to a halt.

But people aren't usually interested in the documentation, instead there are always new projects being made.

Oh no. Certain performances, certain action-based works have already taken on a "classic" character. People are doing lots of performances and so on, they keep trying and trying among their friends or in general, but meanwhile there is a canon. And this canon doesn't require you to keep making new things. Instead it's always the same documentation of the same project that gets shown. Okay, you won't earn very much money with that, but distribution and fame grow pretty fast. You can become very famous without having earned a lot of money.

Could you name an example?

Francis Alÿs is a world star, so to speak. He basically only shows four, five, six, seven documentations of the projects he's made. You could say the same of Santiago Sierra and a few others. I like Francis Alÿs very much, and I am absolutely fascinated by this stuff, but I have to say, wherever I look, it's always the same. I see Francis Alÿs pushing this ice cube through Mexico City. His great topic is the futility of all endeavors and that everything basically leads to nothing. This thought is obvious and well established. But what he did is give it a form that is really fascinating and entertaining.

Compare that to the effect Camus' book *The Myth of Sisyphus* (1942) had. Millions of teenagers and students identified with it. Compared to that, Francis Alÿs is nothing but a rip-off version: much less known, leaves you with a slight smirk.

Most of my younger colleagues have never read Camus. And the association you have and that I have too—they don't have it. People don't read. Camus, either.

Because it's done. Which is why the Sisyphus story leaves only a slight smirk today, because there was a time when this metaphor could really leave you shaken. And that's what I find so interesting about a lot of art

today. You yourself said, there is this examination of the great modern topics, Bauhaus and so on. But it's always just a recap.

> But you see, if we look back to the time of Greek antiquity, then you see Diogenes going through the streets with a lantern; that was the Francis Alÿs or the Camus of that time. That means the futility of our actions is not a new idea. Not even the idea of doing a performance of it is new. Or Francis of Assisi. We have a great tradition that goes far, far beyond the modern and Middle Ages, this preoccupation with certain fundamental questions. These themes have to be presented in the forms that will be convincing to the respective new generations. The great themes themselves remain the same. Because the human existence that they reflect remains the same. We live, die, and nothing remains. � Antje Majewski, 88; Erik Niedling, 25; Thomas Olbricht, 150; and Olaf Breuning, 160. Okay, *that* is the great theme. From that we have other themes. This complex, it may change with genetics, but until now nothing about it has changed. But the art philosophies change because to say that you need a new language for every time, different media, another everyday life, another accessibility. That we can say it applies not only to French philosophy after the war or skepticism in antiquity, but it is relevant to us, here, today. The themes do not become obsolete, but the forms.

Just now you were talking about tourist destinations. Okay, say you attempt to find a new, contemporary form—maybe you just have to accept that. A museum that is very popular in that moment becomes a tourist destination.

> You have to accept that. You have to take a lot anyway. You can't transcend everything all the time. How did Martin Kippenberger put it? You can't cut an ear off every day, right? You also have to accept that you're stuck with only two ears. I think you just have to look at what the conditions actually are and try to make art as interesting as possible under these conditions.

I'd like to tell you briefly about an idea that I have.

> Okay.

Now you have all these things diverging: on the one hand art is moving away from this collector fetish. On the other hand, you have more and more people collecting art all over the world. And to me, collecting also seems like a huge Sisyphus complex. I've spoken to a few collectors

and it's interesting how conscious they are of their own transience. The whole time they also have to think, of course, about the fact that they can't take any of it to the grave with them. Or if they do take it to the grave, then they don't get anything out of that, either. So I thought, how could you actually bring all that together? Meaning this avoidance of the object and then this collector fetish.

> Only if they understand their collection as a kind of self-rep-resentation. In other words, they see it much more as curating and less as collecting. And they feel that they can express themselves or in fact create their own personalities through *what* they collect, ➳Philomene Magers, 70. and develop a relative indifference with regard to the question as to what actually happens to the collection.

The interesting thing is when you look at how much contemporary art has gone up in value since the mid-1990s—that collectors really have problems finding a decent place for their stuff—the problem isn't, as you often hear, that museums can't buy art anymore and all the collectors do is loan it and want to keep all the stuff for themselves. ➳Gregor Jansen, 114. The museums don't want all that stuff, and this is where we get to what you were saying about new museums. They want temporary exhibitions and to save the cost of storage. ➳Harald Falckenberg, 79. And at the same time, these collectors' curatorial activity remains an amateur one. Those are self-taught people, and the professional curators are putting them down. ➳Gregor Jansen, 114; and Thomas Olbricht, 148. So then I came up with the idea that you'd have develop an artwork that disposes of itself.

> Yes, yes.

But one that is so spectacular that it continues to guarantee the collector's fame long after his death. Just this single one, because the specifics of the collection are lost in the end anyway. Who'll know about the Rubell Collection a hundred years from now? It will vanish.

> Yes, that's completely clear. But for starters, I would have to argue that every collection is a kind of unique artwork. Ever since new curatorial practices emerged, ever since installation emerged, we know that art is no longer a thing, but a space. In this space I put certain artworks that I bought, with furniture, with personal things, and so on. What I create is an installation, and this installation is one of a kind. If these things become scat-

tered, that means that *this* artwork—*this* installation—disappears. Just as it is when you do an installation in a museum, break it down again, then the individual things go their separate ways. Think of Marcel Broodthaers' projects, where he only loaned from other museums. And then, once he had given the objects back, his artwork was gone.

But that kind of arrogance doesn't work for collectors.

It doesn't work yet.

There is enormous resistance.

I know, I know. I only want to say that what remains of Broodthaers is the documentation. And I think this understanding of art as an event or as an eventful installation will eventually be carried over to collectors, too. So I tend to think that with time, collectors will also start to see their collections as installation artworks. ➡ Thomas Olbricht, 151. I would almost say it is the task of the critics and curators to teach them how to do it.

Let me tell you my idea. There's a mountain, it's at least a few hundred meters tall. You could also see it as a temporary installation, but one that only consists of one object. From this mountain you carve a pyramid, like a sculpture actually. This is—at least from our current point of view—a futile battle with transience; the pyramids in Mexico and Egypt are the perfect symbol of that. Now you make another pyramid like that, but even bigger, which would be the tomb of a collector. You take his egomania to the extreme. But then when he dies and is put into the tomb, it will be buried again in the debris that had been carved away and will turn into a mountain again.

[*Laughs*] You should suggest this project to a collector. I'm not so sure it's going to work. ➡ Thomas Olbricht, 151.

Why are you not sure?

You see, these days people don't worry about their souls so much, because they don't believe in a soul. But they do worry about their bodies and their corpses. And so this collector will want some document to be signed saying that everything will stay the way it was the moment they were buried.

You mean, the mountain *won't* be poured back on top of it?

I'm assuming …

But that would sabotage the artwork.

Yes, yes. But that's what they will probably do.

That's exactly what is so interesting—that you would have to take on that hurdle.

Yes. And you don't document it; everything vanishes, so to speak.

The pyramid will remain visible so long as the collector is alive. He can thoroughly savor his narcissism until the day he dies.

Okay, but then?

After that there is only the documentation, like the installations that you described.

But there is documentation?

Yes, that's inevitable. You can't forbid people to take pictures. It is a huge ...

So then the real artwork would be the documentation.

No, it's the temporary installation.

Whether or not a collector sees himself within a performance is an interesting question. Let me tell you, it's not particularly important *how* you design this performative character of the collection. The important thing is that the experientiality of art is understood at all. Marinetti made a big issue of it at the beginning of the twentieth century—the fact that art is less a collection of objects than the memory of certain events. Art is experiential. Art is something that happens in time. When *that* is understood, then we've already come a long way.

But this temporary pyramid is also an update of Sisyphus as collector. Instead of it being like Alÿs—where a kid keeps trying to kick a can up a mountain in Mexico or a VW bug driving up the same steep incline over and over again—first you really execute something major in terms of milling this pyramid out of the mountain, or digging it or whatever. And then there's this element with the collector as a mummy, as a rotting corpse or as ashes who's really going in there, and then disappears with the artwork.

Yeah, okay, that's Egypt as a quick run, so to speak. I agree that the Egyptian circumstances are also relevant to us insofar as the Egyptian civilization was also materialistic to a certain degree. They attended to the material side of the body, to the mummy, more than the soul. And that is somewhat consistent with our time, for sure.

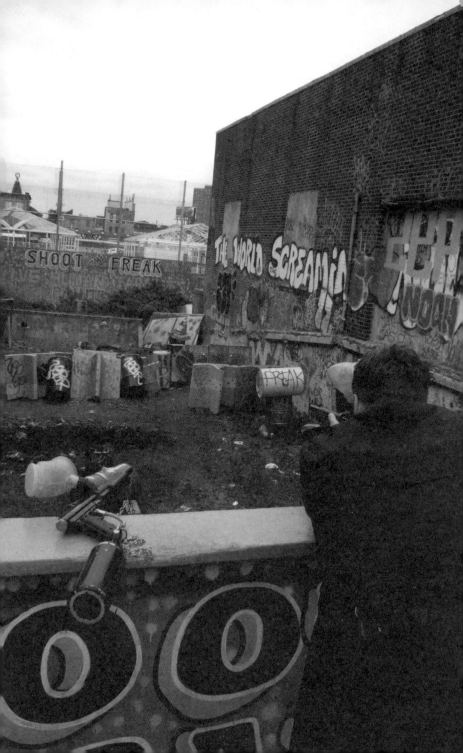

Erik Niedling

ARTIST PERSONA
SHOOT THE FREAK

Back at the hotel on our last night in New York, Erik Niedling and I begin to put together a preliminary summary of our trip. That day we had been on Coney Island and had tried to build a sandcastle as tall as possible with our bare hands. Afterwards, at a carnival attraction called Shoot the Freak, Erik Niedling shot paint pellets at a shielded and helmeted human target.

Well, what are we going to do?

We're moving the coordinates somehow, well for me anyway.

What changed?

I've decided that I've been focusing too much of my attention on the so-called work, in other words, the product, the goods. That the emphasis wasn't really balanced right. ➡ Antje Majewski, 91; and Boris Groys, 221.

Where should it have been then?

On the foundation.

And what's the foundation?

The concept. I've always heard: discourse, discourse, discourse. I've been hearing that since I first started my practice and it was always a totally abstract term. I always kept a lookout on the discourse front and all I saw was fog, and now I have the feeling that, at least for that moment, I was right there on the front line and the fog had started to thin out.

What's going on there?

I had imagined something like a bright room that someone

grants you access to. Once you're in it, everything around you is radiant. And the goal of getting into this room turned out to be an illusion. There are levels of your own awareness, and there are levels in the reception of the work by a third party. The degree of complexity has, in my view, gone up to an extreme degree and that hasn't made it any easier for me. But at least I have a few coordinates now. Whatever that's supposed to mean. Because I want to continue making art, not to the point of complete self-abandonment, but rather as a necessary tool for coping with everyday life.

How does art help you?

It is my catalyzer. Every time I've been at the point of saying it isn't working anymore, I'm giving up, I'm doing something else, the world is so big, the world is so colorful, then I always immediately get the feeling that a void would open up. It is my way of consuming the world. I wouldn't know if I could even do anything else without art. Whenever I made a music video or album cover, ⟶ Erik Niedling was the art director for the label 1st Decade Records from the energy or the feeling of being ca- 2001 to 2008. pable of doing that comes from my preoccupation with art.

What is it about art that you like so much?

When I was really little, still in kindergarten under socialism, they always asked us, what do you want to be when you grow up? Back then my standard response was always a scientist. And then everyone slapped me on the back and said, that's good, Erik. A scientist—you can help move things forward in socialism, you can make a valuable contribution on the way to communism. And then I always said, well, no, not the kind of scientist you all are talking about. My childhood understanding of a scientist was someone in a safari helmet digging things up somewhere and moving earth and exposing things with brushes, and back then it probably held a kind of childish adventure aspect for me. Had I known then what I know now and you would have asked me what I want to be when I grow up, I probably would have said an artist.

Why?

There just aren't any limits, really. You can basically do what you

want as long as the art world responds to it. And that's exactly what I haven't been doing in recent years. I might have been too anxious because I thought, okay, first you have to prove yourself and do something solid in order to get recognition and compensate for the supposed weakness of having had a non-academic education. Once there's a basis of recognition or once the gears are turning in the art world, then I can do what I want. And now I've actually arrived at exactly that point. I haven't reached the base camp on Mount Everest yet, → Olaf Breuning, 162. but I have a gallery, I have an exhibition practice, I regularly produce art, and now, through the film, I've gotten in a very compressed form what I was missing in terms of an academic art training.

Both of us are the directors of the film and at the same time we're observing each other while we do it. We're conducting an experiment, an experiment on ourselves.

Yes, exactly.

Now we really are these researchers with brushes. [*Laughs*] We're actually brushing ...

... the dust off of ourselves.

Yeah, the others are actually our brushes.

Mmh.

They don't necessarily know it. They're brushing their normal movements, and what we're actually doing is—like a car driving through a car wash.

Yeah, yeah. That's exactly the image I was thinking of just now.

And now you just have to maneuver the car through in such a way that by the end ...

... it twinkles ...

... clean and clear ...

... and glitters.

So, I keep trying to achieve this within the film. I've entered into it and am also conducting the interviews in such a way, setting them up so that they help to move me along, so by the end of the film I have at least conceived of a seminal work of art.

With almost every interview I've had this kind of flash; I stood there and my whole body vibrated, I really could feel physical

effects within me. So it's really hard to predict what's going to happen next.

You're actually the biggest unknown right now.

> Yeah. I plunged in there, down under the ice and am still not sure where I'm going to come up again.

Yes.

> To me, the film itself keeps taking the form of an artwork more and more. Even if we were to delete all the material tomorrow, it would have done things to me that no one can take away again.

You could see the film as an artwork; our journey alone could be seen as an artwork. And I'm going to develop an own artwork, too—*Pyramid Mountain*. What do you think?

> This making of the supposedly biggest, best piece of art in the world is also a shelter. It shelters you from routines and from this whole artist thing. On the one hand that's incredibly attractive, on the other hand I see a problem with it because it will always make you a special case in art history and in the way it's received. The piece you're developing now—in its grandiosity, in its dimensions, its complexity—isn't necessarily dependent on the idea of it being the only thing that you make. But maybe that's overkill. ➡ Philomene Magers, 67; and Damien Hirst, 109.

But it comes from somewhere; you can retrace all of the things that came before it.

> Yeah, but is there an afterwards?

Who knows. Maybe I will do more things, they just won't be as great.

> Maybe they'll be even greater.

We know that Salinger had manuscripts all over the place. He just never published anything again.

> And now he's dead.

Maybe he burned everything before. Maybe it's still there.

> Well you're just the …

It's just that the first thing I consider when it comes to every standard in the art world—as I come from a whole other profession—is, yeah, but is it mandatory? I of course see why galleries are so intent on having someone constantly crank things out. That is totally important if you're selling original artworks, otherwise you'll never get anywhere with col-

lectors. You need bullets. If you only have one … But I also see this flood of things. Everyone's actually suffering from this huge amount of art that's being produced. The great thing about art is that you can take it in incredibly quickly. Think about how many books you're able to read and how many are produced in a year, in that case the situation is just hopeless. Whereas until just recently in the art world, you were still in the luxurious position of being able to say, I know the hundred most important contemporary artists. I'm damn sure that I know them all. That's how everyone was walking around still in the 1990s. They already had the Internet. But even the art world is showing signs of exhaustion from this enormous expansion in recent years. ➡ Hans Ulrich Obrist, 128; and Gregor Jansen, 116. There's moaning.

> Picture all of it in one big pile: just the annual output of the top thousand.

And that's why I only want to do *one* piece that will even disappear again.

> Yeah, but you can't forget one thing, and that is the day after. You thought it all out, maybe it's even been sold, it happens, and the day after is … this is about training.

All of it's training. You could pull so many art pieces from my books— they already exist—and with everything I end up writing afterwards it will be the same.

> Yeah, but hey.

All I'm saying is, right now I'm just going to start out following the *one* idea of *Pyramid Mountain*. I see it as compelling and cannot see what else should come of it. Of course it could happen at some point. This idea came out of the Great Pyramid, too. I don't have the energy to re- alize it. I don't have it for this artwork either, I can only realize it if a col- lector is there with me from the beginning. But it is conceived in such a way that a collector really could execute it. The Great Pyramid is not collectable, but this pyramid is. It's the collector that completes it.

> I am indeed having a hard time imagining you standing in front of a mountain with a blueprint in your hand and giving direc- tions. Aren't you?

That isn't necessary. I can just sell the artwork before it's realized.

> In other words you don't care what the pyramid ends up look- ing like. It could be out of red-brown granite, but also yellow

sandstone. The angle of the slope isn't really important, only the basic form, the chamber, and that it's going to be poured over again later.

I'm defining a minimum height. The angle of the incline it takes to reach that height is irrelevant.

For me, setting criteria is what puts the meat in something. And maybe all I want to see is this little, crumpled scrap of paper where it says, this high, this wide, so and so. Imagine if a rock were to fall on your head tomorrow and I would have to try to make something the way you had in mind.

Engineer Heiko Holzberger is the one that ended up deciding how big the stones would be for the Great Pyramid. ➡Appendix, 303. I hate determining those kinds of things. I really have an aversion to building. Now we have yet another construction on our hands, but we bypass the problem in that it is taken out of this mountain, and it disappears again in the end. The artwork expresses my discomfort with the very thing that's so tempting to you about it.

Maybe at some point the film will be seen as nothing more than the prequel to the great artwork by Ingo Niermann. Maybe the film is an artwork in itself. But for me, after ten years of art production, the film is my personal base camp. Everything I produce as art in the future, no matter what rhythm, no matter what medium, will be influenced by what I have experienced here.

Fine. But the problem I see happening with the film is that at some point the film will be over. And whatever is grumbling inside of you now …

… no one will know about it.

Because you look exactly the same as you did at the start of the film, you walk exactly the same, you're wearing the same clothes and there hasn't been any new art created either.

The thing that could be realized for me in the film is this work on the image of me as an artist, because there I was being torn in two different directions. I always thought, you're not going to put on a felt hat now, you don't have a curly beard, and you aren't going to put on a white wig. That's totally ridiculous. On the other hand, you have people like Ruff, Demand, and Richter who elevated soberness to the level of principle, and in the end

they've got their silver wigs on too.

Yeah, Thomas Demand going for an evening swim with bathing trunks and towel in a leather briefcase after slaving away in the studio all day—German quality craftsmanship.

I always tried to push aside parts of my personality—not one that I just made up, just the one that's the way it is or developed that way—because I could never really get a clear idea of the effect. I'm going to change that in a pretty radical way now. I'm not the guy in the colorful hat. But I'm probably the one with a rifle shooting paint pellets at people. I'm the one who said to his assistant ten years ago, hey, that's an incredibly good idea. Let's put on boxing gloves, and then we'll beat each other up until you're totally smeared with blood and then I'll take a picture of you. I'm also the guy that's storming around in the attic, breaking open boxes and tearing down walls to get into whatever old archive material. I'm really Indiana Jones. I have this feel for adventure within me, but it's also tied to a sense of exploration. I feel completely drawn to Ernst Jünger in that respect.

Well then, we still have what Ernst Jünger liked to do.

Take drugs.

Yes.

There is really only one drug; everything else is just for fun.

Exactly.

[*Knock at the door*]

Christian Görmer:➙ Our cinematographer. Oh, you guys have to let some air in here, there isn't any.

We don't need any air.

Görmer: You're going to kick the bucket.

Tobias Rehberger

THE ARTWORK AS PROBLEM
BIG ART
THE ARTWORK AS RUMOR

Boris Groys diagnosed a growing academization of the art world. ➡ Boris Groys, 227. *Regardless of whether or not I find a collector for* Pyramid Mountain, *without academic recognition it cannot become part of the history of art and therefore cannot become its future. Back in Germany, in Frankfurt am Main, I meet with two artists under whom many successful artists have studied to see if my artwork would live up to their standards: Thomas Bayrle (*1937) and Tobias Rehberger (*1966), also a former student of Thomas Bayrle and Martin Kippenberger. I start with Rehberger. His centrally located, rear building studio covers two floors. One is his workshop, the other his office. Rehberger's personal room is crowded with Eiermann desks. A windowpane allows him to keep eye contact with an office assistant who sits facing him. We begin our interview in the afternoon, as all of the other employees are already leaving for the day. Rehberger, as his New York gallerist Friedrich Petzel has already explained, is categorized as part of relational aesthetics.* ➡ Friedrich Petzel, 206. *Coined by French art theorist and curator Nicolas Bourriaud, this term designates art that defines itself primarily through social interactions. This might also explain Rehberger's excellent reputation as a teaching professor at the Städelschule, with students including Danh Vo, among others.*

This is the room you usually work in?

I work everywhere in the studio, of course. But whenever I need peace and quiet, I come here.

I see a lot of pens here, pieces of paper. So you also draw?

Yes, very classic. Usually as a preliminary study for an idea. Whenever I articulate something for the first time, it usually happens

247

with regular old pen and paper. Usually it's not just the idea, but a few things come together. And when I have the feeling that there's enough substance there, that something might be able to come of it, then I start to draw. All of these tables are standing around here because a lot of times I spread things out and let them lie there, sometimes for months at a time, and look at them every three days or so.

But you don't consider the drawings themselves art?

Sometimes I rework them in a way that they could become works. But the majority of these idea-sketches are really just an aid to memory and to have a very rudimentary look at how something could look. Usually there are various stages of development that sometimes involve the computer. And at some point there might be a model, sometimes the drawing goes straight to the workshop.

The ideas, where do they come from? Do you just have them or …

Well, sometimes you just have them, but only because you were tinkering around with something else before. They don't always come about in the same way. If you're just carrying a problem around in your head then they could come to you in the grocery store. But sometimes I do just lie down on my cot here and try to focus my thoughts on something. It isn't always successful, but I think the fact that I sometimes think about something in a concentrated way and then let loose a little, they sometimes come back from the periphery of the brain—like a net you hit a ball against and at some point the ball is thrown back at you.

You mention problems that you then go and try work out. What constitutes a problem?

There are ideas that are directly related to a concrete exhibition situation. But you also consider things like: What characteristics do I use to determine quality? How are they decided? Could I also articulate them in a different way? Do things exist outside of my status quo of how I think about art that could nevertheless be relevant? The bottom line, to put it very basically, is of course, what is art anyway? And why is one thing described as art and not something else? It's never like, okay, now *this* is art and that is why I'm making it. It's more like a guess that this could also be something. Let's say, I don't know, a cigarette

lighter could also have something to do with it. Why doesn't art make fire? And who says that's not a criterion for an artwork anyway? Or why am I saying it to myself? So the work isn't really the solution to the problem, but rather an articulation of the problem itself. Often there's a piece that's maybe already five years old and I start to see things in it that I didn't necessarily understand before. It's a very vague and very wobbly, sensitive process because it's about getting to a point where you assume things that reflect your own insecurities and inscrutabilities. Those are the moments where I would say, that's what makes it a work of art.

If I think about your earlier work … you did artists' portraits in vases, for example—the thought being something like, couldn't a vase portray something?

It wasn't just a vase; rather the whole piece is the flower bouquet that the portrait subject decides on without knowing what kind of pot it will be placed in. And that of course implies ques-

tions like: What happens if you remove the bouquet? Is it just a vase then? Or is it half an artwork? Or is that the piece that I made, and the bouquet is the work of another artist, another person? Those are the kinds of questions I'm dealing with. In other words, when does it turn into something and when not? A flower bouquet doesn't last forever. Not all flowers are around in every season. There are processes of uncertainty in the way I am to understand an object like that. And that's actually the case with all of my work, because I'm never really sure of my own status. In other words, I can't say, now I'm the artist and that's how I'm going to do it! With me it's more of a wobbly moving-towards-it.

You asked museum guards to knit ...

... to knit sweaters, yes (*A sweater for my best friend*, 1996).

Or they had to wear a gold necklace.

They could. There was underwear, too. At the Venice Biennale I made underwear for all the guards (*Underwear*, 1997). The underwear was given to them and they were told, it would be nice, or we would like you to have them on while you're performing your guard duties. But I never checked how they put them on and they didn't have to show that they had them on before they went out onto the parquet. It was mostly an idea of projection. What happens if someone goes there and asks the people, may I see it? How important is it to see something anyway? Is art really something to look at or is it rather something to project onto? Can this be looked at with your eyes closed, even in your sleep, and does it then do something with you, or do you do something with the object then? To the end, this underwear work is fairly close to what I made for the Venice Biennale recently, with this sculpture that was a cafeteria (*Was du liebst, bringt dich auch zum Weinen [Cafeteria]*, 2009). Where it was actually very much about *not* looking at it, very much about what is whirring and flickering around you, but not this idea of a purely confrontational situation.

Do you also allow collectors to participate?

Take these vases, for example. Suddenly all anyone wanted from me were vases. So then I started saying, I am not making anymore at all. But then two, three years later I brought them

in again as an ongoing project that I've continued to this day. I said, a portrait like this can also be a very classic, commissioned work. In other words, these days it mostly happens with collectors that want to have a portrait done and where I still make the pot and they define themselves through picking out a bouquet. And then there's a criteria that I decided on relatively ad lib at some point: I have to have dinner with someone at least once, and then I feel competent to portray him. Which leads to situations where someone that I do not know at all invites me to dinner so that we can do a portrait. [*Laughs*]

Have you done that with other work as well?

That is actually the only piece that has this kind of very classically formulated commission structure. There are of course other situations where collectors invite me to do something in their garden or something in their house. But it isn't that they can then go and say, I'd like to have seven lamps in that corner or something like that. The way it works is rather that they invite me and I then go and look at their house and just try to come up with something, without any parameters from their side. Well okay, there are maybe parameters in that they say they would like to have something in a certain room. But not, there was this such-and-such, I'd like something exactly like that.

But you not only furnish rooms, you also really reconstruct houses?

I myself can't say anything about furnishings at all. For me they are always sculptures that could be furniture and could be a vase and could be a house. These functional aspects are actually only like material. That is part of the concept, it does something very specific with the work, but it isn't furnishing anything in the sense of, I'm going to go and make something that's just going to look good and fits in the room. This work in Venice, for example, it wasn't about doing a cafeteria in itself. Rather this functional moment is, in my opinion, totally important for this piece because it actually isn't supposed to be looked at. [*Laughs*] Instead you're supposed to go there and perform another activity, and then it's there, too.

How big can a sculpture be for you?

I don't think it has anything to do with dimension.

And what was the biggest thing you've made until now?

Funnily enough, I'm now making by far the biggest piece I have ever made—it's for the Essen Capital of Culture 2010 exhibition. Namely a sculpture that is also a bridge over the Rhine-Herne Canal between Essen and Oberhausen. That's over 450 meters long, and those really are unusual dimensions. [*Laughs*] But I wouldn't think, oh God, that's 450 meters long—is it still a sculpture? In other words, I can also imagine a sculpture that is so small that it can't be detected with the naked eye. ➙ Hans Ulrich Obrist, 136.

How did you design the bridge?

I'm a little bit of a bridge fan; they've always fascinated me. And then I started to think about what a sculpture could be that could be relevant as art or could raise questions, but at the same time is also a bridge. So I started to think about what kind of object can even span a distance like that. Is it lines or is it circles side by side or … ? And then an engineer came in pretty early and explained to me why some things just can't work at all. [*Laughs*] But that's always a challenge for me or I think it's fun to get these spokes thrown in my wheel and then to have to rethink something all over again. And then we played a kind of ping pong, the engineer and I, and got closer and closer until we were at a point where I could say, this is now my sculpture, and he could say, but this is also my work as an engineer insofar that it really is a bridge.

What does it look like?

The first main element is a black spiral—a horizontal spiral made of aluminum that winds up to a certain level, because it is after all a canal that ships have to pass through. It bends over the river and winds its way back down the other side. The piece is called *Slinky Springs to Fame*. Slinky is this children's toy, a kind of metal spiral that can walk down steps. And the second main element is a path, a relatively thin surface that has a very brightly painted, striped pattern and moves through this spiral. The spiral is constantly assuming a different position relative to the path, so that it also runs a little high, low, left, and to the right.

You teach at the Städelschule and are notorious for your long class discussions. Are they really that long?

Yes, it's true, if there's enough to discuss—we just had one

yesterday that was ten hours long. It is pretty intensive—I'm relatively straightforward about saying what is maybe worth reconsidering, but never try to give someone the feeling that I'm trying to lead him or her in a certain direction. It's more about the problematic parts of a work. Sometimes they're formal, sometimes they're on the conceptual side. I try not to beat around the bush. Sometimes things are also so foreign to me that I find it extremely difficult to talk about them. It would be easy, of course, if it were only about accessing parameters that I use in my own work. It's just that I don't believe in that at all because these art students or young artists, in the end they have to make something that I myself had not been yet capable of thinking. That is why no one is in a position to teach anybody anything. Art doesn't work like that, that you say three and three is six, and it is forevermore that way. It is rather more of a question of whether three and three is really six, again and again and again.

Yes.

Yes. [*Laughs*]

Then I'd like to use you, and tell you about my idea.

Okay.

There are certainly other reasons that I write, but I noticed that the thing that puts me off about art is its materiality. That you're dealing with objects, objects that you also have to worry about and take care of. Even if you make videos, you're constantly having to set up spaces, in other words think about: Is the video monitor bright enough? Do I paint the walls black? Do I do the floor as well? What kind of a bench am I putting in there? In that moment you are already dealing with objects again. Really always, because it always comes down to these spaces.

Once one of my students made this great piece. He shot a film, really sixty minutes long I think, with actors and a camera and everything that goes along with it. But he didn't put any film in the camera. There wasn't any particular documentation by a photographer or something. It wasn't a performance either, rather this film was made. It just wasn't captured in the usual way.

Did the actors know that?

Nope. No one knew it but him and the cameraman. In other

words, you can do things that are completely immaterial.

I was just talking to collectors, and there I noticed that it's a burden for them, too.

[*Laughs*]

I had always imagined them to be these people that just love collecting these objects. But they're completely aware of the burden that comes along with it. Especially after their death. I was talking to Harald Falckenberg and he said that when he dies, he doesn't want his collection to have his name on it. ➡ Harald Falckenberg, 81; and Thomas Olbricht, 151. It doesn't even have to exist anymore. It's actually a process and then it's already gone.

> Yes, I think there are those like Harald and then there are definitely others that have the idea that it's something enduring. ➡ Friedrich Petzel, 201.

Anyway, what I'm trying to do is …

[*Laughs*] Okay, sorry!

No, no, not at all! I thought about bringing the cumbersome and the enduring and the ephemeral together.

> Okay! [*Laughs*]

Something that stays connected to the collector long after his death and at the same time has also disappeared—that's the idea. It starts like this [*begins to draw*]: you have a rather rounded mountain, in other words more like a hill. A hilly mountain. And in there is actually a pyramid. You could say that the pyramid is actually an abstraction of a mountain. All you have to do is …

… the excess, sucking away the fat, so to speak.

And this pyramid serves as a tomb for one collector. It is actually quite large. I think at least 200 meters high.

> [*Laughs*]

In other words, it's the biggest pyramid in the world.

> It would definitely have to be a collector that takes himself somewhat seriously!

Yes, of course! It's surely one of the biggest structures in the world in terms of volume. On the other hand, it's also just the remains of a mountain. Temporarily you could also take the rubble and just …

… have a picnic on it.

The shape of the burial chamber wouldn't matter to me at all. I personally don't imagine an angular, Egyptian type, but more like a speech bubble, where—this would be the condition—the collector's remains will have to be placed. The collector can also take whatever he wants in there. If he wants, he can take his art collection. And after that, the whole thing becomes complete because then the mountain will be restored to its former state.

 The soil would just be poured back on top of it.

And then the trees will just grow back. So that the pyramid, by the fact that is it protected, can stand much, much longer than the Egyptian ones. The Egyptian pyramids will have long been reduced to sand and this pyramid will probably still be there. And in it is the collector, possibly with his collection, too, which at some point can be discovered by the coming civilizations. But to be considered a work of art, the

pyramid must not be uncovered.

> Yeah. And [*pause*] what do you like about that? What are your parameters?

It's at the same time ... it's an artwork that disappears again.

> Disappears visually?

Yes. So then there's the question, does it still exist?

> Yes, that is absolutely a very good question. That's actually the kind of thing I'm working on, too—does an artwork have to be seen in order for it to exist? For me, a work of art doesn't end with its materialization. I also don't see at all why the pyramid itself has to be the artwork, just because it appears more formally defined than the hill that comes on top of it. The trees on it are just as much a part of it, as is the soil that's poured over it later.

Exactly. Only then is it complete. And of course it needs the collector's remains. With this idea—that that's what completes it—I thought about your vases, of course. What I'm also interested in is that this narcissism of collecting is taken so far over the top.

> In other words, that the collector also makes himself part of the artwork. Completely, so to speak.

But then again, because of the fact that this maximum exposure in the form of a pyramid disappears with his death, it could also mean that this actually rather unspectacular, hilly mountain will pass into oblivion.

> Well, but we always have a certain fascination for places where we know that a lot has happened below the surface. Of course it says something specific, but I don't need to see this pyramid at all for it to be legitimized as an artwork. The quality of the work increases, rather, by the fact that I *don't* see it. And it gets at certain assumptions about how art can actually function. That it is a statement about how for someone, at least the person who made it, it becomes relevant that the most exposed aesthetic articulation—the pyramid—is no longer visible. You could also imagine that the more interesting state of an artwork is when it is completely destroyed. I can imagine there being some kind of fences at a distance so that you can't even get close to it. And nevertheless that would still be the work—even if no one would see it.

All of that would be up to the collector. It's about this process.

It's not only about the process. I think it is important that this thing is there—even if you were to imagine that no one would ever see it.

Otherwise you could say, there is a pyramid in every mountain. That would be boring. There has to be some serious digging there.

I completely agree. Even if no one realizes it. You could even take it further and say, if no one had ever known about it, except for you and the collector, and no one would ever perceive it and it were also never unearthed, would it still be an artwork? In other words, if it's impossible for anyone to ever recognize it as an artwork—that's still an artwork as far as I'm concerned.

I would only have to be assured that it really happened.

And that is such a super interesting problem!

The evidence could be destroyed immediately afterwards.

Yes. But at the same time that articulates the opposite, so to speak—would it be enough if you are only assured of its credibility? You are assured of its credibility, and you believe it too, but it never happened, does it then have the same quality it would have had if it had actually happened and you were assured of its credibility in exactly the same way? For me, that would be something where I'd say, that is a great problem. Is it enough to just tell someone about it and assure its credibility?

Somewhere in Eastern Europe—in the former Yugoslavia, I believe—there is a mountain that looks a little pyramid-shaped. And a few years ago, someone just said, there is an ancient pyramid under there. Pyramids were built here, too. And then they started digging and this mountain became a giant tourist attraction. I never heard anything about it again.

[*Laughs*]

The farmer that the mountain belonged to could collect ten euros per visitor. And the people walked around on this mountain, which had always been there, and suddenly thought, wow! We have an ancient high civilization here, too.

Or some also enjoyed their own uncertainty and walked around there and said, hmm, is that really how it is or not?

Everybody was a kind of hobby archeologist, doing a little digging around. That could happen to *Pyramid Mountain*, too. So maybe

that's part of it, that you never say where exactly this mountain is. Because otherwise people would immediately go there and try to expose the pyramid.

> I once made a piece dealing with exactly that kind of problem, or something similar. It was in Mulhouse in Alsace. There's a potato field in the middle of the city. There, a filmmaker friend and I made a little animation that invents a kind of fairy tale or legend about a golden potato that was planted at some point in front of the gates of Mulhouse, resulting in a relatively large number of potato fields. Because of these golden potatoes, other potatoes grew very well and got to be very big. A completely invented story, but told a little bit as though it were an urban legend. And I actually did bury a golden potato in this potato field. But that's only a rumor and a legend. No one knows if this golden potato is really in there or not—except for the people that helped me bury it and the jeweler that made it. And if someone goes digging around there in 500 years for whatever reason …

Nobody's done any digging yet?

> No, because it's understood as more, okay, that's an artwork. But there's also the idea that someone could maybe be digging around there in 500 years and they'll find this golden potato and then the legend will be legitimized.

If I really want someone to dig this pyramid and then cover it again, what do you think I would have to do to make that possible?

> You'd have to find a relatively megalomanic collector and pitch it to him as clearly and appetizingly as possible, convince him that it is such an incredibly great and amazing work of art that he'll put up the necessary funds. There are always these examples of fairly crazy actions and there are always people willing to go in for very weird and reckless and strange things. The probability is unfortunately not so great—mainly because it has to be 200 meters high, [*laughs*] but I wouldn't rule it out completely.

Thomas Bayrle

SINGING MACHINES
MAO & THE ROSARY
THE PRODUCTIVE FORCES OF THE IMAGINATION

After the interview with Tobias Rehberger, I present the Great Pyramid and Pyramid Mountain *in a lecture at the Städelschule. The next day we drive out of Frankfurt into the Taunus hills, where we visit artist Thomas Bayrle and his wife Helke at their summer house in Weilmünster-Essershausen. They serve us lamb casserole and herb salad from their own garden. Bayrle's work has continued to garner international acclaim in recent years. The work shows a rigorous seriality: bottles out of countless bottles, cars out of cars, geese out of shoes, women out of breasts, women out of eyes, cans out of cans—just as the Great Pyramid is a giant grave formed out of millions of individual graves, yet Bayrle remained skeptical at first.*

You were born in Berlin in 1937.

My mother is from Frankfurt, my father is from Swabia. And we were in Berlin because back then my father had set up an exhibition about Africa for the Reichskolonialbund [German Colonial League]. We were bombed right away at the beginning of the war. We chose to get out, and first moved to a little village in Hessen, then to Frankfurt.

Your father continued to work as an ethnologist?

He worked at Frobenius, like my mother. They met there, at the Frobenius-Institut for Ethnology in Frankfurt. And both were in Africa. My mother wrote her dissertation on Franz Marc and was traveling with Frobenius in Libya. And my father was in Abyssinia with Jensen.

Okay, so we then came to Frankfurt, where I went to school up until getting my secondary school certificate, and then I went to southern Germany for an apprenticeship. I wanted to be a designer in a textile factory. I went to Göppingen and Öhringen and learned textile finishing and weaving. That was a very tough job in those days. That was real factory work. I worked my way up there until I became an assistant foreman. There were over 250 automatic looms there, and you had to run around to keep these looms going on a constant basis, because if they'd stop, the piece wages would go down. Back then, the women got 1.80 Deutschmarks an hour. Then I worked on a loom myself—the noise was hell. Compared to that, every disco is a graveyard. Because there was of course no protection, nothing. You stood there in an unbelievable hell, in the bang, and you stared at your loom, day in, day out, looking for flaws. Meaning you actually just stood there, the machine racing, the little fly-shuttles racing, and you watched. It was no great challenge to almost fall asleep. I plunged down, so to speak, under reality. As

every worker did if he could save himself to some degree—he went to the lowest level of perception and tried to shut everything down. And in my case I immediately started having proper daydreams. ➡ Genesis and Lady Jaye Breyer P-Orridge, 179. It didn't involve any kind of intellectual accomplishment. I just immediately started picturing cities: millions of streets, ten times the size of Los Angeles—of which I'd only heard the name. Or Tokyo. So I thought, all of these fibers in front of me are streets in ten times Los Angeles. I really imagined it like a micro-architecture. And at the same time there's this humming of the machine. After a while something happened that prompted me to leave the company. At a certain level the machines began to sing—to sing like humans. Meaning at a certain frequency the material, the spool started to take on human tones. And I thought, man, now it's getting dangerous. Now you're hearing the rosary you heard as a kid coming from the motor. So I left after two years and said, never again! And at first I just completely suppressed it, ten years. Until I came back to it later in a different way at the applied arts college, because something also started to build in the composition of books: letter, word, sentence, page, book, bookshelf, and so on. An accumulation that could minimize or maximize itself and actually has no limits. Along with it came a shifting, so that you could zoom into the tiny and imagine it huge—or the huge tiny. And that the whole is in every detail and the whole consists of details. So basically lots of truisms if you're in a line of work like that. In Chinese philosophy, which I later became acquainted with through Mao and so forth, they actually applied the same notion to society as a whole. And this doze—it remained a very important initial spark in that direction; I can only see everything as interrelated. I can't separate at all, instead it is all a continuum and it pervades every material. It is also a continuum in the temporal dimension, backwards and forwards. As Jean-Paul Valéry put it, every incident is inevitably also an atrocity. In other words, every millimeter is great and gruesome at the same time, because it can hardly be borne. Yes, a piece of a shirt or part of a pair of trousers is a crazy thing, something you have right there on you. And adapting that structure to a body or on the coming world of consumption, which actually appeared in a vehement way starting in the 1960s, that wasn't so hard either. I had already gotten to know the ma-

chines, what they put out. Bambambambambambambambam! The chocolate candy pieces came thundering out from the back end. Or at a bottling plant: dangdangdangdangdang! And of course no one questioned anything in 1965, it was just great that something was pushing toothpaste into tubes day and night. It wasn't until 1967, '68 that I really started to think about it. We started a reading group with Helke and four, five others and read not only Mao and Marx and Engels but Sweezy and Keynes, too. In other words we also read Western regime critics or analysts. And so it was a kind of world expansion that continued to roll itself out piece by piece. At the same time, this question of meditation in front of machines, that always stayed with me somehow. Because as a kid—the only Protestant in a completely Catholic place—I always snuck into the church nave. In the afternoons I saw the old women, how they sat there in the middle of the church like black clumps, murmuring. And the murmuring is something close to the machine. I always came back to this singsong. When I'm at a huge party, for example, and thousands of people are garbling over each other. Or you read all this gibberish blowing out of every hole every day, and you turn the volume down, make it a little darker. Then everything comes out blablabla ... woahwoahwoahwoahwoah ... and *that* is what the rosary understands. Precisely because it was in Latin, this murmur was a wonderful, warm mass created by these black clumps of maybe six, eight old women that just did it completely automatically. They meet, it's three in the afternoon—so, who's going to start? The first prayer leader ... whack, there it goes. And then they'll just tick it off. It is so refreshing that when it's over, they all laugh.

They are completely happy and awake. Associating this with the machines, at first I felt completely forbidden to do that. But over the years I ... for example, through Wilhelm Worringer, who wrote about the Gothic period and saw the Gothic as the advent of the machine because the Gothic period brought precast elements from different regions together for the first time, like a conveyor belt in an automobile factory. The St. Charles's Church in Vienna was built in ten years. Where it had taken over 100 years to build a cathedral before, in France they'd gotten it down to twelve years by 1250. In any case, very soon after that I started to connect how engine manufacturing is done and how

cathedral building is done. Another thing is that like a cathedral, the architecture of an engine as [Nikolaus] Otto developed it is highly efficient. The Catholic Church, especially during the Counter-Reformation, really pulled out all the stops to get the renegades back into the boat. It really is a very calculated machine—for some years now I have been going back to it even though I had actually rejected it before. This is hard to explain, but now I just identify myself as a Christian person—and I rejected following this idea that there was a total link between these voices and the machines. But because I've been hearing for years all about how machines are so awful, we have to return to nature and so on, now it's really the last straw. All of our wealth, our entire culture is thanks to this so-called perversion. And so I said to myself, I'm not even going to think about taking off into Buddhism. I'm going to stay where I am! Because that's my culture that I have to go ahead deal with. And in the last few years it became clear to me that I really want to finally materialize that: the beauty of engines and the greatness of this development is placed in parallel to the beauty of the rosary's singsong, or liturgy in general. The rosary is really a global phenomenon; everyone has it—however they may call it. All over the globe, there are billions of hands moving through the beads. Bead after bead. And every bead is an accomplishment. When I let a bead pass, then it's like 200 combustions in an engine that it has created and transferred to the axles. That's what I am sitting in, the thing that's driving, that takes me forwards. And this activity of prayer, it came about during the Gothic period—all of this is pure speculation—where every family had sixteen, eighteen kids and every family stuck a boy or girl in the convent or monastery. And they had to labor there just like everyone else on the acre in that they had to pray; they had to meditate for hours on end. The people there sat in the dark and prayed sixty prayers for grandpa, sixty for grandma, twenty-four for good weather, thirteen for the potato harvest and so on and so on ... meaning they just worked through it. And this accomplishment, no one was standing beside them saying, all right, please pay up. Instead what they did was purely abstract. They sat there, they spoke these prayers, and the impression was like that of developing a negative in photography, for what was demanded positively from the Renaissance on. Because of course the Medici

wanted to see the prints. They weren't content to have someone sitting there, meditating nicely; it was more like okay now, here [*knocks on the table*], output. You could see the production we have today as a perverted meditation that is changed over into material, into realization. The Medicis just planted 300,000 olive trees and completely ruined all of Tuscany as people saw it at the time—which is only so wonderful today because it's old. And all of these wonderful achievements, they are—and this doesn't take a huge leap of the imagination—were extorted under violent conditions of labor, squeezed out. The Gothic period still left the people alone. They knew: Karlheinz, he's going to pray me twenty-four Hail Marys and my leg will get better. They still worked on a personal level. I do see quantity as quality—also in consumption, in everything. Many is just more than one. Though of course I know that it depends on the quality of the individual things accomplished. But nevertheless, quantity, not only has it not been seen for a long time, it's still feared in the art market. Five of something is too many, there is always only supposed to be one. Which is complete humbug, of course, because with so and so many thousands of Volkswagons you put out, every individual car is also something. And this question of quantity, it was resolved very early on with machines in China of Tibet, for example. Those were actually machines, the prayer wheels. That either the wind provided for, the fact that there were ten thousand machines. Or even this touching prayer wheels with your hands, where you walk by it and then it keeps praying so and so many times. There's an account for everyone. And this account should be as well looked after as possible so that you would have plenty of the good and, if possible, none of the bad or evil. Example: I was in a church in Italy just before Easter, and everyone sat there, lined up like birds because they wanted to confess. All of a sudden the priest came out of the confessional and said, I have to go over to the bar and drink a coffee! Everyone stayed sitting there, he went to the bar, had a coffee, came back and carried on. This pragmatic element is unbelievably beautiful—that we're not on our last legs anymore and he can't listen anymore because he's just hungry and wants a coffee. Sure, of course it went without saying. There were at least fifteen people waiting there still, like in the waiting room of a doctor's office, waiting to whisper something in his ear. I think

that's just brilliant. That society, when it's working, is a machine in the best sense—a machine that has different outlets, different valves and gears, and different clutch disks that can flange on something or let it alone.

What does your work with engines look like?

My brother spent forty years at BMW. And two of the gentlemen that build engines for me now were colleagues of his at BMW. They're two sons of farmers that had a farm between Munich and Passau, they just set let the cows out and the machines in … and since then they have only been doing special contract work for BMW. Through my brother, who does the drawings for me, I have the engines cut open so that all the inner workings are exposed like a demonstration engine. With that, I mix the sound of the nuns with the sound of the machines so that it creates a trance. And this sound is placed right under the motor, so that I have the feeling I had back then, when I put my ear to the engine block—because I did sometimes have this delusion that the nuns are locked up in there, in this machine. They're sitting in there, praying and praying that they'll get out. Those were their whimpers.

Just now you mentioned a strong interest in Marxism and then in Maoism. Could one say that you were also a Maoist for a time?

Yes, indeed. Because my parents were at the Frobenius-Institut I was exposed to other cultures very early on, in the 1950s—which was very difficult in Germany—and at home we also got into Asia and China of course. But in a very humanistic sense, naturally—philosophy and so on. Confucius, for example, who had all the military discipline and so forth, but also this adding down and up—in other words, I heard very early on, as a child, about this quantity into the next quantity and vice versa. The first *Mao*, I made that one as early as 1964. Back then you couldn't get a picture of Mao in Germany. The only way I found a picture of Mao to work from at all was when we were in Italy, in an Italian newspaper, because here there were only "blue ants," that was obvious. I saw the machine in this Chinese social model, too. That's what I wanted to show with my *Mao* machine, where little by little, there is a new generation growing. It wears a star, and the others go under, and then another one comes up and brings the face of Mao. We read him in our

reading group, too. And I was very impressed with some of his work as a poet, because has he had a very strange—or actually very normal—take on something like the law of gravity, for example. That was absolutely original. To us, the law of gravity is the object's weight and the earth's pull, done. He brought in the bird feathers—there goes our simple, physical law. There you see: that's pretty sharp. Or even the Cultural Revolution—not what one had to experience later on. Once you really saw it for exactly what it was, Maoism was of course over. But still it's true: Mao freed this continent from the Japanese, English, Germans, French—from everyone romping around there—and united this country for the first time. Even though the West was throwing stones in there until the end, with Chiang Kai-shek and so on. That is absolutely an accomplishment. In other words, it's at least fifty-fifty. But it's more; it's sixty-forty. He pushed it through and called it a day. It's time that we recognize that. China is just great. So then Deng came along and shot down another truism: namely that when you're communist, you're poor, and when you're capitalist, you're rich. All right, it goes both ways. Meaning they can emulsify. And this emulsification, that goes all the way down into the food, all the way down to the last little morsel. That permeates the feeling that we as Europeans either don't want to perceive or were ultimately too insensitive to recognize. Now the Chinese have learned a great deal. You have to study your enemies—that's one of Mao's sayings—instead of saying, he has nothing to offer. Study until everything is out in the open. And now we actually have to do the same if we want to have any say in the future.

Something we haven't talked about yet—how did you then become an artist?

I am a great skeptic and for a long time I called myself a teacher. I feel more like a teacher than I do an artist. Not that I see that as being so successful or something. The boys and girls that made it would have also made it without me. But I saw that I have a societal clump—hundreds of individuals—that I also wanted to let in as input and out again. I realized from the start and went ahead and told them, I actually can't do this. I don't know that much. The only thing we can do is exchange. I'll tell you what I know, you tell me what you know, and so on. To

this day I'm skeptical—no palliation whatsoever—about what it means to be an artist in the first place and I'm amazed that it works at all. The fact that there is actually a level where that can be enforced somewhere. In any case, the doubt is always on my mind. For a long time I had doubts about art commerce; I made ads, kept taking side paths where you'd say, man, do you have to put yourself through all of that? Can't you just get to the point? But all of these detours, all of those are Chinese too: if you want to reach your objective quickly, make a detour. Questioning all of it wasn't such a bad career in the end. For a long time we only had writer friends, for example. For a long time that was much safer and more important to us than getting involved with painting. The only thing I was sure of was the material quality of the work. The woodwork underneath was always important to me. What was that? Was it canvas? What was its weave? Which knots did it have? Meaning I saw the whole thing very micro-architecturally and for a long time I didn't think, what's on it? And if I didn't, then I often tried to reconcile whatever was painted with whatever it was painted on. In other words, a material quality, how something is woven, how it is put together, that was where I started to do it, too. But I would never turn into the proper artist who does production. Instead, every piece gives me a headache—is that really something or is it nothing? And besides that, I think other people—yeah, I can go ahead and say it—are much better than I am. There are just people that can do it better. I honestly have to say that Tino Sehgal's concept is really super good, because he takes dance as a point of departure, as production, as a factory. And avoiding environmental pollution to the point of denying a certificate is a radical, brilliant thought. ➡ Hans Ulrich Obrist, 135. Or Forsythe, too—the way the human body is conceived as a machine or a process of production. Radical thoughts like that would never have occurred to me. And I think that's fantastic. Whereas these fantastic things we saw rolled out in minimal art seemed obvious to me. It's just that a utopia has to appear in society, too. We have to see that we get something going. And that is movement. Movement in every regard. Forwards—that sounds wrong, that's only in one direction. It's just: now, now, now, now, now—forever. I honestly have to say that our getting to know each other is something refreshing in that respect. I also have the good fortune to have

such good artist colleagues, young artist colleagues, they just don't sleep. They keep it going.

When I was first telling you about the idea with the Great Pyramid, you seemed skeptical.

> Yes. The fact is, I pictured it too much in social terms, also with regard to its feasibility. I thought it would only work with a section of a religion and I hope of course that—as do you, and how you also had good results with in your competition—it becomes an overlapping reality, integrating at least a broad part of society and also countries and religions. I also made a few designs for myself. The works with film, where film serves as a material, came out of that. I just thought that every person gets a film image—in other words it's on a much smaller scale. Not as a 90 x 90 x 60 centimeter cuboid but as a film image that you can also experience. I imagined it as being a little bit more like Boltanski. But I have to say it is great how you all have democratized it in the tightest possible parameters. Yesterday during your lecture it also became very clear that it has to do with provocation in the sense of thought provocation and a provocation to action. Also the boundaries in there, or blowing up this mortality in such a monstrous way—that will set something into motion.

I don't want to give away the first pyramid idea, but now I've already gone and worked it over again ...

> Yes, yesterday I thought it was really fantastic. That this dimension of time also comes in: everything is made and then poured over again—in other words, this mortality of ideas as well. And the nice thing is that this is kept in balance. That a pyramid is built and afterwards there's a mountain or a hill and after some time no one is sure if there really is a pyramid under there. I think that's very important, this uncertainty. That we become uncertain of reality in a way. Yesterday I also heard about a piece by Bruce Nauman where he poured a concrete block over a tape recorder. And that's too single-lane for me. There it's clear that there's a cassette in there and that it isn't working anymore. But *here* it's not clear if the pyramid is still in there after some decades. Yes, it could even be a fairy tale. I think a very important aspect of it is that it's a motor for the imagination. In other words, reviving the imagination as a productive force. It's like this Hans Christian Andersen story where a man's shadow sud-

denly breaks free of the man—which is horrifying enough—and then the shadow becomes independent and even starts to fight and compete with the man. In other words, a gruesome dimension that continues to become more and more gruesome is also part of the tale. And of course we have a crazy imagination for what is going on there, what comes after, what happens to us, and so on. But yes, maybe we're competing with our shadows. Or here, this pyramid—was it really there? No, it wasn't there at all. Whatever cirrus grows over it. And then suddenly it's a hill where people have parties and so forth, in a much shorter time than in Egypt. Yeah, there was a pyramid down there, and there are still thousands of dead inside! In other words, a place that simply switches the imagination on.

Hans Georg Wagner

SLIGHTING CASTLES
THE RIVALRY OF COLLECTORS
THE AMBER ROOM

Wachsenburg Castle, Thuringia, Germany. The most elevated area in the "Drei Gleichen" of Thuringia is Wassenberg, where the Wachsenburg Castle, built in the tenth century, sits. Hans Georg Wagner has privately owned the castle since 2001, and the family operates a restaurant, a hotel, and a museum there. Choosing a possible site for the pyramid would be premature; the decision should rest entirely on the buyer. The question, however, is where to find the ideal mountain.

We drove here by car from Frankfurt, heading in the direction of Berlin. There is a lot of wonderful, hilly land to see, the Thuringian Forest, and suddenly you find this ideal, almost pyramid-like mountain with the Wachsenburg Castle on top.

The mountain is 421.2 meters above sea level. That's the highest elevation here in the Drei Gleichen region. And that is of course what makes this castle's location so unique. You can easily see it from the highway, and from the castle you can see very far out into the Thuringian countryside. The abbots of Hersfeld—among the most intelligent of their day—they of course put some thought into finding the perfect place. Running along what is now the A4 autobahn was the oldest trade road we know, Via Regia. And naturally they wanted to protect this road and their landholdings. If you look at the Wartburg Castle, for example, there you can only see to the front, to one side. To the back you see the forest. Whereas here you have a view in all four directions.

When you buy a castle like that, what kind of magnitude are we talking about in terms of purchase price?

> Well, the purchase price wasn't the decisive factor. We—my wife and I—were of course extremely aware that the management costs alone would be immense. Most people don't believe it—since we have been here (for twenty years), we have not received a single cent or penny of subsidy money.

You have to meet certain guidelines?

> Yes, but there we really made an agreement. Meaning we would not change anything about its distinctive exterior. And the interior is not monument protected because most of the renovations happened in the late nineteenth century. That was in the time of historicism. Back then there was this romanticizing way.

And the core?

> The core of Wachsenburg Castle still exists. The oldest part of the building is the northern wing, or the *Dirnitz*, as they called it in Old High German—that structure is from the thirteenth

century. Those are the two core buildings. Then the Kemenade, which is Old Greek—it means women's area—is from the seventeenth century. The only thing that is relatively new is the Hohenlohe Tower, it's from 1905.

I have been working on a project for some time now. It's the idea of building a very large pyramid in Germany. One bigger than the Egyptian pyramids.

Well, that's of course difficult.

But now I have a new pyramid idea. I thought that it would be much easier to take a mountain and basically carve the pyramid out of it.

The way they used to chisel the pyramids in stone. Or the tombs.

Exactly. Then we thought, okay, but where can you find a lovely, ideal mountain like that, one you could get a pyramid out of? And, well, there's usually some castle on top of it.

Yes, yes.

The pyramid is supposed to be an artwork, a tomb for a rich collector. The special thing, though, is that once he's dead and buried, the pyramid just disappears again. Then the old discarded material is poured back on top of it, trees are planted on it, and it is restored to its previous state. Now the idea is—when every one of these ideal mountains has a castle sitting on top of it, then you would have to temporarily remove the castle.

Yes, it's just that we should have done that a few hundred years ago. There is a technical term for it: back then they razed the castles, in other words, flattened the land. No one would do that now! If you take our castle wall, for example—which is a substantial part of the castle—it is 270 meters long and some six to nine meters tall in the middle. If you were to build a wall like that with the current costs, you would be up to four to six million euros for that alone. All you would have is a fortress wall, you wouldn't have a structure, you wouldn't have anything.

In other words, you're saying it would be very expensive to clear away a castle like that and then rebuild it?

It wouldn't make any sense. The statics were completely different back then. This part of the building, the so-called Palas, has casemate cellars—those are cellars under the cellars—where

the outer castle walls are between 3.80 and 4.5 meters thick. Not a soul on earth would come up with the idea to build a 4.5 meter-thick wall today. These two things in America, from September 11, they might have had one-meter thick walls, if that. Back then, of course … you had rocks, you had sand, but you didn't have this adhesive agent that keeps sand, water, and so on together—which is why they made it that thick.

Assuming I find a collector that would say, I'm going to be part of this pyramid. I'm going to allow myself to be buried in it. And I think this mountain here, with this castle on it, is perfect. And I'm also prepared to assume the costs for dismantling the castle and building it again. And the monument preservation office would go along with it as well. What would the collector have to pay you?

I haven't really considered that in principle. Because for me, one of the main things was that because we have children, our children would take over the property and it would remain in the family for a hundred years or so, if you can plan it like that.

Say the collector was sixty years old. How old would he get? Eighty, ninety tops. You would only have to leave the castle until then. Then it could be rebuilt. What it would really be is a temporary hand over. You could almost call it a loan.

One should never rule anything out in this world, that much is clear. But I think that might fall a bit in the fable category.

So if I were to find a crazy collector like that … collectors are prepared to shell out 100 million for a painting, after all.

Yes, but you can't mistake one for the other. I've been versed in that scene for about thirty years now. And I have been to many auctions in London, Vienna, Munich, and so on. And these absurd prices that come out of there sometimes, those are of course contingent on the fact that, for one, there are at least two potential contenders. Meaning there are about 400, 500 people sitting in a hall in these big auctions like Sotheby's, Christie's, or Dorotheum in Vienna. You've raised your hand for the first time. And then it gains momentum. Then they call out in the hall: fifty more. Then you raise it again. That's happened to me so many times. I have often gone over budget because the brain takes a backseat in an atmosphere like that, all you do is hand movements. ➡ Philomene Magers, 65.

g des Germanischen
e sich der Binnensee
ichte Meeresbucht, in der
e Sande zur Ablagerung
nden bildete sich der ca.
elblichgraue **Seeberger**
idstein), der schon seit
onders am Seeberg bei
Röhnberg für allerlei
stein gebrochen wird.

ion widerstandsfähigere
t die Gipfelregion der
enburg" und ist hier
. Er lieferte teilweise das
urganlage.

STEINMERGELKEUPER UND GIPSKEUPER (

Vor 200 bis 235 Millionen Jahren wurde
Thüringens verschiedene Gesteinsschic
Oberen Keuper abgelagert. Sie gehöre
Zeitalter der **Trias** und sind Bestandteil de
riesigen Binnensee des Germanischen B
gips- und kalkhaltige Tone und So
Kalkschlämmen und Sandschichten a
Jahrmillionen der **Gips**, der **Sch**
Steinmergelkeuper. Letzterer besteht a
bis dunkelgrauen Mergeln und den cha
hellgrauen bis graugrünen **Steinmerg**
vegetationsfreien Steilhänge an der „W
Burgberges wurde in früheren Jahrhund
in kleinen Steinbrüchen gewonnen.

Rätsandstein

Steinmergelkeuper

Gipskeuper

Okay, so your advice is to find not one crazy collector, but two?

Like I said, one should never say never. Here, lay down a bank guarantee and you can do whatever you want. [*Pause*] I wish you the best of luck with your search.

Thank you very much.

But I think you will have better luck finding the Amber Room than finding someone. Although there are some. I heard the Japanese completely rebuilt a castle in Japan.

Now that you mention the Amber Room, there is a restricted area close to here—aren't there rumors that it's there?

Well, there are many, many rumors, the seriousness of which is highly doubtful. What we know for a fact is that the Americans were here on the Wachsenburg fairly early on, 1945, and that various things were started from here. Count Stauffenberg was very often up here. His binoculars are supposedly still down

there somewhere in the well. In other words, I can't imagine that valuables of that kind would be kept up here. I have also never tried to open certain doors and stone walls.

So they say the Amber Room is really up here in the Wachsenburg?

Yes, there is speculation to that end. The potentates from 1933 to 1945 were also up on the Wartburg and had this wonderful golden cross taken down. They were up here, too.

5:
Epilogue

Meadow

At the end of our journey, Erik Niedling and I are resting on a blooming, Thuringian mountain meadow near Ilmenau. It is mid-June. The nights are still cold and damp but the sun is strong; after several hours of discussion, our noses have turned red.

How long have we been at it now?

Fifty days, you said. That sounds about right.

In any case a lot more has happened than I had planned or expected. I couldn't have pinpointed that as a destination because the place as such was still unknown to me.

And what kind of place is that?

It's a place that is permanently in motion, but where there is a kind of stillness, contemplation.

You're actually the ideal viewer for our film.

Why?

If we edit the film well, then it will contain the exact same thing that triggered this change in you.

I'm now noticing that I can really follow my individual phases of evolution in the film. I can hear how tight the knot was in my voice, the choice of words I used, and the speed with which I came to whichever emotional point I found myself in. And it's only in the discussion at the Jane Hotel that it went away. ➡ Erik Niedling, 239. And then the hypnosis, ➡ Marcos Lutyens, 209. where at the time I wasn't sure if it had hit me or not. But the next day, I suddenly had all of these things going on in my head.

What will you do in the future?

All of these different fragments came together for me after the hypnosis. I had always dealt with history in the past, or rather social reflections on certain events—I'm going to keep doing that, too. It's just the form, in other words the receptacle for this kind of research, will be different. It's not that all this is completely new—all sorts of artists deal with their own lives or rather document it. It's just that now I'm thinking, I'm going to go back

and deal with just a single day. In *Redox* (2010) I dealt with a single day, a day chosen at random—and by burning the newspapers I partially destroyed the information contained in them, condensing it into a big melting pot that consists only of fragments that are hard to comprehend and connect together.➡ Erik Niedling, 25. And I've been thinking that I'd like to let this process run in reverse. In other words, I'd like to pick a day from the past and reconstruct it, a day where some very important and defining experience happened to me as an individual, at best one that involved several different people or groups of people. A reconstruction would have to happen in such a way that I would find a reporter, a journalist, a TV news team so that the participants in the event don't end up feeling unsettled by my presence, or without me influencing it in one way or another. The reporters will interview every individual that participated in this situation; will create sound, image, and text documents. In the second step, these reporters and I will collect information on everything else that happened on that day—from this point, this little cell of individual experiences that is turned out into the world—what other catastrophes were going on in the world on that day? What political events? What other threatening scenarios were going on? Out of it will come a library, an archive. This archive will also contain a collection of relics from wherever this event took place. And I will create work from exactly this material: photographs, sculptures, installations. Picture a container, maybe a shipping container, some kind of industrial thing. Maybe it's black powder-coated, and inside of it is a kind of drawer system and every artwork has its place. And there's a monitor in the back of the container and a huge hard drive. This hard drive contains all the basic information previously gathered in the research process. And then this container is transported to wherever the exhibition will be held and I start filling the exhibition with work from the container. And from that moment on, this process of pulling the work out will also be documented. In other words, I also understand the installing of the exhibition as a performance that is again documented and added to the other material in the black box. The idea is actually to ask, what happens to the artwork a hundred years from now? In a hundred years it would be exhibited maybe five, ten, twenty times, and will document its own history. Meaning

the artwork is never completed. It continues to develop more and more, becomes independent in a certain way. So that even a third party could open the container, follow directions, and install the artwork when I'm gone. And they can always come back to the point and see the way people handled this material in such-and-such a way ten years ago. Fifty years ago, they did it completely differently.

What kind of a day would that be?

Several days would come into question. Just now I've set my sights on one day in which I consumed drugs with a larger group of people in my hometown of Erfurt—LSD. Completely unintentionally, it was just for fun, but it developed into a situation with a fairly abstruse group dynamic. The outcome of which was that I came to certain decisions that led to my becoming involved with conceptual art, even though I wasn't exactly conscious of it at the time. I was in my mid-twenties. Our group dynamic developed into a state where no one could communicate anymore. Where things happened, things were discussed, activities carried out that rendered everyone completely powerless. And that stayed with us a long time, long after that day.

What happened?

I don't want to talk about it now. I might also pick another day.

How did it lead you to conceptual art?

Well it had really practical effect, namely that first of all I withdrew from the whole party business. And that lead to me using the time to think about what I wanted to do with my life. I was already taking photos back then, though looking back it was a little aimless. I then started reading in a more directed way and compensated for art historical deficits. And then, this was a really important point, I read about Tobias Rehberger, ➥ Tobias Rehberger, 247. that he had furniture rebuilt from memory. Suddenly there was a concept that I could really follow. Back then I did have a reference to the modernists, to Bauhaus—I could really relate to design, fashion, furniture, interior design. I sat around in the province and had seen nothing, I knew nothing. And suddenly I learn about an artist that had twentieth-century design classics rebuilt from memory by African craftsmen and I notice, hey, there's a huge world out there, and if you some-

how want to be able to participate in that world, then after this phase of rebellion where you think you're the greatest, the most fantastic … I tumbled from that state directly into the humility phase, where I saw what has happened in the past 150 years. Yeah. Can you understand where I want to go with the work? Because for me it's only a system in the end. Theoretically, I could develop one kaleidoscope after another until I die—taking days from my past as a point of departure—and put it in this container and send it on an endless journey. Like that probe they shot into space with a record in it. So basically I'd make time capsules. I wouldn't send them out into the universe; I'd send them out into the art world. And there they would become more and more loaded with information.

I don't like this container.

The container is actually just an image for …

It reminds me of eToy, the Swiss artists' group. They want to boil someone's biography down to a USB stick, and then they have a container that travels around the world, and they plug the stick in somewhere, and then add a little bit of this person's ashes. I think you'd have to develop this receptacle yourself. The receptacle is definitely a sculpture, which is why you could also just …

… come up with one myself. I also thought of that, yes.

Is the research an open-ended process or does it end at some point?

It's concluded at some point.

But it can never end. The thing I like so much about the idea is allowing for this war of materials to take place, as you normally would do only with a historically set date like 9/11, where everything is documented: who sent what text message, who called whom, who was in a radius of such-and-such meters, who else took a picture? What I liked is that you do it with a very private moment, one that has happened to many others in a similar way. We met up with Gregor Jansen. How did he end up getting into art? He was rock climbing, had an accident and wound up in the hospital. ➡ Gregor Jansen, 113. Youthful impetuousness followed by a moment of contemplation. There's no rule for how much you get into it. You can keep sending new researchers to the protagonists. You can also send the protagonists in a room ten at a time—I don't know how many people were involved.

Yeah, it was about ten, twelve people.

You could put all of them into one room—encounter therapy. ➙Antje Majewski, 92.

> I also thought about if it should be about this one day until the end of my days.

Yeah, I think it would be much more radical than saying, whatever, and then I'm going to open another container and then day Y goes into that one. If you do it, you'll have to completely dedicate yourself to this one day.

> At that point, connections, cross-connections that I'm completely unaware of, things that might have also happened on that day. Meaning it's a mycelium. And what that will mean concretely in terms of artwork is still completely unclear.

Are all of them even going to fit into this container? That's what I don't like about this container, either you design it as something virtual from the beginning—then it's just a hard drive—or you could also pull together the furniture from back then or reconstruct it. The setting.

> Exactly. That's what I was saying. It will incorporate original relics from the place. The gray cabinet that's sitting in my studio now was sitting in the very same room in which it all took place.

Maybe you should use this cabinet as a starting point and just tell the history of the cabinet. Then it's obvious that the cabinet's exhibition history has to be documented, because it continues to be about the cabinet. But I think the thing with the day is better.

> The cornerstone of the whole thing is …

Well okay, you could also start with a day and then wup-wup-wup it's the cabinet.

> I'm not setting off on a search for an archive, rather I'm creating the archive for myself.

And with every new realization you have, with every new exhibition you've also changed the world a little bit. And you could meet everyone again.

> One idea that I really like is not to bring the works together physically at all, but only the image or the documentation on the hard drive—that that becomes the thing that moves through time. Maybe in 2070—I'm dead—a curator would only have the hard drive and then the task of putting together the work they see on the hard drive.

The thing that puts me off is just that. Okay, until then the research has been concluded, and then the artistic process begins. Let's assume you become world famous with this piece. Then your night with these people becomes a global event. On Wikipedia it would say, "On this day in Erfurt, Germany, a few young people sat around and tripped their heads off." Even if a few of them shut you out and say they're not going to be part of the research, other researchers will come and deal with those people. You have to react to this dynamic, and you also have to aim for it.

> In my artistic practice until now, there has always been a moment in which I concentrated on what was there. There was always this point where I said, okay, that's it. The glass shards, that's what we've swept up and there aren't any more than that.

But the moment in which you yourself are the one putting together this archive, and are still living ... that won't prevent you from setting a break point over and over again.

> Right, there shouldn't be a cap on it. Which is why the container thing doesn't make any sense at all. The container is way too hermetic. But the hard drive is good. Did I ever show you my *Black Boxes* (2005)?

Yes.

> What's in the *Black Boxes*? I made it a secret. Until now I've kept every bit of information that goes beyond the medium of photography, every work, every conceptual approach to myself, and only communicated it with very few people. I've kept all of it classified because I didn't know how I'm supposed to hook it into the world out there at all. And now, with the film, I can open the box. And I just know the places where it belongs. I know I can go out there now. Maybe that's why I picked the container as an image, like a kind of stall. The little sheep come out into the meadow and do their thing and in the evening they all come back in again.

Do you know Duchamp's ➡ Antje Majewski, 96; and Boris Groys, 215. *Box in a Valise* (1935-41)? It was wartime, and he just made all of his work in miniature form so that all of them fit into a box.

> That's basically the same as my idea with the hard drive. And if I have a big sculpture ... it was always clear to me that that would of course pose a limitation.

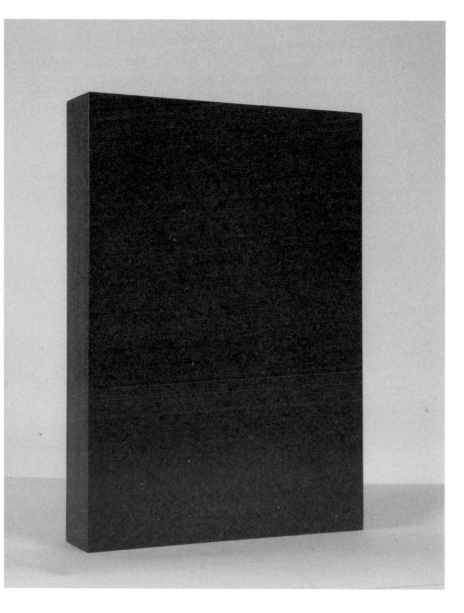

Erik Niedling, *Black Box #01*, wood, glue, lacquer, hidden content, 40 x 30 x 7.5 cm, 2005.

Yeah, you could make a huge ...

> ... dugout canoe.

You could reconstruct the space on a 10:1 scale. Not ten times smaller, but ten times bigger. A pyramid, the biggest structure in the world could become the very space you all were back then. You could be the collector that buys my pyramid. And when you die, you put it all in there.

> Will it all fit in there? Maybe all of it's really small, I don't know yet.

But the nice thing about it is the size of both the pyramid and the burial chamber are still up in the air. You just have to take a smaller or bigger mountain.

> Okay, collector. If you'd want to start using the term collector ...

Collector just means you purchase this receptacle, and that is *Pyramid Mountain*.

> Not bad. *Pyramid Mountain* is just the shelter for this day.

So that solves one fundamental problem with my piece. We met these two collectors, and they're just not thinking of themselves as great enough. ➡ Harald Falckenberg, 73; and Thomas Olbricht, 145.

> The collectors are also just saying what they believe people want to hear from them. No one wants to hear them saying, he's the greatest, he's in it for the posthumous fame, more money, and that somewhere there's a big sign with his name on it. No collector is going to tell you that, even if it were true.

But that's how it would be perfect.

> What's perfect would be to just jump over this flaw in the work—the fact that you probably won't find anyone that wants to do it—by saying, okay, you'll sell it to an artist.

Sell it ... I can also just give it to you.

> I can work for you. I can work off my debt.

Compared to what the pyramid construction costs will be, the purchase price could only be symbolic at best.

> In other words, you give me the pyramid as a repository, but I have to bear the cost of construction myself. Then my becoming a superstar is practically unavoidable.

With this piece, yes.

Because I don't have enough money otherwise.

Do you realize, now we can work for each other on different levels. In other words, I can also offer to be a researcher for you so that you become a superstar.

Actually I would only want to send you out to talk to the people. The whole time I've been thinking, is that presumptuous? But you wanted to do a big interview with me anyway. Maybe that's the big interview.

Yes, exactly.

There were a few times where I thought, hey, fuck, now Ingo's going to do the pyramid, which I let go of at some point. ➡ Erik Niedling, 32. There wasn't this option of me being able to incorporate that into my creative process. And now, of course, it's come to this point where I can say, okay, I have to get into a position where I can build the pyramid. Meaning I need money. I need lots of money.

You once told me you want lots of money. You also said that you want to build a collection. So, you have all of that in you.

I'm going to walk a little ways. I'll be back in a minute.

What are you doing?

I'm going to walk across the meadow.

The sludge?

Yes. It's also getting in my shoes.

Just now I thought that you were doing a pretty good job of staying on top of it. How do you manage that?! Is it your ingenious Clarks soles?

I'm going to walk across the water.

You look so green right now. Oh my God.

Yeah, but Ingo, look, look—the funny thing is before we were talking about who of us is Faust and who's Mephisto.

Yeah, you just can't separate the two anymore.

Sure you can. I sometimes have the feeling that I'm a test person—in other words, what you meant by a perfect viewer. And seen in a Faustian light, you're the one that's promising me eternal success. So if through the film, in developing your work, it comes to a promise that I just have to fulfill, then I'm the one in the Faust position and you're Mephisto.

Erik Niedling, *Forst #03*, C-print, 145 x 180.5 cm, 2004.

Yes, you also want to always continue to be an artist, and I wanted to do something that is complete in itself. That interlocks in a very complex way—as it never has before, I think. It really could be that the novelty of this work really consists of how ... [*Laughs*]

... it came about?

Yes. But also how entangled we make everything.

Do we want to take a picture? I'd like a picture of us.

Sure, why not.

That's actually quite pretty, with the little flowers and everything. This valley probably has a name. I mean, everything has

290

a name. This is where I made *Forst* (2004). I stood up there by the little lake with my large format camera, set everything up, sat down on a tree stump and waited for the sun to go away so there wouldn't be any hard shadows. Spent months hanging around this Thuringian forest and made this series.

That's the beautiful thing about this pyramid; afterwards it's just [*places a hand on the ground*] something like this.

Oh, hey, watch out ... here, take a look, a giant.

Huge beetle!

A huge bug. Come here, buddy. [*Pause*] I'm not sure our little friend likes lying on his back. Then get up again. Come on! You can do it! Come on, little beetle! You're doomed otherwise. You have to get up on your own, pull up on your stomach or you'll never get anywhere. Come on! [*Pause*] Yeaaah, you did it! If you can do that, you can do anything. [*Pause*] Come on, go up. Go to the top! No one can hold you back. Go on, go a little further. Don't settle for the base camp! Come on, just a little further. Come on! Go! Aaaah, he crashed. Bye, little beetle.

Come on Erik, we wanted to go to hunting blind over there.

[*Pause*] Okay.

But first I need a sip of water from the spring. Aaaah!

Ha! Stepped in a hole, eh? All of those are mouse holes. [*Pause, splashing water*] Hole for hole—but it holds up. [*Pause*] Time for a climb, hmm?

The door is closed, isn't it? No, there is no ... those are real panes.

Yeah, when it's cold—but Plexiglas.

How do they shoot? They crouch down in there.

No, they have another board here. I'm guessing that fits right in there, and then you shoot. Have you ever killed an animal?

My father had a slaughterhouse. I helped him out there, but I can't remember. I don't know.

I thought you said you'd already killed some bull.

Maybe, with the pop rivet. I really can't remember. I don't know if I've ever cut anything's throat. There were always these two steps. The first is numbing them with a shot and then you have to cut the carotid artery so the animal bleeds to death.

Knife ... no. But I once shot a pigeon. I made it my mission to hunt a pigeon and at first I was totally in this hunting mode. Walk forward quietly, sneak up, take aim.

With what kind of a gun?

I had an air rifle, but one that had been completely redone. It had a much stronger kick and a pretty high penetrating power. And I was totally in this hunting mode right up to the moment where I had to shoot. And then from one second to the other I was confronted with exactly the opposite, namely suffering and an urge to help. I shot, hit it, and in that very moment the sympathy set in. And then I set about the completely senseless business of trying to help the animal.

It was only wounded?

Yeah. But eventually I shot again and killed it.

How old were you?

I was in my mid-twenties.

You'd never shot before? At a target or ...

Yeah, sure, I'd shot at targets. It was a really popular thing in the GDR days; you did it at festivals or also holiday camp. Not until military training camp, when we were supposed to shoot with automatic weapons ... I was in boot camp in 1989 as the protests at Tiananmen Square were going on in Beijing. I heard that because we'd smuggled a little radio in there. And in the course of that and because of the age I was when I was in there, I just rejected the idea of shooting. And because of that, a few others and I were thrown out. I lost my hard-won apprenticeship as an ornamental blacksmith. When I was young I really had my own anvil, a forge, and really started learning various forging techniques. And actually from the time I was eleven or twelve, up until I went to this boot camp, I was completely convinced that I would become a metalworker. All of that crumbled when I had my first confrontation with the powers that be. And then there was reunification and everything turned around again anyway. I didn't finish school until after reunification. It was still the GDR, but there was almost nothing left of it. [*Pause*] Are you ready to get out of here?

Yes, but tell me more about the air rifle.

My friends and I used to shoot at targets even when I was in the civilian service. At bottles, at paper, at anything you can think of. Back then we had a really long hall in the flat we were sharing, and at the end of the hall we built up a target. And at some point we realized, hey, all of us are in the civilian service and have a crazy good time shooting things. I did actually go back and forth about that, about the idea that weapons as such have such a crazy appeal, but the way we are raised, society causes you to shy away from it—also the fear of injuring someone. I'm no pacifist, and I do not fundamentally oppose violence as a solution to problems. Because there can be situations in life where the person who is not prepared to take the last consequence into consideration will not survive. So I never ruled it out for myself as a means, because I never wanted to surrender.

But the fact that you went and shot the pigeon, that's what you planned on doing?

No. I lived in a kind of loft. It was in an industrial complex, and

there were just tons of pigeons. They shat all over everything; there was pigeon shit everywhere. And then, by coincidence, I got this air rifle and at first I legitimized it as an act performed in the name of hygiene: fewer pigeons, less shit. They really are just rats with wings.

And then you only injured the first one.

It fell on an awning, right on the blanket where a few other neighbors in the apartment building were having a picnic. And then it lay there and—grr grr grr—struggled to survive. I went over, looked at it and decided, well okay, we can't do anything for it. Loaded the gun and delivered the final blow in the circle of these people sitting there. Packed it in a baggy and moved along. [*Pause*] That was also an important point in my life.

You have a few. You really do have these points. I don't have those.

You're also almost too smart for what you do. Because of that you probably make very few mistakes.

What do you mean by mistakes?

Well, with me there are just a lot of mistakes, ones where I maybe end up falling on my face. But you, on the other hand, you're cushioned with all this knowledge and always get into things by reason of the fact that you seldom make a false step—and maybe because of that you haven't had this or that other basic experience. Maybe it's also this math-analysis thing. You're always out to prove something, you know? ➡ Gregor Jansen, 119.

Yeah, I actually ended up in the wrong area—that is exactly my mistake.

The film is over, and there's the book, and the happy lore comes out: Ingo Niermann did such-and-such and went out on a limb here and there. And I will execute this work, become successful with it or not. So I really have an objective. Really a point where I'd have to score. And *you*, what are *you* in that time?

We're still friends. [*Laughs*]

[*Laughs*] Okay. Because if the film is over, I actually don't need you anymore.

No, you can just go right ahead.

That can have various consequences, this not-needing-you-anymore. On the one hand I could say, cut the dead weight, I don't need it anymore, it'll probably just piss me off at some point,

bellyache about, keep going with this—I got a raw deal and my name is so small back there! You know? I could care less. There's always some whiner moaning about something.

Well, my name is bigger and on top of yours.

Yours? [*Laughs*] And now we've come to exactly where I wanted to be. What I propose to you is that I build insurance for you in there. Even if something in life takes a totally different course than you thought it would, I would offer you the following.

Yeees?

As a token of my deepest gratitude, I would offer you a retirement plan. Regardless of the course this will take, I would guarantee your livelihood for the rest of your life. In other words, whenever you go into the red, whenever you find yourself in really dire existential situations in the future—anything that unhinges everything you've done until that point or threatens your fiscal well-being, then I would balance it out—at least I would always bring it back to zero.

Oh.

I'm your lifeboat, so to speak.

Yeah, and for that you have the pyramid.

Thank you.

Yes, thank you.

[*Laughter*]

This right now—to speak with Thomas Bayrle—is the total interweaving. But the funny thing is, the individual has been preserved at the same time.

That's what you call interweaving.

Dear collectors, by now you all have a general idea of what this is about. We also know that it's always good when more than one person wants something like this. And the chances of there being more people besides *you* interested in this whole thing, you're going to have to figure those out for yourself. If you want to be a part of something great, then now is the time.

My ashes are still available. [*Laughs*]

Exactly. We still have something in the jackpot! We still have ashes!

Indiana Jones, just now that was Part 1—min.! [*Laughs*]

> There's still a screw left over from the Bayrle motor. And around that we're going to build on all the parts that are missing from the perfect motor. And if there's another screw left over, then we'll just keep doing it again and again until there is no screw left. Simple.

There's also the Great Pyramid.

> For me, it really feels as though it's gone. We've developed it further. And because it was just an idea before that ...

The uneasiness I always had with it was this building it up. And that's the great thing about *Pyramid Mountain*. But of course there's also the Great Pyramid, too. On the one hand we have the collective people's pyramid, and here we have one that is the total opposite. In other words, we're not even taking a human life, we're only taking ...

> ... one day.

I don't really think it's necessary for your ashes to go in there at all.

> Nooope. The day is going in there.

That's why your ashes are still ...

> *Our* ashes are still there.

Yes! You can think about whether or not you want them going in there. Maybe mine as well.

[*Erik takes a blanket and spreads it over his head.*]

> Hmm, that's nice. Are you coming under my roof, too?

Mhm, I'm coming too.

> It really is protective, a roof like this. There's also an inside and an outside.

Yup.

> We're always talking like we're making history ...

Why not? *That's* also just what history feels like.

> But if we had made it all up, it really would have been like the smart little piggy.

Oh, so smart little piggy-esque. [*Laughs*]

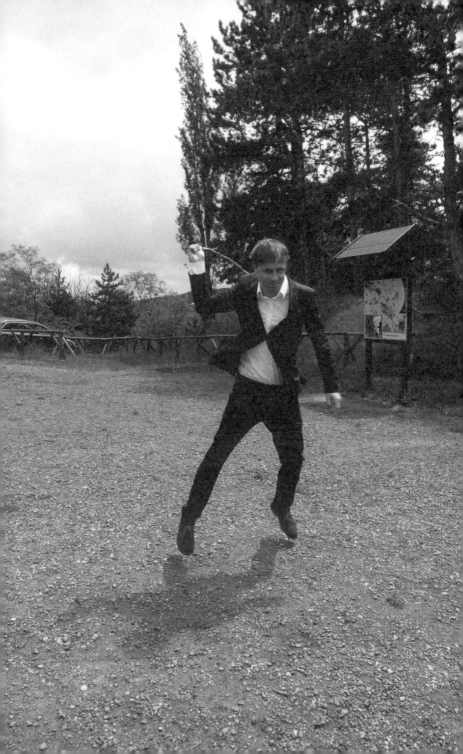

Appendix

Genealogy of Pyramid Mountain

I. THE GREAT PYRAMID

In the fall of 2006 I began publicizing my idea for the Great Pyramid, a gradually growing tomb for potentially every human being in the world. Every stone in this pyramid could house the ashes of a deceased individual. It would grow, layer by layer, over decades and centuries. Every stone would be identical in size and would at some point be covered by others, because we are all the same, at least in death. Economist Jens Thiel, structural engineer Heiko Holzberger, and I founded the Friends of the Great Pyramid Association, ➡ "The Great Pyramid," Friends of The Great Pyramid e.V., and we successfully secured funds from www.thegreatpyramid.de. the German Federal Cultural Foundation to locate a site, conduct feasibility studies, and carry out an architectural competition under the direction of Rem Koolhaas. We presented the results in the book *Solution 9: The Great Pyramid* (2008), published by Sternberg Press. Frauke Finsterwalder documented our efforts in the film *The Great Pyramid* (2010).

Newspapers, blogs, radio and television broadcasters, and architectural and funerary trade magazines from around the world reported on the project. But how could the Great Pyramid become a reality? Despite all the enthusiasm shown by local politicians from various parties in Dessau-Roßlau—our intended site—it became clear that no municipality was prepared to invest their own capital in the project, no matter how culturally unifying such a tomb would be or what it would generate in the way of tourism. The best-case scenario

would be that they provide a cheap site for development. Though the initial cost of construction appears rather modest when compared to other large-scale architectural projects, it would still require a few million euros for the site evaluation, the land, the foundation, and a simple marketing campaign.

The venture capital-based start-up model is virtually nonexistent in the real estate industry, as it does not anticipate any new concepts for use. Moving from the idea that information on those buried in the Great Pyramid could be made available in a virtual 3-D model, Jens Thiel and business consultant Stefan Dieffenbacher expanded the concept into a social network, a "Facebook for the dead." But the Great Pyramid was too large and too expensive to serve as a promotional measure for a web portal in that sense. At the same time, the question came up as to whether private, profit-oriented financing should be pursued at all. One compromise could be that profit would come not from the pyramid itself, but only the surrounding Pyramid Park—hotels, restaurants, chapels, parking spaces, and so on. The pyramid stones would be made so inexpensive that prices could easily compete with an anonymous urn burial—currently the cheapest standard form of burial available. Ideally, burial in the Great Pyramid would even be free of charge and thus actually available to every human being in the world, which is why Stefan Dieffenbacher, Alexander Schmid, and I outlined a benefactor model. Should there be a single benefactor involved, he or she would be allowed to decide where the Great Pyramid should be built.

Who could a benefactor like that be? With Erik Niedling, who had led me to the idea of the Great Pyramid in the first place (not yet conceived as a tomb), I had settled on the wealthy art-collector type as the perfect financier for the project. ➡ Gregor Jansen, 122. That is, someone who has satisfied all of his or her personal needs for comfort and for whom the collection of unique artistic works has become routine. For a sum that would be just enough for one of many better Picassos or Warhols, the collector would get this huge and also steadily growing one-of-a-kind artwork—one that needs no museum to be erected or won, but that in itself is already spectacular enough to attract hordes of visitors from all over the world.

Stefan Dieffenbacher worried that selling the Great Pyramid to a collector would mean forfeiting control over its realization. Yet an artwork obliges the purchaser to respect it beyond the point of purchase and can force him or her to assume risks that could not be covered

by a one-off foundation. In art it is possible to make the conditions of purchase part of the work itself; an artwork can even consist primarily of purchase requirements. The costs associated with purchasing the Great Pyramid would, however, be immense, and the collector's honor would require that these would not be passed onto a third party. No matter how the price of concrete or whatever material should develop in the future, the collector must have the resources to lay these millions of urns to rest and pass these onto a custodian for the period following his death.

The Friends of the Great Pyramid initially decided on a stone size of a generous length and width of ninety centimeters and a height of sixty centimeters. One block of concrete of this size would weigh in at well over a ton, and its pouring and setting would put the cost in the three-digit euro range. To make the stones any smaller would compromise its stability, and it would be a significantly longer period of time before the Great Pyramid could reach an imposing height.

The search for an affordable and yet imposing solution brought me to the idea that the pyramid would have to grow from top to bottom, emerging gradually from an existing volume, a mountain—for what is a pyramid if not an abstraction of a mountain? ↪ Hans Ulrich Obrist, 141. The urns would then be directly embedded in the stone. This would also guarantee that the urns would not disappear at some point under the next layer of stones, but would forever remain visible and accessible. In an effort to protect them against the elements, abrasion, and vandalism, they should be sealed. Though quarrying the pyramid from the rock would create a large amount of noise, it can be contained within short construction phases. What is more, the building activity would only take place below the urns already in place and not above them, as in the original concept. The burial can be done by hand. The pyramid would also either cascade in steps, or the gradient incline would be so low that it could also be climbed without steps.

For reasons of cost and natural preservation, the structure could be no higher than that of a low mountain. All the same, assuming a surface of ten centimeters within the square for every urn, a square kilometer would accommodate one hundred million urns. At some point, however, the pyramid will be filled to capacity and can at most grow downwards into the ground.

What worried me more is the fact that as dedicated to art as a collector may see himself as being, it is nevertheless his property. The collective tomb belongs to a single person who is not its creator.

Would any individual really be willing to give this person their ashes, or those of their loved ones? The reasons purchasable artworks and participatory art actions—or social sculpture, to borrow a term from Joseph Beuys—are typically mutually exclusive go beyond the art historical. ➡ Gregor Jansen, 125.

II. THE COLLECTOR'S TOMB

A social sculpture that can be sold without reservation to a collector is contingent on his participation alone. Traditionally, this would consist of sitting for a portrait. The commissioned portrait, however, has increasingly fallen out of favor with the differentiation in the art system ➡ Philomene Magers, 70. and has persisted as a casual gimmick at best. ➡ Tobias Rehberger, 250. It contradicts art's claims to autonomy by way of its representative function. At the same time, collectors today feel a higher calling than to be degraded to the level of an object by an artist. Here they regard their collecting as creative work in which they express themselves. The collection is a collaged self-portrait under constant revision, which the collector reveals to the public in his own rooms, a new section with every showing. ➡ Philomene Magers, 70.

Collectors need not have many illusions as to the survival of their collection after their death. It will be shattered by heirs or, at best, subsumed by a public museum collection. Even if collectors establish a foundation for the preservation and presentation of their collection, public interest will in all likelihood rapidly subside in the absence of new acquisitions. ➡ Friedrich Petzel, 202. Yet it is precisely the finite nature of their efforts that elevates the act of collecting to a temporary installation that is above banal claims to eternity. ➡ Thomas Olbricht, 151; and Boris Groys, 235. Only if it is spectacular enough, the collector leaves a lasting impression at least on experts, even beyond his death.

Curators sense in collectors a dilettantish, yet fantastically wealthy competitor. ➡ Gregor Jansen, 117. Artists generally hesitate to concern themselves with collectors or even take them up as a subject in their art. Felix Gonzalez-Torres' collectors' timeline on the facade of their home is a rare example (*Untitled [Portrait of the Stillpasses]*, 1991). Andrea Fraser's video *Untitled* (2003) shows the artist having sex with a collector, but in a wide shot and without sound. ➡ Friedrich Petzel, 205. It is meant to be a general metaphor for the exploitation and instrumentalization of art, and at the same time, overcoming it, because she

was practically the one who paid and not the collector,
who was obliged to purchase one copy of the edition
of five, though at a drastically reduced rate.➙ According to Andrea Fraser at a lecture
There are heaps of examples of institutional cri- on December 14, 2010, at Hamburger
tique, because the institutions or their curators com- Bahnhof, Berlin.
mission it. There is, on the other hand, almost no curator
and collector-critical art because the majority of them are
not so confident to commission their own criticism after all. And
artists are not so confident as to spoil their chances with potential
patrons.

Unlike a curator, a collector could devote the rest of his life
to a single work of art. Participation art could demand more from him
than it could an individual passerby. How better to express himself
than in the selection and completion of a personal challenge as defined
by an artwork?

The pyramid-as-collector's tomb is that kind of challenge. Upon
purchase, the collector agrees to quarry an at least two hundred meter
high (and thus by far the world's largest) tomb from a mountain, and
commit to burial in it directly after his death, or at the latest after the
pyramid's completion. There are no specifications as to the shape and
size of the burial chamber. The collector may take with him whatever
he so desires—even his complete art collection or selected parts of it,
what he sees as the worst or best artworks, for example.

As much as the collector may see himself as the mere guard-
ian of a third party's claims to eternity, these will inevitably reflect on
him as well, at least while he is still alive. This participation becomes
explicit with the collector pyramid. The collector is not only portrayed,
he becomes a central part of the artwork—though only after his death.
It exaggerates the collector's narcissism and at the same time subor-
dinates him to the artist's claims to eternity, because this mausoleum
can only be entered and seen as long as the collector is still alive. The
waste material from the quarry will be piled into a hill next to the pyra-
mid that can be used as an observation deck. The mining waste will be
poured over it again once the collector has been buried, allowing the
mountain to return to a form as close to the original as possible.➙ Erik
Niedling, 143; Thomas Olbricht, 152; and Boris Groys, 235. The pyramidal tomb—para-
gon of high-cultural cultural achievement—will once again be interred
in a burial mound.

Paradoxically, this could enhance the posthumous reputation
of both the collector and the artwork.➙ Tobias Rehberger, 257; and Thomas Bayrle,

268. There is also a possibility that at some point someone will ignore the wishes of the artist and expose the pyramid, open the burial chamber, and bring its treasures unscathed into the light of day where the other relics of this time are long gone. The artwork reveals itself when it is no longer respected and there is a rupture in art history that past avant-gardes had proclaimed to no effect.

It is, however, also possible that in the future it is not the burial chamber, but only the mountain and pyramid structure encasing it that is regarded as valuable. The contents of the chamber can also be x-rayed without the chamber being opened and perfectly reproduced as often as one likes. The only restrictions apply to the material with which this takes place.

One hallmark of the visual arts today is the fact that it does not exhaust its technical reproductive possibilities. It is an irreproducible original, or reproduction is at least very limited. Where art used to claim permanence through transcendental content, it now does so by refusing the very mass distribution that inevitably leads to it being pushed aside. Mass products are throwaway products. But the future bodes a massification of originals as well. ➡ Boris Groys, 226. Everything can be copied perfectly at any time and thus lose its status as a one-of-a-kind original, but new originals can also be produced automatically: as a systematic variation, at random, and according to the will of suppliers, buyers, or third parties. Everyone has the leisure and technology to be actively creative on their own or to alter existing products at his or her discretion. They can also be reissued on a need basis or can be just as effectively simulated.

Appropriation art, with its critical examination of the concrete original, anticipated the massification of one-of-a-kind work. Through performances, interventions, temporary installations, and concepts, art has overcome an otherwise ever-present materiality. ➡ Hans Ulrich Obrist, 137; and Boris Groys, 221. Could it be that from now on, only diehard nostalgics will be buying, storing, and conserving certified originals? Or will owning originals become a common luxury, similar to buying designer clothing? As the haute couture of originals, the visual arts could continue to be characterized by its struggle for lasting meaning per se. Still, the musealization of common originals continues to accelerate at an ever-growing pace. Buildings are placed more and more quickly under monument protection; a growing number of conditions with ever more temporal, spatial, and numeric limitations are placed on the use of ordinary goods; inheritances are more and more frequently made

into foundations. The art-like status of these sites and situations is fixing more material and domineering coming generations.

Pyramid Mountain exaggerates the claim to permanence—conservation is not for decades, as is usually the case, but for thousands of years with no further care necessary—and betrays it again through concealment. Since lone, bucolic mountains were popular sites for the construction of castles, it seems natural to consider such an acropolis hill for the pyramid. The castles standing in Europe today were generally reconstructed and reinvented anyway as per nineteenth- and twentieth-century historicist fashion. So why not tear down a castle like that and re-erect it some years or decades later on the once again covered-over mountain➡Hans Georg Wagner, 273. as a decorative and at the same time concealing ornament?

It stands to reason that the purchase price for the collector's pyramid (building costs aside) would have to be high enough to get construction on the Great Pyramid underway. Even in the Great Pyramid, each gravestone will soon be covered after the funeral—by another gravestone. The individual recedes and the whole becomes all the more visible.

This is not to say that the collector's pyramid should be sold only once. The artwork would have to cope with the fact that, like any other ordinary product, the number of editions isn't necessarily determined from the outset. In doing so, I as an artist also relieve myself of the pressure to constantly have to produce more and more art to generate further income and land in more and more important collections. Instead, I put pressure on the buyer to locate the most magnificent pyramid mountain possible and begin work on the structure as soon as he can.

The collector's pyramid will be sold in an open-ended, first-offer auction. The accepted bid need not necessarily be the highest and I reserve the right to sell pyramids for completely different prices later on. The sale need only represent such a dramatic sacrifice for the collector that he or she would be forced to severely cut back on future collecting or even sell off parts of his or her collection. In doing so, the collector would not necessarily need to consider himself egomaniacal in building the largest tomb in the world, but could consider himself its servant. Or he does not even have the necessary funds to realize the pyramid at the point of purchase. Its building will become his life mission. It seems only logical that he ultimately also be buried there. The more distinguished the treasures the collector takes with him in the burial chamber, the more glorious the funeral will be.

III. THE CHAMBER

An artist has more license to grandiose self-dramatization than a collector. But were *Pyramid Mountain* to become my own tomb, I would be giving myself less to art than to the Great Pyramid. In an effort to kick-start its construction, my own ashes would be put into a pyramid, which will then disappear.

Instead, I could offer the pyramid to another artist, one whose art also essentially consists of collecting and is especially sensitized to eventual disappearance. To me, no one seems better suited to this than Erik Niedling who, in the course of making the film, decided to devote the remainder of his artistic work to his own past. ➡ Epilogue, 281. He has chosen to concentrate on a single night in his hometown of Erfurt in the late 1990s, in which he and a few friends came to experience physical and psychological excesses that until now have moved him to limit himself artistically as a photographer and archivist of things constructed, planted, and photographed by others.

In order to intensify his examination of his own life, starting March 1, 2011, Erik Niedling has been following a drill I developed: he is living one year as though it were his last. Life-coaching books often advise readers to become conscious of the finite nature of their lives as a way of savoring it more. Seneca asks that we live every day as though it were a life in itself, yet one can only succeed in doing so by largely marking time. Meanwhile, one year is so long that the supposition of approaching death—even without believing in it—develops into an inescapable practical and thus mental dynamic. Erik Niedling dedicates himself to the transgression he experienced on the night of December 24, 1998, by means of a new shock that renders his end palpable.

Niedling has accepted my gift of *Pyramid Mountain*. He has decided to sell his works that surround the events of that night—The Chamber series—on the condition that the work be allowed into his burial chamber as a final exhibition at his funeral. If one were to take the artist seriously as the actual artwork, ➡ Prologue, 14; and Boris Groys, 220. then he shall remain the proprietor ➡ In the sense of Max Stirner's *Eigner*. See Max Stirner of his works beyond its point of sale and *Der Einzige und sein Eigentum* (Leipzig: Verlag von Otto Wigand, 1844). continue to decide on an ongoing basis which work should be taken with him into the burial chamber. The collectors involved would then have to relinquish their right of use for an un-

limited amount of time.

As opposed to the Great Pyramid, a monument to humankind, *Pyramid Mountain* will stand not only for a single individual, but also for only a few hours of his life. Just as with the Great Pyramid, where the ideal of human equality is realized only in death, *Pyramid Mountain* is the irrevocable command of the self.

Erik Niedling, who inspired my idea for the Great Pyramid, will receive a pyramid from me as a gift. In return, he has promised to help support me in financial emergencies until my dying day. I in turn have offered to research the said night through various interviews and regard this work as my own work of art, which Niedling can enact as he sees fit. *Pyramid Mountain* remains my artwork, but Niedling may resell it to a collector if he wishes to do so. The pyramid's construction can follow only long after his death.

Works of art are repeated in Appropriation art, but in our case, one and the same object will go through a repeated process of becoming art, and will disappear soon afterwards. The pyramid's enormous dimensions will be used efficiently and sustainably. That is the art of the future.

Commentary

Chus Martínez

FUTURES OF ART

In his infamous memoirs, *No Niego Nada* (I don't deny anything), Espartaco Santoni—actor, playboy, and a key figure in the making of Marbella—confessed to having some blanks as to whether or not he had actually slept with a number of prominent Spanish women. And it is definitely best to ask. With the motivation of a man who hates inaccuracies, he called a legendary Spanish singer: "So Lola, did we end up sleeping together?" She hung up, he writes in his book.

To figure out whom and when to ask is tough.

"It is naturally gayer to describing what anyone feels, acts, and does in relation to any other one than to describe what they just are, what they are inside them," wrote Gertrude Stein, and a little bit later she goes on: "If you think about how many generations, granting that your grandfather to you make a hundred years, if you think about that, it is extraordinary how very short is the history of the world in which we live, the world which is the world where there is a world for us."→ Gertrude Stein, "The Gradual Making of The Making of Americans," in *Selected Writing of Gertrude Stein*, ed. Carl Van Vechten (New York: Random House, 1946), 220.
And so, the search for the future of art and the making of the Great Pyramid into art history or the art imaginary can be seen as an exercise in realizing the centrality of description. The very act of telling this story to other men and women becomes crucial, the account of everything that we take for art reveals itself as a way of making things happen, of opening up a space. After all, in a TV series like this,→ In autumn 2010, the film *The Future of Art* premiered as a web TV series on the now-defunct website, www.3min.de.
knowledge is not synonymous with what you know but with what is happening—the words that artists use. When watching people being interviewed about the future of art, one needs to bear in mind that the description of art is not art but something that has the potential to happen, or, better said, has

the potential to become art. And for that very reason, the pyramid is already inscribed in art history if it wishes to be. It marks the process of this inevitable becoming that is part of artistic and cultural production. The pyramid could of course be an art-work, manifesting the fact that civilization is indeed short; it can be counted by centuries, and that each hundred-year rehearsal performs civilization. Civilization only lasts for the time "which makes a period that can connect you with some other one."→ Stein, "The Gradual Making of The Making of Americans," 224.

As far as modernity is concerned, the apparent absurdity of an image or an object does not imply absurdity in the doctrine, or the thinking that produces it. It is premodern thinking which believes the "naïf"—such as the quest for art, or the recurrent question concerning the art status of a giant pyramid build in, let's say, Germany—has a strong relation to the "false." It is not enough to satisfy the speculative standards of the current times. This series of interviews, presented as a search for the future of art, plays with the idea of imagining an earlier stratum of the art world as if it were still possible to pose that question again. The universe that the series presents holds together, seeming to share a common understanding of what the interviewees refer to when they talk about art, and the intrusion of "the wanderer"—the interviewer—is both naive and a perverse fabrication of naiveté. The reason why a literalist may be puzzled in watching the interviews is that the searcher is trying to get at something which is not there—or is ontologically insignificant. The purpose of such an apparently inatten-tive effort towards the future of art, and towards the acceptance of the Great Pyramid as the future, is not to produce answers but to produce a distinct atmosphere—one that irritates because it gloomily drama-tizes a state of no clear consciousness of the fact that art thinks. Art definitely exists and therefore can cease to exist, or it can be mistaken with other existing things. And, so far, so good. But the reason that the interviews enervate is their deliberate attempt to conceal the oblivion of how art releases thinking. The whole exercise deliberately distances itself from the experience of such thinking, and even more so from the language by which thinking is able to say what it thinks.